MAKING & MEANING

# RUBENS'S LANDSCAPES

 *In association with Esso UK plc*

MAKING & MEANING

# RUBENS'S LANDSCAPES

CHRISTOPHER BROWN

National Gallery Publications, London

Distributed by Yale University Press

This book was published to accompany an exhibition at
The National Gallery, London
16 October 1996–19 January 1997

© National Gallery Publications Limited 1996
Reprinted 1996

First published in Great Britain in 1996 by
National Gallery Publications Limited
5/6 Pall Mall East, London SW1Y 5BA

ISBN 1 85709 154 X hardback
525213
ISBN 1 85709 155 8 paperback
525214

British Library Cataloguing-in-Publication Data.
A catalogue record is available from the British Library.
Library of Congress Catalog Card Number: 96-69977

Editors: Felicity Luard and Diana Davies

Editorial Assistant: Katharine Eyston

Designer: Tim Harvey

Printed and bound in Italy by Grafiche Milani

Front cover and frontispiece: Details from *An Autumn Landscape with a View of Het Steen
in the Early Morning* (Plate 58)

Back cover: *The Watering Place* (Plate 46)

# Contents

# *Author's Acknowledgements*

Like the previous exhibitions in the 'Making and Meaning' series, *Rubens's Landscapes* is a collaboration between three departments in the National Gallery: the Curatorial, Conservation and Scientific Departments. My principal collaborator has been Anthony Reeve, a senior member of the Conservation Department and the Gallery's specialist in the conservation of panel paintings. He was responsible for the restoration of *The Watering Place* fourteen years ago and many of the questions discussed in this book were first raised at that time. Chapter 8 is largely based on information which he has supplied and the technical Appendix is the result of his painstaking analyses of the physical make-up of the panels on which most of Rubens's landscapes were painted. Ashok Roy, Head of the Scientific Department, has provided much-valued help and advice.

The Rubenianum in Antwerp is the most important resource for the study of Rubens and on my visits there I have always been treated with great kindness. Arnout Balis, Frans Baudouin, Carl van de Velde and Hans Vlieghe were particularly generous in answering my enquiries and reading my text, as was Paul Huvenne, Director of the Rubenshuis. Many other friends and colleagues read parts or the whole of my manuscript, which they improved greatly. I would like to thank Michael Jaffé, Walter Liedtke, Gregory Martin, Elizabeth McGrath, Justus Müller Hofstede, Konrad Renger, Hubert von Sonnenburg, Jørgen Wadum and Christopher White. Roland Baetens, Marco Chiarini, Egbert Haverkamp-Begemann and Jan de Maere kindly answered questions and provided photographs. My wife Sally was, as ever, my severest critic and substantially improved my prose style.

Anthony Reeve would particularly like to thank Bengt Kylesberg, Curator at Skokloster Castle, Sweden, for his advice on seventeenth-century tools. Finally, we would both like to thank the many colleagues at the National Gallery who assisted in the preparation of this exhibition.

Christopher Brown

# Sponsor's Preface

It is a pleasure to be once again associated with the National Gallery in this the fourth exhibition in the 'Making and Meaning' series.

As in our previous exhibitions with the Gallery, 'Rubens's Landscapes' exemplifies the quality of research and scholarship that are the Gallery's hallmarks. In building on the success of previous 'Making and Meaning' exhibitions we are delighted that this study analyses in depth one of the Gallery's greatest treasures and examines Rubens's career as a landscape artist.

Our sponsorship of the National Gallery has been established since 1988 and we are pleased that this has enabled the Gallery to explain in depth to the general public more about its vast array of treasures. We are delighted to continue with our relationship again this year and fully support the Gallery in its very worthwhile mission of increasing public understanding and appreciation of its collection.

K.H. Taylor
*Chairman and Chief Executive, Esso UK plc*

# Foreword

If the British have often been nervous in the face of Rubens the creator of full-blooded baroque allegory, apologist of Catholic dogmas and absolutist monarchs, they have always loved Rubens the landscapist. Gainsborough paid homage to him in his *Watering Place*. Reynolds bought *Landscape with Moon and Stars* for his own collection. And Constable's *Hay-Wain* is merely the most famous instance of England's desire to see itself through the eyes of Rubens. By the end of the eighteenth century indeed, most of his landscapes were in collections in this country and the *Landscape with Het Steen*, perhaps the greatest of them all, was part of Sir George Beaumont's founding gift to the National Gallery in 1824. Since then, four other landscapes have entered the Collection, giving the Gallery an incomparable holding of this aspect of Rubens's work.

They have proved difficult pictures to look after. Rubens, immaculate craftsman in his religious and mythological works, for his landscapes frequently made his panels out of a number of pieces of wood, apparently off-cuts, awkwardly joined together, with grains running in different directions, and thus peculiarly vulnerable to sharp changes in humidity. Visitors to the Gallery can still easily see the split in the *Landscape with Het Steen*, which fell apart in the great frosts of 1947. Many of the landscape panels are demonstrably not of the standard that was required by the Antwerp guild for sale on the open market – a feature unusual across his work as a whole, but one shared with a number of portraits of his family and friends. And as many of the landscapes were in his own possession at the time of his death, it seems likely that we are dealing in both instances with pictures that Rubens painted essentially for himself, that we are looking at the private work of the most public painter of the seventeenth century.

In the landscapes, Rubens can explore what he believes and what he loves – providence watching over his family and Flanders. It was to make Flanders peaceful and prosperous that he travelled to the courts of Europe as diplomat as well as artist, and in the paintings we see its countryside as it was meant to be, fertile and sustaining, tended by man under the guidance of God, and, at the end of Rubens's life, providing a home for his family and himself. As this exhibition argues, Rubens's biography can be traced almost as clearly through his landscapes as through his letters.

Given the fragility of Rubens's panels, we have been exceptionally fortunate in securing so many loans, and we are more than usually grateful to the lenders. Especially, we are indebted to the generosity of Esso UK plc, in supporting this, the fourth 'Making and Meaning' exhibition. Since 1989, Esso has enabled the National Gallery, year after year, to present to the public recent research on how and why the pictures were made. Rubens had a particular admiration for those who were steadfast in friendship, and he was adept at celebrating them. He might have painted an allegory. We can only say thank you.

Neil MacGregor, *Director*

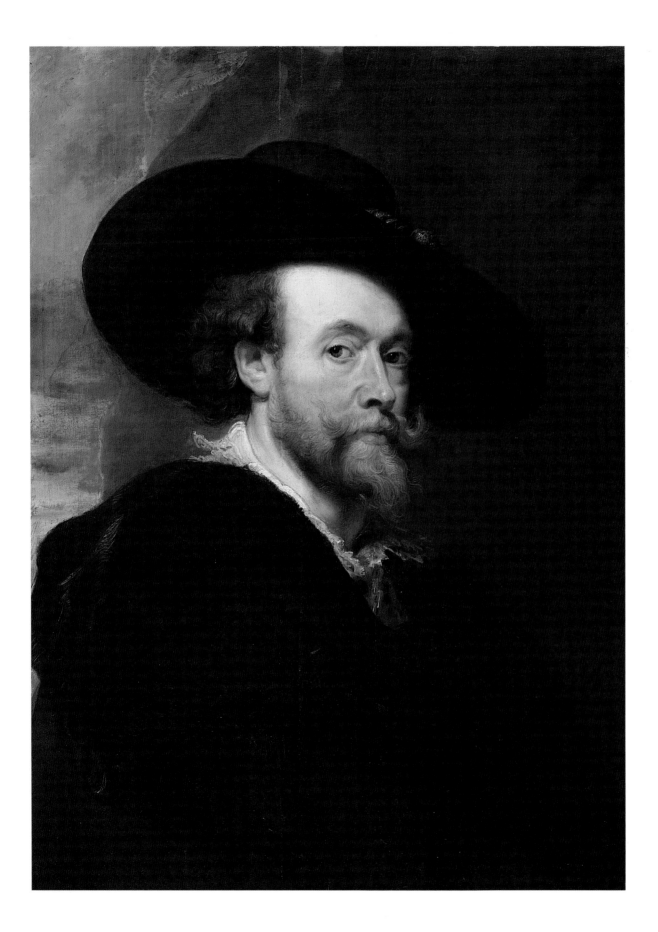

# Introduction

I N 1648, eight years after visiting the Antwerp studio of Peter Paul Rubens, the English miniature painter Edward Norgate noted that Rubens was so enthusiastic about landscape in his later years that he 'quitted all other practice in Picture and Story, whereby he got a vast estate, to studie this, whereof he hath left the world the best that are to bee seen.'[1] Norgate was exaggerating Rubens's concentration on landscape – in fact he continued to paint commissions 'in Picture and Story' until the end of his life – but his remark gives an impression of the importance that Rubens himself attached to landscape painting and the admiration that his landscapes commanded among his contemporaries.

Rubens was principally a history painter, that is to say, he painted religious and mythological subjects and scenes from classical history. History painting was traditionally the highest category of painting, in which the greatest artists achieved distinction. Rubens's immense reputation, which extended throughout Europe in the early seventeenth century, was based on the monumental altarpieces painted for Flemish churches in the years following his return to Antwerp from Italy in 1608 and the great series of paintings and tapestries made for the French Queen Mother Marie de Médicis, King Charles I of Great Britain, the Archduchess Isabella in Brussels and Philip IV of Spain in the 1620s and 1630s. To enable him to undertake these great enterprises Rubens built a large studio adjoining his house in Antwerp in which there were many pupils, assistants and specialist painters – among them specialists in landscape and still life – who painted substantial sections of huge panels, canvases and tapestry cartoons under Rubens's close supervision. And yet this remarkably energetic and versatile artist also painted portraits, scenes from peasant life and about forty landscapes.[2]

Painting landscapes seems to have been an intensely personal activity for Rubens. Very few landscapes, perhaps none at all, were commissioned works like Rubens's religious and mythological paintings. The *Landscape with Het Steen* – or to give it its full title *An Autumn Landscape with a View of Het Steen in the Early Morning* (Plate 58) – and the *Landscape with a Rainbow* (Plate 59) are just two of the eighteen landscapes by Rubens which appear in the list of paintings in his own collection drawn up at the time of his death in 1640.[3] Those two large panels probably hung at Het Steen, his country house in Brabant, and others like the *Landscape with Moon and Stars* (Plate 72) and the *Forest at Dawn with a Deer Hunt* (Plate 71) must have hung either at Het Steen or in the artist's house in Antwerp. Others entered the collections of friends like his brother-in-law Arnold Lunden[4] and patrons with whom Rubens had an especially close relationship such as the Duke of Buckingham[5] and Evrard Jabach.[6] It is clear that landscapes were painted by Rubens for his own pleasure and that of a few favoured friends and patrons.

Despite the essentially private character of Rubens's landscapes, his activity as a

(opposite) *Self Portrait,* 1623
Oil on panel, 85.9 × 62.3 cm
London, The Royal Collection
This self portrait was sent by Rubens to Charles, Prince of Wales (soon to be King Charles I) in 1623.

landscape artist became widely known and admired. At the end of his life he commissioned a favourite printmaker Schelte à Bolswert to engrave at least one landscape (Plate 106), and others were engraved shortly before or after Rubens's death. Another associate, Lucas van Uden, also made reproductive prints after Rubens's landscapes. The paintings themselves were relatively little known in Rubens's lifetime as so many of the most important of them remained in his own possession. The posthumous sale of his collection naturally enabled them to be more widely appreciated. The landscapes were praised by Philip Rubens in the account of his uncle's life which he gave to Roger de Piles: he noted that although few in number, the landscapes were among the greatest of Rubens's works.[7]

Rubens's landscapes were passionately admired in Britain in the eighteenth and nineteenth centuries by painters and collectors and as a consequence the National Gallery possesses the most important single group of them to be found anywhere. It consists of five paintings and includes two of Rubens's most ambitious landscapes, *The Watering Place* (Plate 46) and the *Landscape with Het Steen* (Plate 58). The *Het Steen* was part of Sir George Beaumont's gift to the National Gallery at the time of its foundation in 1824.

In the present study the National Gallery's landscapes are placed within the development of Flemish landscape painting as a whole and the evolution of Rubens's own landscape art. They are also considered as expressions of Rubens's personal response both to the beauties of his native countryside and the political events of his lifetime. Rubens's landscape drawings and their relationship to the paintings are discussed, as is the often complex physical structure of the paintings. Finally, the reputation and influence of the landscapes are described. It is hoped that in this way these profoundly personal works, which are among the finest achievements of this immensely gifted artist, can be better enjoyed and understood.

Note
The seventeenth-century spelling of certain Flemish place names has been retained for the sake of consistency, namely Laeken (Laken), Eeckeren (Ekeren) and Perck (Perk).

All the works reproduced are by Rubens unless otherwise indicated.

## CHAPTER I
# *The Flemish Landscape Tradition*

IN RENAISSANCE ITALY the representation of landscape was considered to be a Northern speciality. Michelangelo is reported to have told his friend the poet Vittoria Colonna that in Flanders

> ... they paint stuff and masonry, the green grass of the fields, the shadows of trees, and rivers and bridges, which they call 'landscapes', with many figures on this side and many figures on that. And all this, though it pleases some persons, is done without reason or art, without symmetry or proportion, without skilful choice or boldness and, finally, without substance or vigour.[8]

Michelangelo's dismissive judgement was evidently prompted by the widely acknowledged superiority of Northern artists in landscape. In 1509 Francesco Lancilotti had written that 'a certain talent and discretion is needed for [the depiction of] near and distant landscape which the Flemish seem to have rather than the Italians.'[9] Forty years later Paolo Pino, struggling to explain how the Flemish could excel Italians in this type of art, came up with the idea that

> The Northerners show a special gift for landscape because they portray the scenery of their own homeland, which offers most suitable motifs by virtue of its wildness, while we Italians live in the garden of the world, which is more delightful to behold in reality than in a painting.[10]

During the fifteenth century Italians had seen Northern landscape in the backgrounds of a handful of Flemish religious paintings such as Rogier van der Weyden's *Entombment*, which was in Italy by 1449, and Hugo van der Goes's *Portinari Altarpiece* (Plate 1), which was in Florence by 1485, and in portraits by Hans Memlinc. They could have also seen it in the Flemish tapestries of historical and mythological subjects with which the Medici and other noble families lined the walls of their town palaces and country houses.

In these works landscape provided a setting for religious and mythological figures. It was also in the North and in particular in the leading town of the Netherlands in the sixteenth century, Antwerp, that landscape established itself as a suitable subject for independent works of art. The emergence of pure landscape, which is a key phenomenon in the development of Western painting, took place during the first half of the sixteenth century and is principally associated with two leading Antwerp studios, those of Joachim Patinir and Pieter Bruegel the Elder.

Patinir[11] came from the area around Dinant in the Southern Netherlands, at that time part of the Principality of Liège. Its topography is characterised by steep, vertiginous rocky outcrops, and these rocks, made even more fantastic in the imagination of the artist, are a striking feature of Patinir's painted landscapes. He had a short but highly successful career in Antwerp: he is recorded there from about 1515 until 1524. In his work the traditional balance between figures and landscape in religious scenes subtly

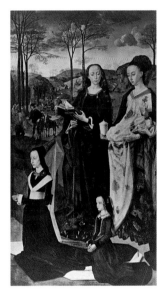

1. Hugo van der Goes, *Maria Portinari and her Daughter with Two Saints*, c.1473–5
Right-hand wing of *The Portinari Altarpiece*
Oil on panel, 253 × 141 cm
Florence, Galleria degli Uffizi
Van der Goes's altarpiece had arrived in Florence by 1485 and was placed in the church of the Santa Maria Nuova hospital.

2. Joachim Patinir (with Quinten Massys), *The Temptation of Saint Anthony*
Signed by Patinir
Oil on panel, 155 × 173 cm
Madrid, Museo del Prado
Massys painted the figures.

alters. Patinir's figures of the Holy Family fleeing into Egypt (Plate 3) or Saint Jerome in his solitary retreat are dwarfed by mountains and isolated by plains and distant vistas towards the sea. Patinir was greatly admired by his contemporaries and collaborated with leading figure painters like Quinten Massys (Plate 2) and Joos van Cleve. Patinir was praised as 'der gut landschafft mahler' (the good landscape painter), a very early use of this term, by Albrecht Dürer in the diary he kept of his journey to the Netherlands in 1520 and 1521.[12] The two men met in Antwerp in 1520 and again in the following year when Dürer drew his portrait and gave him 'four Saint Christophers on grey-grounded paper', four studies of the saint on a single sheet for use by Patinir in a painting.[13] Like many pioneering artists, Patinir was much copied and imitated. One of his most inventive and successful followers was Herri met de Bles, who came to Antwerp from Bouvignes, opposite Dinant on the River Meuse. He developed Patinir's style in a highly idiosyncratic manner and, encouraged by the Italian demand for Northern landscape, moved to Italy, where he died in Ferrara during the 1550s.[14]

A characteristic feature of Patinir's landscape compositions is the so-called bird's-eye or world view.[15] The landscape is seen as a panorama, as if viewed from a mountain top or by a low-flying bird. This gives the artist the opportunity to represent an extensive vista disappearing towards the horizon. The sea can often be glimpsed in the distance and the curve of the earth can sometimes be seen. The world view has a symbolic value because it suggests the insignificance of the tiny figures who populate

the landscape, and so recreates God's-eye view of humanity. It seems to provoke in the viewer's mind thoughts about the divine plan and the individual's inconsequential role within it. The world view is a continuing feature of Flemish landscape in the sixteenth and seventeenth centuries, although its theological resonance may have largely been lost by 1600. Rubens's *Landscape with Het Steen* takes its place within this tradition.

Pieter Bruegel the Elder (*c.*1525–69) developed Patinir's initiatives in landscape and was the founder of an important and influential dynasty of painters.[16] He had an intensely original vision of landscape, which was developed, at least in part, as a consequence of the trip he made to Italy in the 1550s. On his way from Antwerp to Rome, Bruegel crossed the Alps and this experience had a profound effect on the young painter. He made drawings of the Alps which emphasise their drama (Plate 5). His earliest biographer, Karel van Mander, vividly recounts that 'on his travels he drew many views from life so that it is said that when he was in the Alps he swallowed all those mountains and rocks which, upon returning home, he spat out again onto canvases and panels, so faithfully was he able, in this respect and others, to follow Nature.'[17] Having travelled the length of the peninsula – he made a drawing of a fire in Reggio di Calabria in 1552 – he then lived in Rome for two years, and was back in Antwerp by 1555. The *Flight into Egypt* of 1563 (Plate 4)[18] shows him cautiously developing Patinir's manner towards greater naturalism. He retains the world-view composition and places the tiny figures of the Holy Family against a dramatic backdrop of high mountains and an extensive vista. The scale of the painting itself, as well as the figures, is relatively small. This panel, which had been owned by Cardinal Granvelle, Philip II's chief minister in the Netherlands, was later in Rubens's possession and is recorded in the inventory made of his extensive collection of works of art at the time of his death in 1640.[19] Bruegel's work, and this painting in particular, undoubtedly exercised a crucial influence on Rubens's own vision of landscape.

3. Joachim Patinir, *The Rest on the Flight into Egypt*
Oil on panel, 121 × 177 cm
Madrid, Museo del Prado

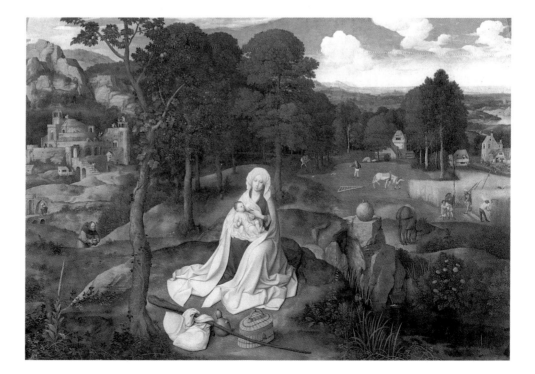

4. Pieter Bruegel the Elder,
*The Flight into Egypt,* 1563
Signed and dated
Oil on panel, 37.2 × 55.5 cm
London, Courtauld Institute
Galleries, Princes Gate
Collection
No. 191 in the *Specification*, the
list of paintings in Rubens's
collection made at the time of
his death in 1640.

5. Pieter Bruegel the Elder,
*Landscape with River and
Mountains,* 1553
Dated
Pen and brown ink on paper,
22.8 × 33.7 cm
London, British Museum

Later, especially in the series of landscapes of the Months painted for the merchant Nicolaes Jongeling in 1565,[20] Bruegel developed the conventions of Flemish landscape in a highly original manner. Bruegel was consciously referring to the tradition of the calendars in Books of Hours, of which the best known and most beautiful is that in the *Très Riches Heures* illuminated by the Limbourg brothers for the Duc de Berry in about 1415. There the activities of each month are placed in front of one of the Duke's castles. In conflating the tradition of calendar illustrations with that of Flemish landscape painting as developed by Patinir and his followers Bruegel created a new and vigorous landscape art. He showed the activities of the months of the year within the landscape, giving a deliberately heroic scale to the figures of peasants hunting, chopping firewood and harvesting. In these landscapes the bird's-eye view is lowered (but not abandoned) and the focus both on the figures and on the details of the landscape is intensified so that the viewer is brought into close contact with the rigours – and pleasures – of country life. In *The Hunters in the Snow* (Plate 6), for example, the viewer's eye moves from the 'close-up' of the returning hunters on the left across to the distant vista of snowy meadows on the right in a way which extends the possibilities of landscape painting far beyond the formulae of Patinir. Bruegel's *Months* hang today in the Kunsthistorisches Museum in Vienna, the National Gallery in Prague and the Metropolitan Museum of Art in New York and are regarded as among the greatest works of Western art. We should remember, however, that in Jongeling's house in Antwerp they were probably hung high up on the wall above a series of figure paintings by Frans Floris at eye level and that the broadly painted passages which we so admire were executed with the considerable distance between the viewer and the paintings in mind.

Bruegel's landscape compositions were widely circulated in the form of prints. He made one etching, *The Rabbit Hunters* of 1560 (Plate 7), which shows the hunters, one

6. Pieter Bruegel the Elder, *The Hunters in the Snow*, 1565
Signed and dated
Oil on panel, 117 × 162 cm
Vienna, Kunsthistorisches Museum
One of the series of *Months* painted for the Antwerp merchant Nicolaes Jongeling.

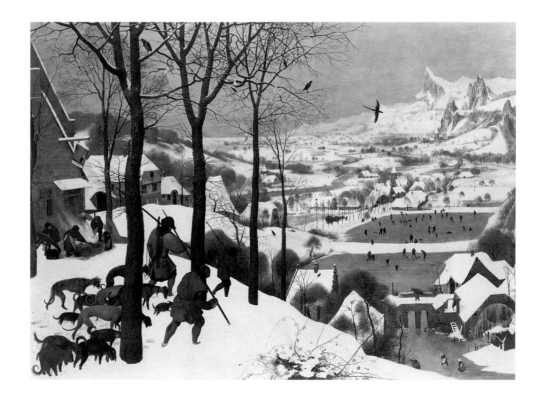

7. Pieter Bruegel the Elder,
*The Rabbit Hunters,* 1560
Signed and dated
Etching, 22.4 × 29.2 cm
London, British Museum
This is the only etching
known by Bruegel, who acci-
dentally transposed the last two
digits in the date.

8. (opposite) Pieter Bruegel
the Elder, *Solicitudo Rustica*
(Country Concerns)
Engraving, 32.2 × 42.9 cm
London, British Museum
One of the twelve engravings
which make up the *Large
Landscapes* series published after
Bruegel's designs by
Hieronymus Cock.

9. (opposite) Pieter Bruegel
the Elder, *Pagus Nemorosus*
(The Woody Grove)
Engraving, 32.4 × 43.6 cm
London, British Museum
Another of the engravings
from the *Large Landscapes*
series.

armed with a crossbow and the other with a spear, on the side of a steep hill overlook-
ing a river landscape with a view of a distant town. Bruegel's most influential
landscapes, however, were the twelve engravings after his designs by Hieronymus Cock
which make up the so-called *Large Landscapes* series. *Solicitudo Rustica* (Country
Concerns), for example (Plate 8), shows an extensive world-view landscape of a river
valley with a group of peasants on a steep winding path in the foreground and a moun-
tain range in the distance. The most exceptional print in this series is the *Pagus
Nemorosus* (The Woody Grove) which adopts a far lower viewpoint to show a village
in the forest: in the foreground a covered wagon accompanied by horsemen crosses a
ford (Plate 9). The *Large Landscapes* were extremely influential: indeed, to a great extent,
they established the conventions within which Flemish landscape was to develop from
the sixteenth until the end of the seventeenth century. The *Solicitudo Rustica* and the
*Pagus Nemorosus* reappear constantly with slight variations as archetypal world-view and
forest landscape compositions.

The forest landscape on the right of the *Pagus Nemorosus* engraving was a particu-
lar motif developed by Pieter Bruegel. It consists of a densely massed group of tall trees
which often have elaborately gnarled roots. Around these roots cluster the animals of
the forest. In the case of the *Pagus Nemorosus*, there is a solitary rabbit, but in other
examples there are deer, wild boar and even bears. This aspect of Bruegel's landscape
art is relatively little known because, apart from the *Pagus Nemorosus*, it survives today
only in a handful of drawings, most of which are copies after lost originals by members
of his studio.[21] One of the finest of these drawings, in this case probably by Pieter
Bruegel himself, is in the British Museum. It shows the dry bed of a stream within a
forest in which a family of bears searches for food and fights playfully (Plate 10). The

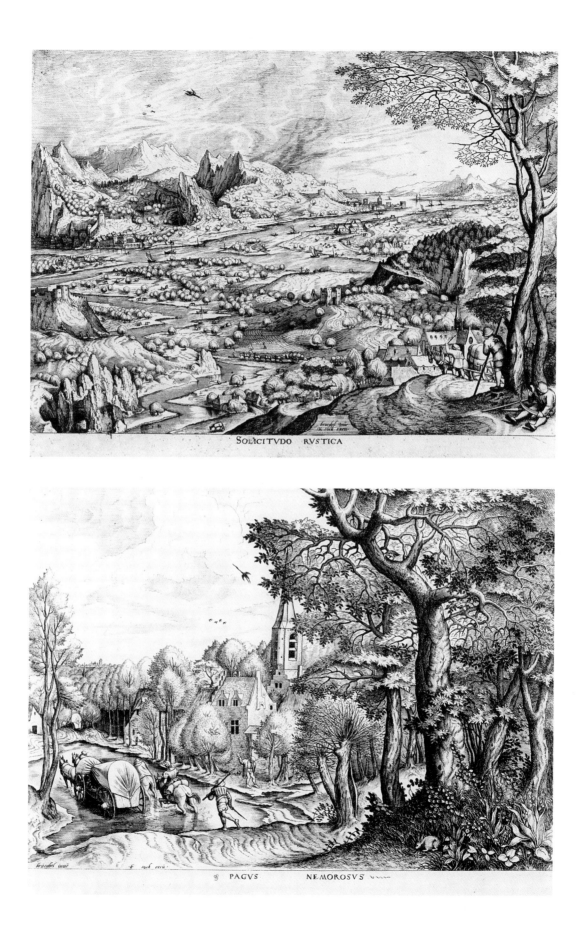

SOLICITVDO RVSTICA

PAGVS    NEMOROSVS

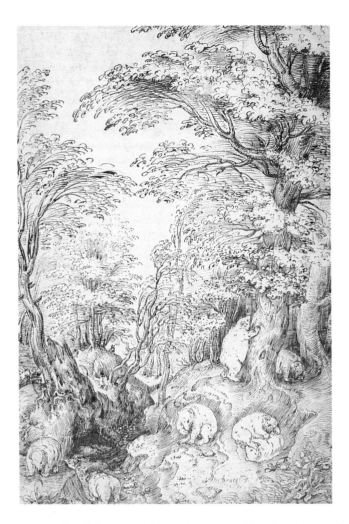

10. Pieter Bruegel the Elder, *Forest Landscape with Bears*
Pen and ink on paper,
33.6 × 23.2 cm
London, British Museum
This drawing has only recently been reattributed to Pieter Bruegel the Elder; it was previously thought to be by his son, Jan Brueghel the Elder.

penwork of the trees with their over-arching branches and tangled roots is vigorous and immediate.

The tradition of Bruegel's forest landscapes was continued not only by his most talented son, Jan the Elder, but also by a group of Protestant landscape artists led by Gillis van Coninxloo who fled from Antwerp to Frankenthal in Germany and later moved to Amsterdam in order to escape religious persecution. The painters of the Frankenthal school transplanted this landscape format to the North Netherlands. Karel van Mander considered that Coninxloo was the best landscape painter in Holland, adding that in 1604, when he was writing, Coninxloo's style was beginning to be widely followed, to such an extent that 'the trees which were a little bare and defoliated have become leafier and more developed.'[22] Rubens's *The Watering Place* (Plate 46) belongs to this Bruegelian tradition of the forest landscape.

Pieter Bruegel the Elder moved from Antwerp to Brussels, the seat of the court, in about 1563 and died there in 1569. His eldest son, Pieter the Younger, enjoyed a lucrative career painting copies and pastiches of his father's scenes of peasant life. His second son, Jan the Elder (1568-1625),[23] developed his father's landscape style in far more original directions. For the most part he worked on a small scale, often painting on copper or oak in order to obtain a very high degree of detail and finish. He painted landscapes and scenes of country life but also religious and mythological subjects like *Noah's Ark*

11. Jan Brueghel the Elder, *Latona and the Lycian Peasants* Oil on panel, 37 × 56 cm Amsterdam, Rijksmuseum The subject is from Ovid's *Metamorphoses*. Latona was mocked by the peasants of Lycia and in revenge turned them into frogs.

and *Latona and the Lycian Peasants* (who were transformed into frogs) which called for precisely described animals, birds, insects, flowers and trees (Plate 11). We know from Jan Brueghel's correspondence with his Italian patron Cardinal Federigo Borromeo, Archbishop of Milan, that Jan Brueghel possessed a great deal of ornithological and botanical knowledge.[24] He also painted highly finished flower still lifes.

It was usual for young Flemish artists to complete their training with a visit to Italy and Jan Brueghel, following in the footsteps of his father, was there from 1592 until 1595. After his return to Flanders he had a very successful career. In about 1606 he was appointed court painter to the Regents of the King of Spain in the Southern Netherlands, the Archduke Albert and the Archduchess Isabella. Despite this appointment, he did not move to Brussels but remained in Antwerp. Jan Brueghel was nine years older than his close friend Rubens and, having preceded him to Italy, must have given the younger artist much valuable advice about his stay there. After Rubens's return, he and Jan Brueghel collaborated on a number of paintings in which Rubens painted the figures and Jan Brueghel the landscape and animals. An outstanding example is the *Adam and Eve in Paradise* in The Hague, which is signed by both artists, and dates from about 1615 (Plate 12). In 1617 they painted the series of the *Five Senses* now in the Prado in Madrid, which is scarcely less than a visual encyclopedia of the court culture of the age rendered in fascinating and exquisite detail. The *Sense of Hearing*, for example, in which the naked figure of Hearing plays a lute amidst a rich array of musical instruments, scores and clocks, is set in a large upper room which commands an extensive view over the countryside around Albert and Isabella's palace of Mariemont. Certainly this close contact with Jan Brueghel had a profound influence on Rubens's own approach to landscape.

A contemporary of Jan Brueghel in Antwerp was the landscape painter Joos de Momper (1564–1635),[25] who used the tradition of Patinir to create a formula which he

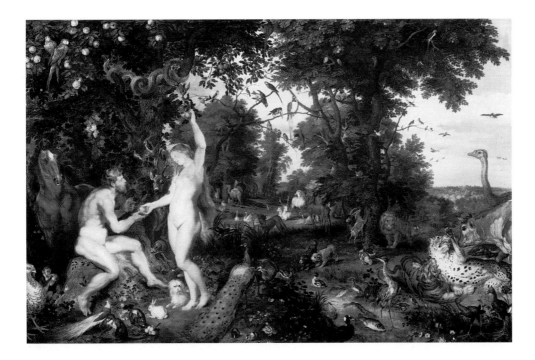

practised with only slight variations throughout a long career. He painted large canvases showing riders making their way through mountain passes, which hung in prosperous Antwerp houses and seem to have served the same essentially decorative function as tapestries had for earlier generations. De Momper specialised in depicting mountain ranges, stretching one after the other into the far distance: in Anthony van Dyck's series of etched and engraved portraits of his contemporaries made in the 1630s, which

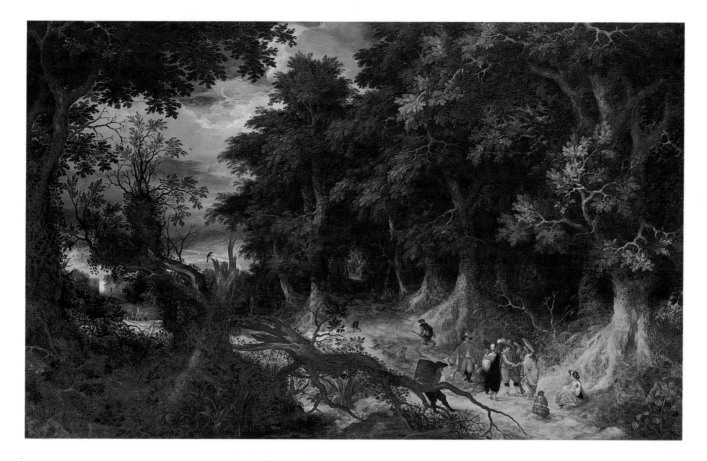

14. Abraham Govaerts,
*Forest Landscape*, 1612
Signed and dated
Oil on panel, 62.5 × 101 cm
The Hague, Mauritshuis

became known as the *Iconography*,[26] De Momper is described as *Pictor Montium Antverpiae* (Painter of Mountains from Antwerp). The colour scheme of De Momper's landscapes, derived from Patinir, is simple: brown for the foreground, green for the middle ground and blue for the background. However, despite the repetitive and limited nature of his compositions, De Momper enjoyed great contemporary esteem, serving as Dean of the artists' guild in Antwerp and painter to the Archdukes. Like Jan Brueghel, he collaborated with figure painters: his *Mountainous Landscape with Saint Peter and the Centurion Cornelius* (Plate 13) was probably painted with Frans Francken the Younger (1581–1642).

Jan Brueghel and Joos de Momper were the leading figures of the generation of landscape painters whose work Rubens would have studied during the years of his apprenticeship in Antwerp. In a city with as lively an art market as Antwerp, there were, of course, many others, among them Rubens's own teacher and relative Tobias Verhaecht, and Abraham Govaerts, whose *Forest Landscape* of 1612 (Plate 14) is essentially a skilful and elegant variation on Jan Brueghel's scenes of massed and tangled trees.

All these artists, near contemporaries of Rubens, were landscape specialists. Tobias Verhaecht, Abraham Govaerts and Joos de Momper painted only landscapes. Jan Brueghel also painted a few religious and mythological scenes and some allegories, but by far the largest number of his works consisted of still lifes and landscapes: in Van Dyck's engraved portrait from the *Iconography* he is described as *Pictor Florum et Ruralium Prospectuum* (Painter of Flowers and Country Views).

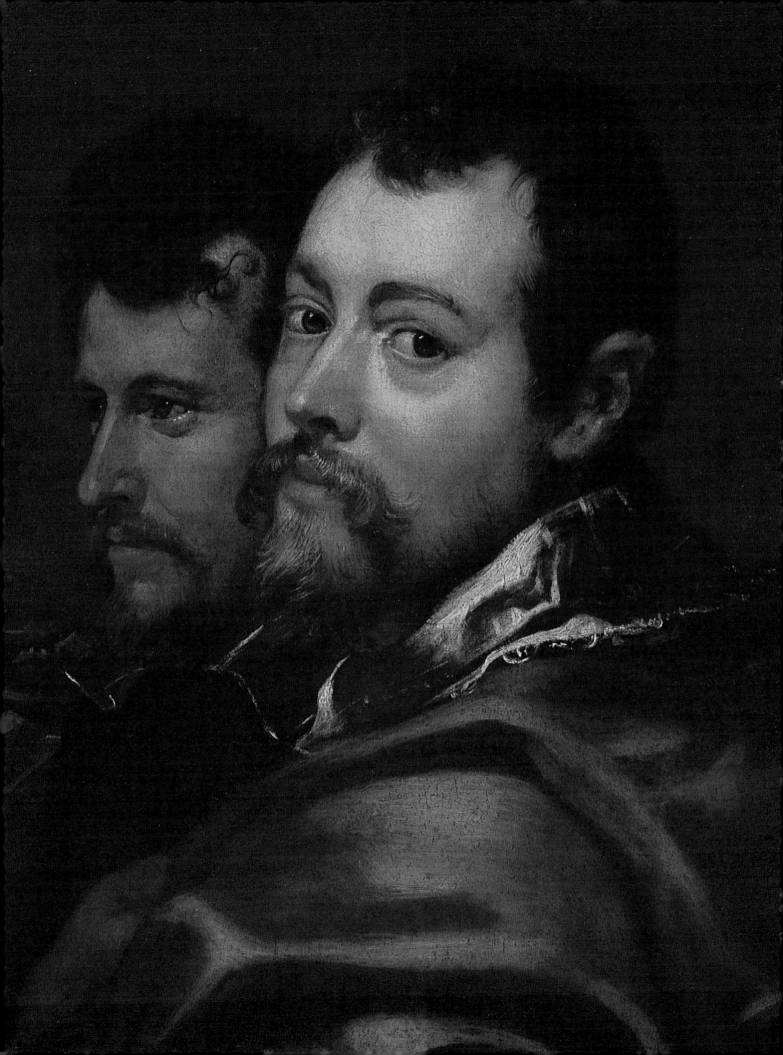

CHAPTER 2

# Rubens in Antwerp and Rome

RUBENS'S FATHER, JAN, a lawyer trained in Rome who had become an alderman of his native city of Antwerp, converted to Protestantism and was forced to leave the Southern Netherlands in 1568. The family moved to Cologne and later to Siegen, where Peter Paul was born in 1577. After Jan Rubens's death, his widow, Maria Pypelincx, moved back to Antwerp in 1587 with her two sons. It is unclear whether or not she shared her husband's faith during their stay in Germany but she seems to have had no difficulty in returning to Catholic worship and both Peter Paul and his elder brother Philip were to be devout Catholics throughout their lives. In Antwerp Rubens attended the Latin school of Rombout Verdonck and then began his training as a painter.

Rubens's first teacher was the landscape painter Tobias Verhaecht (1561–1631), a distant relative of his mother. Rubens probably entered Verhaecht's Antwerp studio in about 1590, when he was thirteen. There he would have learnt the basic skills of his craft: how to prepare a panel or canvas, how to grind colours and how to treat brushes. He would have learnt to draw from plaster casts in the studio and to make drawn and painted copies of his master's work. He would presumably have received some instruc-

16. Tobias Verhaecht,
*Mountainous Landscape with the
Flight into Egypt*
Oil on oak, 37 × 48 cm
Hamburg, Kunsthalle

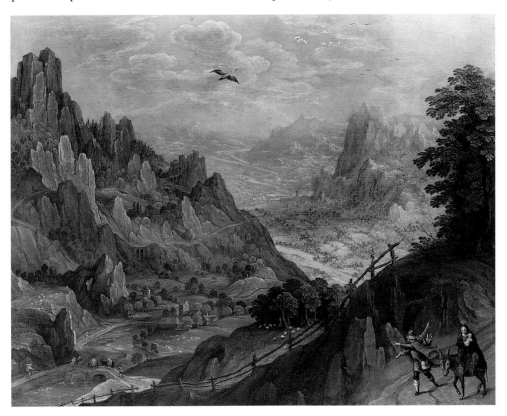

15. (opposite) Detail of *Self
Portrait with Friends* (Plate 24)

*Rubens in Antwerp and Rome* 25

tion in how to paint landscape in the style of Verhaecht, which was in the tradition of Patinir and closely related to that of De Momper. Like De Momper, Verhaecht used a simple three-colour scheme of brown, green and blue to indicate the gradual recession of landscape. He massed his trees in a similar manner and also showed distant vistas of successive mountain ranges (Plate 16). Although the few painted landscapes known to be by Verhaecht seem rather dull and formulaic, his pen drawings are far more spirited and give a better idea of what Rubens could have learnt from him.[27] After what seems to have been a short stay with Verhaecht, the young Rubens moved to the studio of the history painter Adam van Noort and, finally and most importantly, to that of Otto van Veen, history painter, humanist, antiquarian and emblematist.

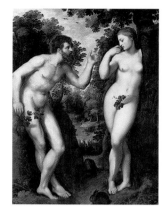

17. *Adam and Eve,* before 1600
Oil on panel, 182.5 × 140.7 cm
Antwerp, Rubenshuis

Having completed his apprenticeship with Van Veen, Rubens entered the Antwerp Guild of Saint Luke as a master in 1598. Two years later he set out for Italy to study classical sculpture and Renaissance and contemporary Italian art. No independent landscapes painted by Rubens during the years before his departure for Italy are known. However, the background landscapes in the *Adam and Eve* in the Rubenshuis (Plate 17) and *The Judgement of Paris* in the National Gallery, London (Plate 18) – the figures in both are based on engravings after Raphael by Marcantonio Raimondi – reveal how thoroughly Rubens had absorbed the Flemish landscape manner. The plants in the foreground are described in very precise, closely observed detail and yet in both paintings the entire scene is bathed in an unnatural light which has the effect of heightening the colours of the landscape. The brown foregrounds, the massed green foliage of the trees and the distant blue of the horizon place them unequivocally within this convention.

For much of his time in Italy Rubens was in the service of the Gonzaga Duke of Mantua, but he spent several years in Rome, sharing a house with his brother Philip, who was a distinguished scholar of classical literature and philosophy. The two young men explored Rome together, studying the remains of classical antiquity and planning a work on diverse aspects of ancient civilisation, from Grammar to the correct folds of a toga, *Electorum Libri Duo,* which was published in Antwerp in 1608 with illustrations by Rubens. It was in these years in Rome that Rubens built on the foundations laid in the Latin school in Antwerp to deepen his knowledge of classical history and art. He read widely, becoming very familiar with the works of the Roman historians and poets. It is clear from his subtle and precise interpretations of Roman history and mythology that, presumably under Philip's guidance, Rubens had studied Tacitus, Virgil, Horace and Ovid, as well as many other Roman authors, during these years. In his letters he often expressed his most personal sentiments in the form of quotations from the Roman poets.

While he was living in Rome, Rubens got to know many fellow artists and in particular made friends among the community of Northerners living in the city. Two of these friendships, those with Paul Bril and Adam Elsheimer, are of particular importance for the development of his landscape style.

Paul Bril (1554–1626)[28] was born in Antwerp and had travelled to Rome to join his brother Matthijs in about 1575. His earliest works made in Rome were highly finished, elaborate forest scenes painted on small oak and copper panels. His style was, however, transformed by his study of contemporary Italian landscape painting, and in particular, by the broadly brushed classical landscapes of Annibale Carracci (Plate 20). Bril's frescoes in the Vatican and Lateran Palaces, carried out in the 1580s and 1590s,

already show his study of Annibale's landscapes. Later Bril worked on a larger scale, usually on canvas, creating an elegant marriage between what the Italian critic Giovanni Baglione, writing in 1642, was to call his 'prima maniera Fiamenga' and the 'buona maniera Italiana' (Plate 19).[29] Bril's new style, showing well-ordered and calm landscapes which are ideal yet based on close observation of nature and a confident handling of aerial perspective, was to prove immensely successful with Roman patrons and profoundly influential on both Italian and Netherlandish landscape painting. He was widely acknowledged as the leading landscape painter in Rome: in 1621 the critic Mancini called him the best in the city.[30] Flemish merchants and pilgrims visiting Rome bought his work, which was also engraved, and in these ways knowledge of his new style was circulated both north and south of the Alps. Bril was to remain in Rome for the rest of his life, dying there in 1626.

Rubens and Bril collaborated on at least one painting, the *Landscape with Psyche* (Plate 21).[31] Bril painted the lush, dense landscape, with its rocky outcrops to which trees cling, and the dramatic waterfall in which the sun creates a double rainbow. Above the waterfall is a fortified hill town of a type familiar to Bril from his travels, sketchbook

18. *The Judgement of Paris,*
*c.*1600
Oil on oak, 133.9 × 174.5 cm
London, National Gallery

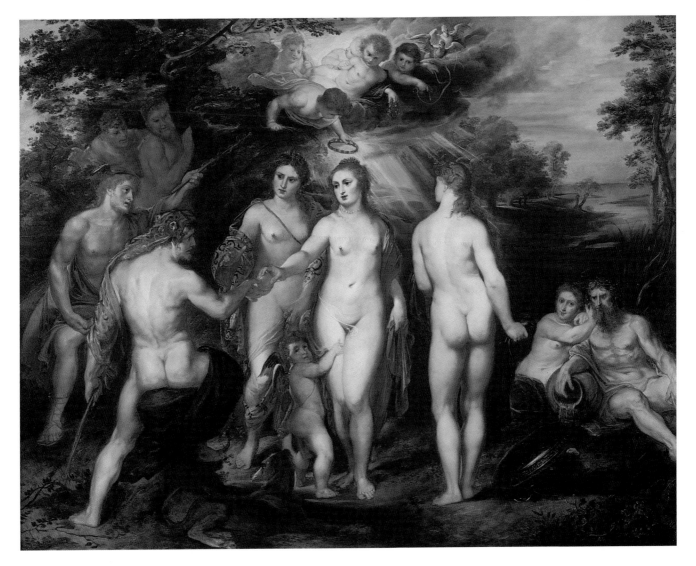

in hand, in the countryside near Rome. The naked figure of Psyche, painted by Rubens, sits on a rock overlooking the waterfall. Her task was to fill a cup with water from the river Styx and Rubens shows her at the moment when Jupiter, transformed into an eagle, took the cup from her in his beak; he then flew to the river, filled it and returned to her. This large canvas bears the date 1610, two years after Rubens's return to Antwerp, and so was presumably sent from Rome to Rubens for him to add the figure. In the inventory of Rubens's collection made in 1640 is 'Un paysage de Paul Bril avec l'histoire de Psyche'.[32] It may well be this picture, which was subsequently bought by the Spanish King and is first recorded in the Alcázar Palace in Madrid in 1666.

During his years in Rome Rubens also came to know well the German painter Adam Elsheimer.[33] Elsheimer had been born in Frankfurt-am-Main in 1578 and so was an almost exact contemporary of Rubens. In 1598 he travelled to Venice and by 1600 had settled in Rome where he remained until his death. Elsheimer was a remarkable and innovatory landscape painter. He was a very skilled and controlled artist, working in precise detail on small copper panels. He painted religious subjects, often set in lush landscapes, like *Tobias and the Angel* and the *Flight into Egypt* (Plate 22), but he also

19. Paul Bril, *Mythological Landscape with Nymphs and Satyrs*, 1621
Signed and dated
Oil on canvas, 70.5 × 93 cm
London, Mahon Collection

20. Annibale Carracci,
*Landscape with the Flight into Egypt*
Oil on canvas, 123 × 230 cm
Rome, Doria Pamphilj
Collection

produced one 'pure' landscape, the *Aurora* (see Plate 23). This probably dates from about 1606; Rubens was then in Rome and so could well have seen it in his friend's studio. On the left a hunter strides out against a screen of trees which overlooks a small Italian hill town and a distant plain. It is dawn and the sky is suffused by a delicate rosy glow.

On hearing of Elsheimer's early death in 1610 Rubens wrote from Antwerp to their mutual friend in Rome, Johannes Faber:[34]

Surely, after such a loss, our entire profession ought to clothe itself in mourning. It will not easily succeed in replacing him; in my opinion he had no equal in small figures, in landscapes, and in many other subjects. He has died in the flower of his studies, and *adhuc sua messis in herba erat* [his wheat was still in the blade].[35] One could have expected of him *res nunquam visae nunquam videndae; in summa ostenderunt terris hunc tantum fata* [things that one has never seen and never will see; in short, fate will allow the world merely to glimpse him].[36]

For myself, I have never felt my heart more profoundly pierced by grief than at this news, and I shall never regard with a friendly eye those who have brought him to so miserable an end. [Elsheimer is said to have died in poverty, shortly after his release from a debtors' prison.] I pray that God will forgive Signor Adam his sin of sloth, by which he has deprived the world of the most beautiful things, caused himself much misery, and finally, I believe, reduced himself to despair; whereas with his own hands he could have built up a great fortune and made himself respected by all the world. But let us cease these laments. I am sorry that in these parts we have not a single one of his works. I should like to have that picture on copper (of which you write) of the 'Flight of Our Lady into Egypt' [Plate 22] come to this country, but I fear that the high price of 300 crowns may prevent it.

Nevertheless, if his widow cannot sell it promptly in Italy, I should not dissuade her from sending it to Flanders, where there are many art-lovers, although I should not want to assure her of obtaining this sum. I shall certainly be willing to employ all my efforts in her service, as a tribute to the dear memory of Signor Adam.

Living in Elsheimer's house in Rome was a certain 'Henrico pictore', Hendrick Goudt (1573–1648),[37] a Dutch nobleman and artist, who was also Elsheimer's patron. On his return to the Netherlands after Elsheimer's death Goudt made engravings of his friend's work which were circulated widely and came to have a profound influence on the development of landscape painting in both the Northern and Southern Netherlands. Goudt appears to have owned *Aurora* and may even have painted parts of it. He engraved the composition in 1613, omitting the figure of the huntsman (Plate 23).

Elsheimer's work was to be a constant source of inspiration to Rubens. He owned no fewer than four paintings by him:[38] *Ceres* now in the Prado, *Judith and Holofernes* in Apsley House, London, an *Annunciation* and an unidentified 'landscape in a round frame'. He presumably also owned a set of Goudt's engravings after Elsheimer's compositions. The first landscape Rubens painted after his return from Italy, the *Landscape with the Flight into Egypt* (Paris, Louvre), is essentially a variation on a composition by Elsheimer, and the starry sky in the *Landscape with Moon and Stars* (Plate 72) is inspired

21. Paul Bril and Rubens, *Landscape with Psyche,* 1610 Oil on canvas, 93 × 128 cm Madrid, Museo del Prado The landscape was presumably painted by Bril in Rome and sent to Antwerp where Rubens added the figure and the eagle. It probably remained in Rubens's collection and can be identified with no. 26 in the *Specification*.

22. Adam Elsheimer, *The Flight into Egypt*
Inscribed on the back: Adam Elsheimer fecit Romae 1609
Oil on copper, 31 × 41 cm
Munich, Bayerische Staatsgemäldesammlungen, Alte Pinakothek

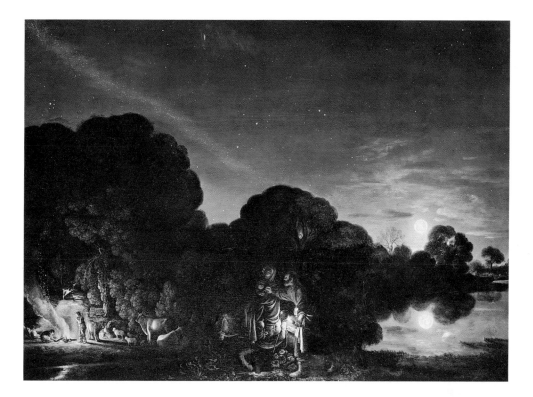

23. Hendrick Goudt (after Elsheimer), *Aurora*, 1613
Engraving, 16.5 × 18.7 cm
London, British Museum

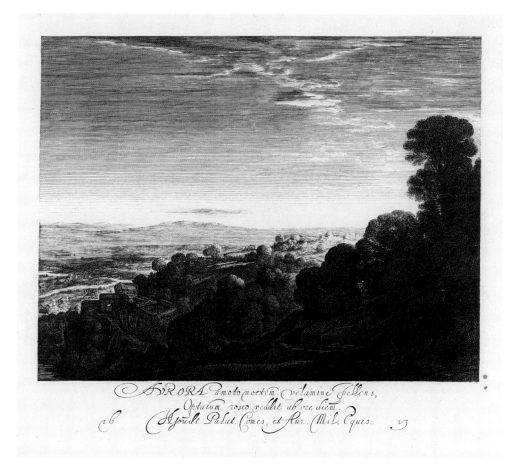

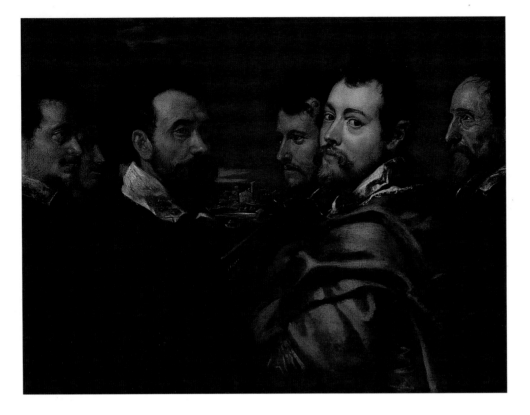

24. *Self Portrait with Friends,*
*c.*1602
Oil on canvas, 77.5 × 101 cm
Cologne, Wallraf-Richartz-
Museum (on loan from the
Federal Republic of Germany)
Rubens spent his years in Italy
in the service of the Gonzaga
Duke of Mantua and here he
shows himself in Mantua with
a group of friends. The portrait
probably does not record an
actual event. Behind Rubens
himself (the most prominent
figure in the centre on the
right) and slightly to the left is
his brother Philip and on the
far right is Philip's teacher,
Justus Lipsius. The principal
(bearded) figure on the left,
facing Rubens, is probably the
painter Frans Pourbus the
Younger. The other two
figures have been identified as
Gaspar Scioppius and
Guillaume Richardot. The
view across the lake at Mantua
was presumably that from the
artist's apartment in the
Palazzo Ducale.

by Elsheimer's exquisite depictions of the night sky. Elsheimer's influence on Rubens's figure scenes was no less profound: for example, the *Samson and Delilah*, painted in about 1609 for Nicolaas Rockox and today in the National Gallery, London, can be thought of as a composition in the manner of Elsheimer expanded on to a monumental scale.

During his years in Italy Rubens did not, of course, restrict his study of landscape painting to the work of émigré Flemish and German artists. He must have been fascinated by the landscapes of Annibale Carracci and Girolamo Muziano, a Brescian who worked in Rome. Muziano (1528–92) had been trained in the Venetian tradition: his work is imbued with the spirit of the idyllic landscapes of Titian and Giulio and Domenico Campagnola, which Rubens must also have admired and studied in the form both of paintings and prints. However, landscape was by no means Rubens's central concern during his Italian years. He was in Italy primarily to improve his skills as a painter of religious and mythological scenes. Rubens did travel to Tivoli but, as far as we know, he did not make sketches in the Campagna, as many other Flemish painters did, nor did he make drawings from nature elsewhere. Rather he haunted the great collections of antique and Renaissance art, drawing, for example, the *Laocoön*, the Farnese *Hercules* and Michelangelo's *Night* and *Day*. Rubens never contemplated a career as a specialist landscape painter. Fully aware of his exceptional gifts, he always aspired to the highest calling of a seventeenth-century painter, the depiction of the great dramas of classical literature and of the Old and New Testaments.

It is therefore only in the backgrounds of the paintings made during his years in Italy that we glimpse Rubens's evolving skills as a landscape painter, and his absorption of what he had learnt there. For example, in the remarkable group portrait of the artist

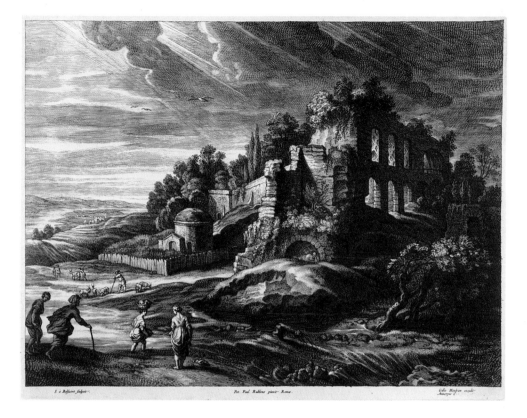

and his friends (Plate 24) painted in Mantua in about 1602, there is a vista of the Ponte di San Giorgio reaching across the lake towards a church on the distant bank. The equestrian portraits of Marchese Giancarlo Doria (Florence, Palazzo Vecchio), painted in Genoa in about 1602, and of the Duke of Lerma (Madrid, Prado), painted in Spain in 1603, are both framed by overhanging trees and set against a dramatic sky. In the *Saints Gregory, Domitilla, Maurus, and Papianus* (Berlin, Gemäldegalerie), which appears to have been a trial piece painted in 1606 for an altarpiece for the Church of the Oratorians in Rome, there is a view of Roman ruins seen through an archway. Trees and bushes, which have overgrown the ruins, are outlined against a cloud-filled sky. It is an effect very similar to that of Bril's landscapes.

Classical ruins set in landscape and overgrown by vegetation, in this case the Palatine hill with the church of St Teodoro, are also the subject of an engraving made by Schelte à Bolswert after a painting by Rubens (Plate 25). This was published in Antwerp by Gillis Hendricx, probably shortly after the painter's death. In some states it is inscribed 'Pet. Paul Rubens pinxit Romae' but we cannot be sure that the painting it records, which is today in the Louvre,[39] was made in Rome: the inscription may well have been an invention of the engraver or the publisher, and it is likely that the picture is a reminiscence of Rome recorded in a drawing and painted in Antwerp several years after Rubens's return.

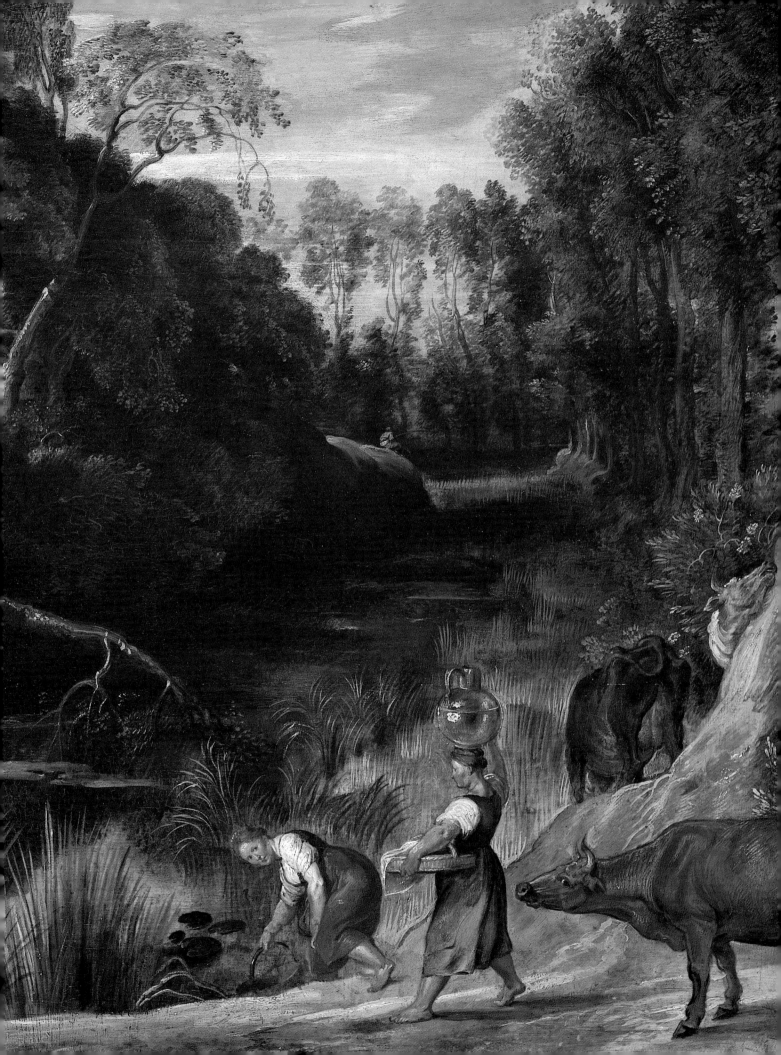

## CHAPTER 3

# Rubens's Early Landscapes

LATE IN 1608 RUBENS received the news that his mother was seriously ill in Antwerp and hurried home. It was probably his intention to return to Italy, although service to the Gonzaga had become irksome. He arrived back in Flanders, however, at an extremely important moment in the history of his country, which marked a turning-point in its fortunes. On 9 April 1609 a truce was signed between Spain and the United Provinces which had broken away from Habsburg rule in the Dutch Revolt. In the early years of the Revolt, which began in 1565, Antwerp had been a centre of opposition to Spanish rule and the so-called Spanish Fury of 1576, when the mutinous Spanish garrison went on the rampage, drove the city into the rebel camp. It was only in 1585 after a prolonged siege that Antwerp was reconquered by the Spanish armies. Antwerp, which had been the economic motor of the entire Netherlands in the sixteenth century, was particularly badly affected by the war, losing a large part of its trade as a result of the Dutch blockade of the Scheldt and half its population when Protestants were required to leave the city after the reconquest.

By 1609 the boundary between the Spanish Southern Netherlands and the Dutch Republic had effectively been drawn and the war had settled down to a gruelling pattern of attrition. Both sides were exhausted and there was a widespread desire for peace. The most active peacemaker was the Archduke Albert (Plate 27), an experienced Habsburg governor – he had previously been viceroy of Portugal – who had married his cousin, Philip II's daughter, Isabella Clara Eugenia (Plate 28), in 1599; together the Archdukes, as Albert and Isabella were known when they ruled jointly, were Regents of the Spanish Netherlands until Albert's death in 1621. Isabella was Philip IV's Regent for a further twelve years. Albert and Isabella's power always rested on the presence of Spanish garrisons in the largest and most strategically important towns in the Southern Netherlands and all negotiations for peace with the Dutch had to be approved by the royal council in Madrid. However, using skilful propaganda for which their court artists were pressed into service,[40] the Archdukes achieved in the eyes of their subjects a real independence of the Spanish crown and were widely perceived as representing Netherlandish rather than Spanish interests. Albert had entered into peace negotiations with the Dutch and carried the Spanish council with him. The Truce of 1609 was to last for twelve years but at the time it was seen by many as the prelude to a permanent end to the fighting. The peace created a new mood of confidence in the Southern Netherlands, which had suffered far more than the North from the ravages of war.

After the truce the process of economic regeneration began, and the recatholicisation of the South, a process spearheaded by the Jesuits and the Dominicans, received a new boost. It was a time for talented young Catholic Flemings like the two brothers Philip and Peter Paul Rubens (Plate 29) to rise to the challenge of playing their part in the restoration of their country to its former wealth and eminence. Philip served as one

26. (opposite) Detail of *Pond with Cows and Milkmaids* (Plate 32)

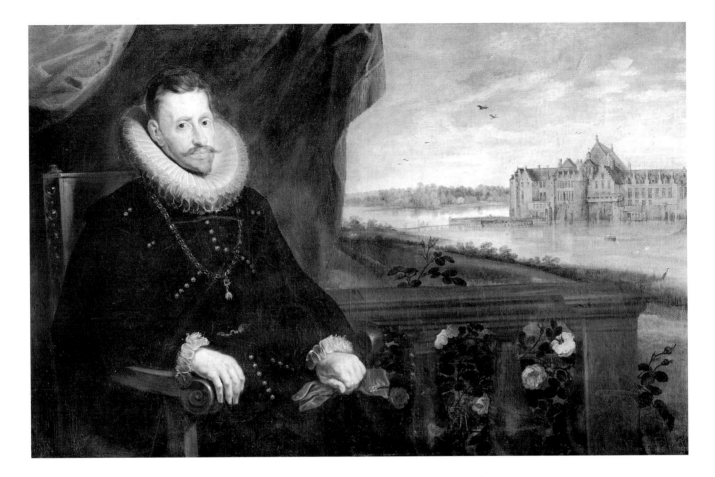

of the secretaries of the city of Antwerp, a key municipal post, while Peter Paul Rubens found his principal role in the revival of the Spanish Netherlands in the creation of monumental altarpieces for the churches of Antwerp and other Southern Netherlandish towns. They were painted in a new and exciting style which represents the successful union of his Flemish heritage and the lessons he had learnt in Italy. In these great religious works Rubens responded to the widespread mood of renewal and Counter-Reformation fervour (Plate 30).

It is no accident that it was at about the same time that Rubens painted his earliest landscapes. These landscapes are essentially celebrations of his native country by a young Fleming who had just returned from Italy and was rediscovering the lush, wooded landscape of Flanders and Brabant. The artist who had signed himself 'Pietro Paolo Rubens' had come home, and his impulse to paint landscape was motivated by a profound identification with his country and his hopes for its future. Rubens's desire to celebrate his native countryside continued to be the principal well-spring of his activity as a landscape painter throughout his career, as it was for the Dutch landscape painters of the seventeenth century.

The chronology of Rubens's landscapes is extremely difficult to reconstruct, as none of them bears a date and there is very little documentary evidence about them. Rubens's religious and mythological paintings were painted on commission and documents concerning the patrons and payments often survive, enabling the paintings to be more or less precisely dated. The landscapes, however, do not seem to have been

27. Rubens and Jan Brueghel the Elder, *The Archduke Albert*, *c.*1615
Oil on canvas, 112 × 173 cm
Madrid, Museo del Prado
The portrait is by Rubens and the setting and background by Jan Brueghel. In the distance is the castle of Tervueren.

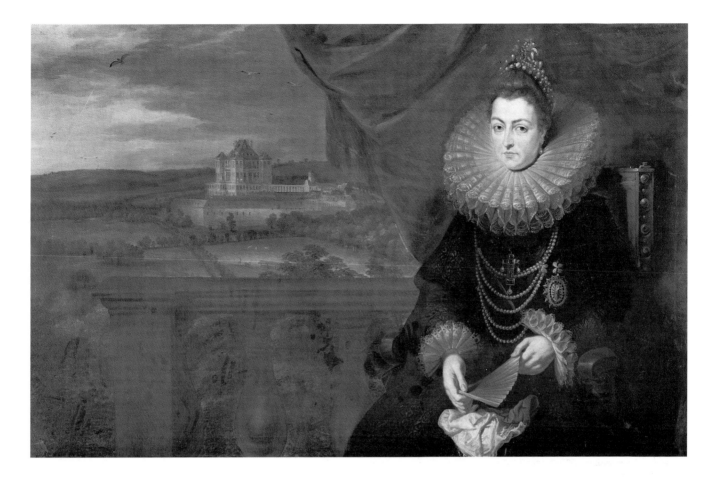

28. Rubens and Jan Brueghel
the Elder, *The Archduchess
Isabella, c.*1615
Oil on canvas, 102 × 173 cm.
Madrid, Museo del Prado
In the background is the castle
of Mariemont.

commissioned, nor, with the exception of the view of the Escorial (see Plate 31),[41] are
they discussed in any detail in Rubens's extensive correspondence or in any of the
numerous accounts by contemporaries of his work. Nor are the documents very help-
ful. There were, for example, three landscapes by Rubens listed in the inventory of the
collection of the Duke of Buckingham who was assassinated in 1628.[42] These have not,
however, been securely identified with extant paintings and so, apart from confirming
that Rubens painted landscapes before the Duke's death, the inventory does not help
significantly with the chronology of the surviving landscapes. The *Landscape with Het
Steen* and its pendant the *Landscape with a Rainbow* (Plates 58 and 59) were presumably
painted after Rubens purchased the estate of Het Steen in 1635 and so we can be sure
that these two key works date from the last years of his life. Rubens mentions his land-
scape painting in letters of 1636 and 1640[43] and near-contemporaries, including the
English miniaturist Edward Norgate[44] and Rubens's nephew Philip,[45] praise his land-
scapes but apart from such fragmentary information, there is very little external
evidence for their dating.

Placing the landscapes in a convincing sequence must largely be done, therefore,
by comparing them with landscape passages in datable religious and mythological paint-
ings, and with scenes of animal hunts, which naturally take place in landscape settings.
On this basis Gustav Glück in 1940 constructed a chronology which has been accepted
in its broad outlines by subsequent authors.[46] There are three principal groups of land-
scapes: a small early group painted after Rubens's return from Italy in the period

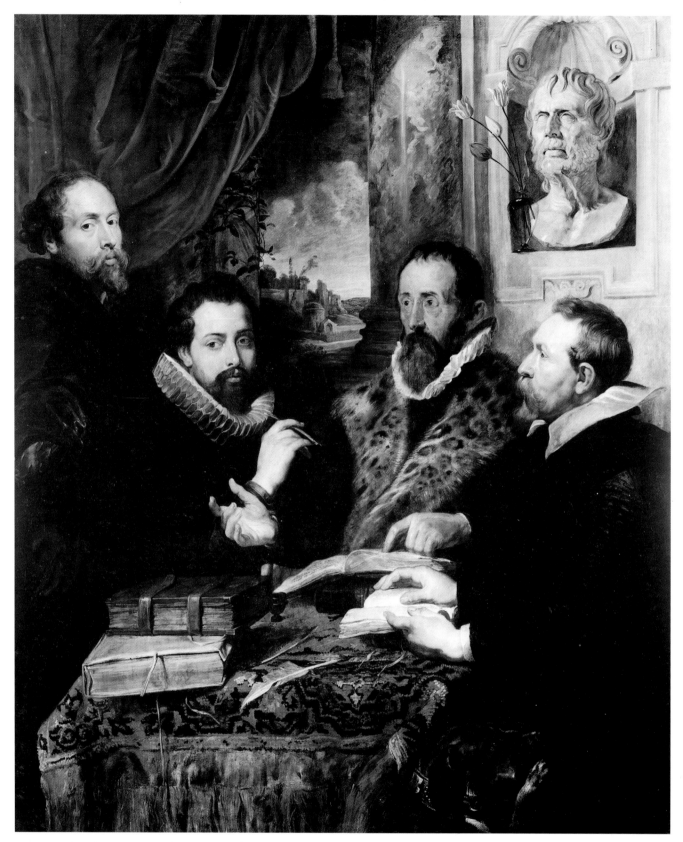

29. *The Artist with his Brother Philip, Justus Lipsius and Jan Woverius, c.*1612. Oil on panel, 167 × 143 cm. Florence, Palazzo Pitti
From left to right the sitters are Rubens, his brother Philip (who died in 1611), Justus Lipsius (who died in 1606) and Jan Woverius. On the right is a bust thought at that time to show Seneca, whose work Lipsius had edited and whose ideas were very influential on all four men. In the glass jar beside the bust of Seneca are four tulips, two blown and two in bloom, which refers to the fact that two of the sitters in this ideal portrait were dead and two still living. The portrait may well have been painted shortly after Philip's death as a memorial to him.

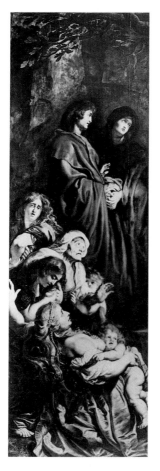

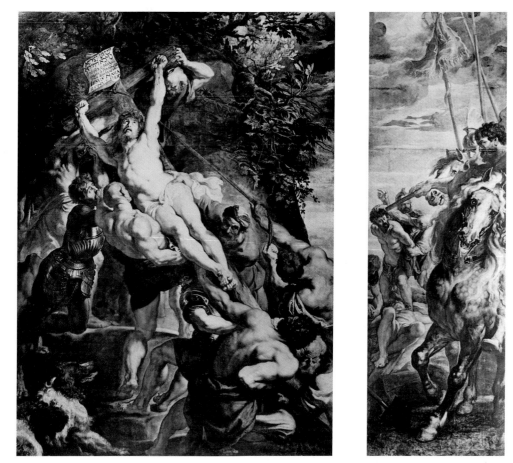

30. *The Raising of the Cross*, 1610-11

Oil on panel, 462 × 641 cm

Antwerp Cathedral

Rubens received the commission for an altarpiece for the church of St Walburga in 1610 through the good offices of his great patron and friend, Cornelis van der Geest. It was completed in the following year and was the first of a series of altarpieces for Flemish churches painted during the decade following his return from Italy. It reveals the powerful influence of Tintoretto's *Crucifixion* in the Scuola di San Rocco in Venice.

1614-18, including the *Pond with Cows and Milkmaids* (Plate 32) and *The Farm at Laeken* (Plate 33); a larger group of works which fall within the period 1618–25 and includes the so-called *'La Charrette Embourbée'* (Plate 44) and *The Watering Place* (Plate 46); and the third and largest group painted between 1635 and 1640, in which the painter was inspired by the countryside of Brabant around his country house Het Steen, where he spent more and more of his time in his last years. As well as landscapes based on the countryside near Het Steen, Rubens painted in these years a number of 'pastoral' landscapes which are not in any sense topographical but which owe their inspiration to Venetian landscape and to classical literature, above all to Virgil's idylls. Each of these groups will be considered in some detail in successive chapters of this book. There are also a number of individual landscapes which fall outside these groups.

Even in this necessarily imprecise chronology, it can be seen that Rubens's activity as a landscape painter was spasmodic. His life in Antwerp was always busy as he undertook more and more large-scale commissions, increasing the size of his studio to do so. It was only on Sundays that he could undertake the design of title-pages, for example, work which he enjoyed although it was not lucrative. There was a period between the mid-1620s and mid-1630s when he seems to have painted landscapes only occasionally. These were years of great personal sadness, with the death of his first wife, Isabella Brant, in June 1626, and of diplomatic travels to Spain and England between 1628 and 1630. Acting as a representative of Philip IV, he was away from Antwerp for almost two years and the only landscapes from this time seem to have been strictly

topographical: a view of the valley of the Manzanares from the Alcázar in Madrid[47] and another of the Escorial (Plate 31),[48] and the London riverfront seen in the *Saint George and the Dragon* (London, Royal Collection).[49] It was only in the mid-1630s when Rubens's diplomatic career was largely over and after his second marriage in 1630 to Hélène Fourment that he returned to landscape painting. At this stage in his life his landscapes seem to have been an expression of his renewed commitment to his country and the pleasure he took in its beauty, as well as of his own personal contentment. There is no other aspect of Rubens's varied and immensely productive career that so closely mirrors the events of his life and therefore must be studied in the context of his biography.

Among the early group of landscapes the *Pond with Cows and Milkmaids* (Plate 32) and *The Farm at Laeken* (Plate 33) both celebrate the fruitfulness of the Southern Netherlandish countryside, which after the recent restoration of peace could be enjoyed and exploited to the full. The *Pond with Cows and Milkmaids* was probably painted first, in about 1614. With its closely massed trees on the central mound and the carefully spaced willows along the edge of the pond which is thick with reeds, there can be no doubt that Rubens is evoking the landscape of southern Brabant, the area between Antwerp and Brussels. It is a countryside of gentle, low hills and dense woodland interspersed with ponds and streams edged by rows of tall trees and lined with lush reeds. This is a rich agricultural region which in these years was beginning its recovery after the devastation of the years of war.

31. Lucas van Uden (after Rubens), *The Escorial, from a Foothill of the Guadarrama Mountains*
Oil on panel, 49 × 73.5 cm
Cambridge, Fitzwilliam Museum
Rubens painted this scene during his second visit to Spain (in 1628-9). The original has not survived but the composition is known in several contemporary copies. Van Uden has omitted the left-hand side, which shows a range of mountains dominated by a wooden crucifix in the foreground. Rubens describes his painting in a letter of April 1640.

The sturdy, barefoot milkmaids in the foreground on the right of the painting have completed their tasks and are returning to the farm. One carries her brass milk-churn on her head and a straw basket of freshly picked fruit under her arm, while her companion stoops to retrieve her basket from the water's edge. Behind them follow their plump, well-fed cattle.

The style of the painting is, as we should expect, a subtle fusion of Flemish and Italian elements. The tangled mass of trees in the centre, growing at a variety of angles and overlapping one another, and the interest taken by the artist in complex arrangements of roots and branches and in gnarled tree-stumps derive from the Flemish landscape tradition, while the broadly painted hillside and the prominent reeds in the foreground as well as the palette of rich deep blues and greens recall the landscapes of Paul Bril and Annibale Carracci which Rubens had seen and admired in Rome.

The landscape in the *Pond with Cows and Milkmaids* is unlikely to be an actual topographical view like his landscapes of the Palatine hill and the Escorial. It is a carefully composed landscape, an amalgam of individual motifs – willows on the bank of the pond, reeds at the water's edge, fallen tree-trunks, upright trees with overhanging branches – which Rubens sketched directly from nature or adapted from earlier landscape paintings.[50] He must have made a considerable number of such drawings but only a handful – which are all illustrated and discussed in a later chapter – are known today.

*32. Pond with Cows and Milkmaids, c.1614*
Oil on panel, 76 × 107 cm
Vaduz Castle, Collections of the Prince of Liechtenstein

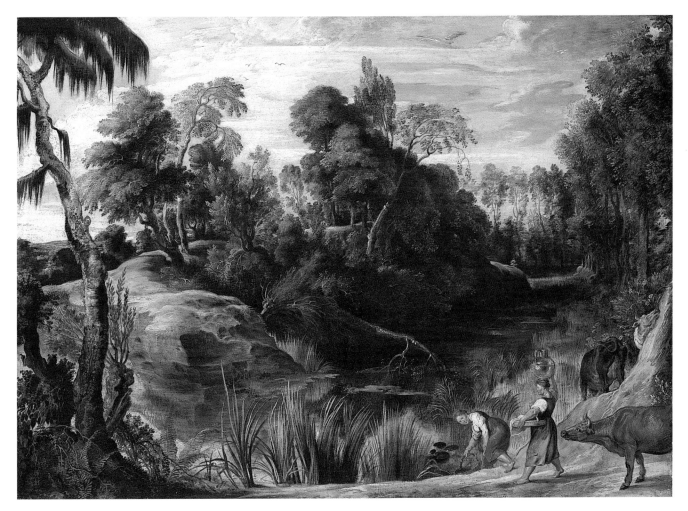

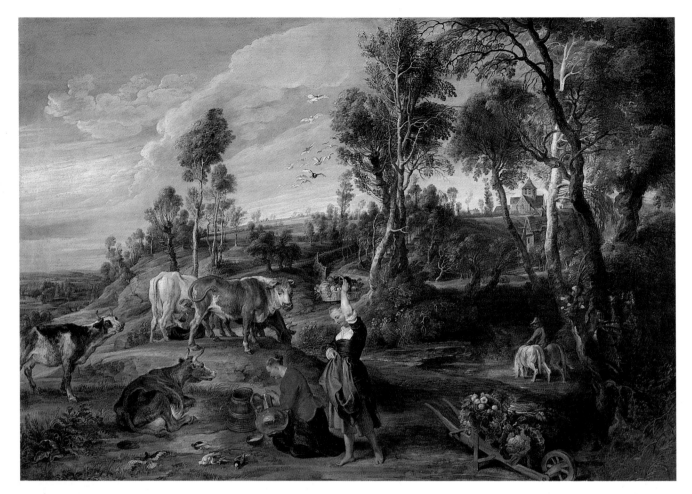

Rubens's knowledge of the countryside of Brabant was not just that of an urban visitor. On both sides of his family he came from prosperous bourgeois stock and although Jan Rubens's flight from Antwerp to Cologne was a substantial blow to the family fortunes, his mother Maria Pypelincx retained several country properties, farms and pieces of land, from which she received an income. After her return to Antwerp she may well have taken her son to visit these modest estates, which came to him after her death in 1608 and that of his brother three years later. During his lifetime Rubens added very substantially to this family inheritance, buying property in the countryside as well as in Antwerp. A careful study of the *Staetmasse ende rekeninge der goederen*, the full inventory of all Rubens's possessions which was not finally drawn up until 1645,[51] five years after his death, reveals that his house on the Wapper at Antwerp, today the Rubenshuis, and his country estate at Het Steen, were only a part of his extensive holdings. He owned, for example, a farm at Zwijndrecht on the River Scheldt opposite Antwerp: it is first mentioned in the inventory of his first wife's estate drawn up in 1628 and remained in Rubens's possession until his death, subsequently coming into the ownership of his heirs. In 1627 he purchased a small country estate at Eeckeren, just north of Antwerp, centred on the 'Hof van Ursele', a late medieval stone building which had been erected by Renier van Ursel, Treasurer of the city of Antwerp, in the 1480s. Rubens paid 7407 guilders for the house and the estate, which comprised eighty-two acres of arable land and woods.[52] He apparently paid for the estate with the

33. *Milkmaids with Cattle in a Landscape: 'The Farm at Laeken'*, c.1618
Oil on panel, 86.4 × 128.2 cm
London, The Royal Collection

35. (opposite) Detail of Plate 33

34. *Study of an Ox*
Black and red chalk and wash on paper, 28.3 × 43.6 cm
Vienna, Graphische Sammlung Albertina
A study for the ox in *The Farm at Laeken* (Plate 33)

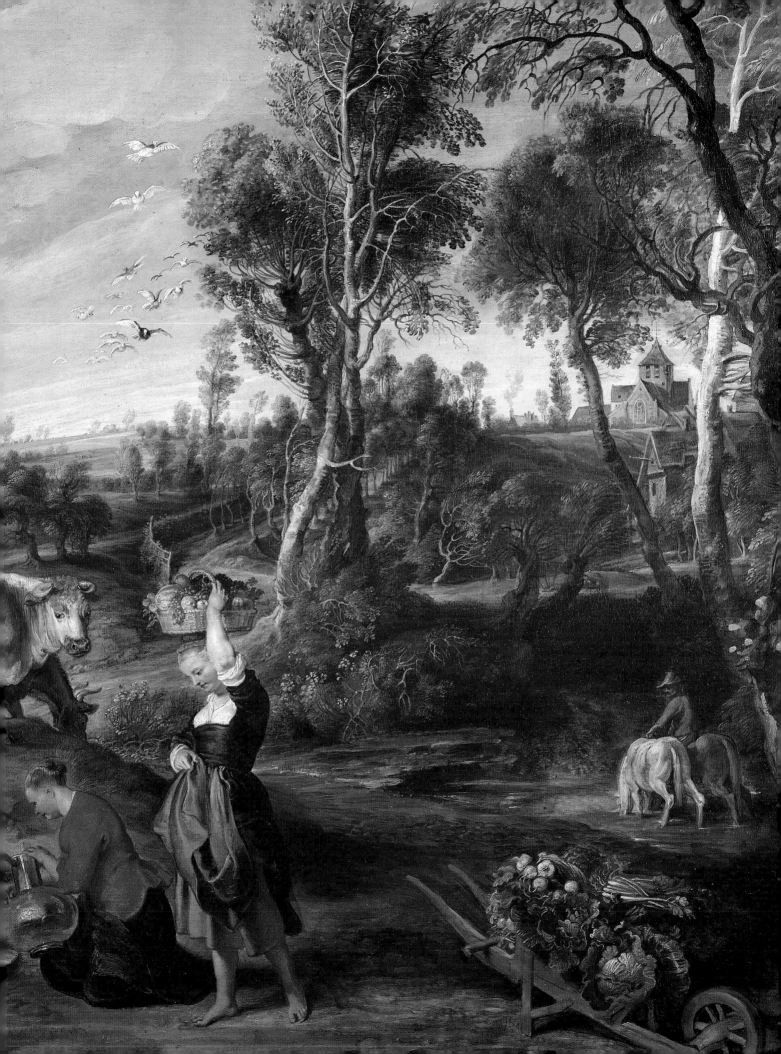

36. Nicolo Boldrini (after
Titian), *Landscape with a
Milkmaid*, *c.*1525
Woodcut, 37.3 × 53 cm
London, British Museum
It has been suggested that the
copy of the woodcut now at
Chatsworth may have been in
Rubens's collection. He
certainly owned a copy.

proceeds of the sale of his collection of sculpture that year to the Duke of Buckingham
and it seems to have been first and foremost an investment. The farm on the estate was
tenanted. It is difficult to know whether Rubens also bought the estate in order to have
a house outside the city during the summer months, although at this moment in his life
– just after the death of Isabella Brant and with his increasing involvement in peace
negotiations – it is unlikely. Whatever is the case, he began his diplomatic travels shortly
after his purchase of the Eeckeren estate and so cannot have spent much time there
before 1630, when he returned to the Netherlands. In 1635 he bought the far larger
estate of Het Steen at Elewijt but he still owned the Eeckeren estate at the time of his
death.

The composition of *The Farm at Laeken* is loosely based on a woodcut after Titian's
*Landscape with a Milkmaid* (Plate 36). It contains, however, a specific topographical
feature. On the right-hand side of the painting is the church at Laeken, which was
identified by J.-B. Descamps in his mid-eighteenth-century life of Rubens.[53] A
comparison with the engravings of the church in Antonius Sanderus's *Chorographia sacra
Brabantiae...* of 1659[54] confirms this identification. Laeken is just to the north of Brussels
in the largely flat area where the principal residence of the Kings of the Belgians, the
Palais Royal, now stands. The church was almost entirely demolished in 1894/5, but
was re-erected in the late 1890s in memory of Louise-Marie, first Queen of the
Belgians. Photographs taken shortly before its demolition (Plate 37) show the distinc-
tive outline of the tower. Rubens's view seems to show the west door of the church
with the extended north transept on the left.

The church contained a thirteenth-century statue of the Virgin and, with the
churches at Scherpenheuvel and Halle, was one of the principal Marian shrines of the
Netherlands.[55] Its inclusion in Rubens's landscape seems to have been regarded – when

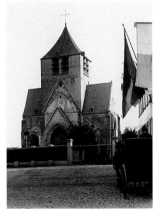

37. Photograph of the church
at Laeken in 1893

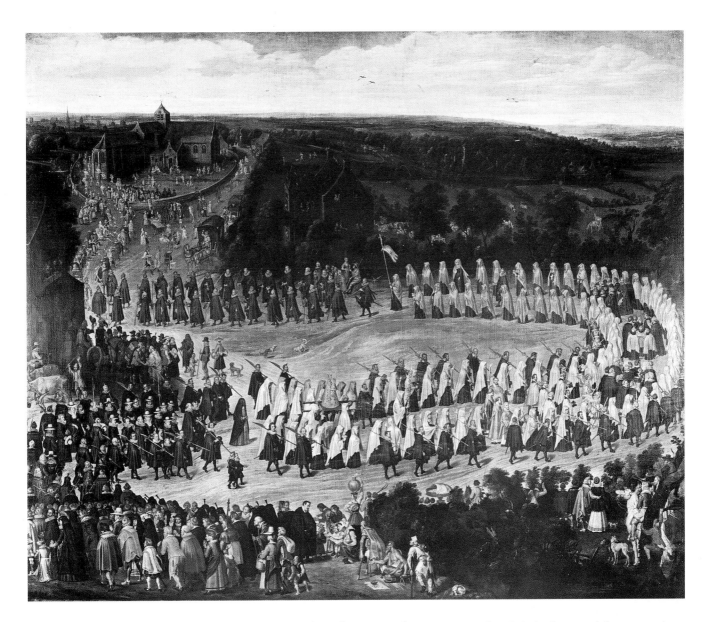

38. Nicolas van der Horst,
*Procession of the Archduchess
Isabella to Laeken*, 1623 Signed
Oil on canvas, 160 × 190 cm
Brussels, Musée Communal

it has been discussed at all – as merely picturesque, but it is in fact crucial to an understanding of the painting. The church had extremely important nationalistic and religious associations which would have been apparent to Flemish seventeenth-century viewers. It was an ancient foundation consecrated by Pope Leo III in 803 or 804 and a chapel was added to commemorate Hugues, a natural son of Louis of Bavaria, who died in a battle nearby in 895. In succeeeding centuries several miracles, in which the mortally ill were restored to health through the intercession of the Virgin Mary, took place in the church and, as a consequence, it became an important pilgrimage site. The church was extended, and at one point the Virgin, accompanied by Saints Barbara and Catherine, was said to have descended from heaven to guide the builders. She left behind a thread with which she traced the foundations of the new building: this became the holiest relic of the church. The church was attacked and seriously damaged by Calvinist iconoclasts on Saint Barbara's day, 4 December 1581. The building was stripped and the choir converted into a grain store. (The miraculous image of the Virgin and her thread were

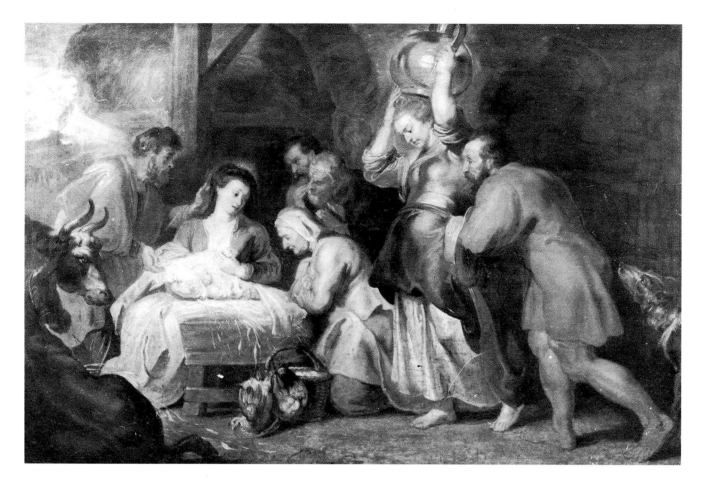

removed before this sacrilege and hidden.) The church was restored and re-dedicated during the reign of the Archdukes. On 16 and 17 September 1601 the Archbishop of Malines consecrated the altars dedicated to the Virgin, the Trinity, Saint Anne, Saint Nicholas, Saint Guidon (a local hero and former priest at the church) and Saint Barbara. Archduke Albert commissioned a new window for the church designed by Gertruud van Veen, daughter of Rubens's teacher, which showed the Infanta Isabella receiving the miraculous thread from the Virgin. Shortly afterwards, a new and very ornate stone rood screen designed by Wenceslas Coebergher was installed in the church.

The Infanta Isabella had a special devotion to the church at Laeken and its relics. In 1623 she made a pilgrimage attended by the women of her court and four hundred lay religious sisters, or béguines. Her chapel musicians sang during the Mass and afterwards a large dinner was held in the open air. There were three great tables, one for Isabella and her court ladies, a second for the béguines and a third for the musicians. The whole party then heard vespers and returned to Brussels. Isabella erected small chapels along the approach to the church and the visitor can still see the fountain she built in 1625 with the inscription that records that she did this at the request of the priest at Laeken, Andrea de Soto, a Spanish Benedictine from the abbey of Afflighem.

The landscape represented in *The Farm at Laeken* (Plate 33) is very rich. The wheelbarrow in the foreground is weighed down with freshly gathered fruit and vegetables, while the standing woman supports a basket of ripe fruit on her head. A woman kneels to pour milk from her pitcher into a small bowl for the birds. Behind them a third

39. *The Adoration of the Shepherds* (predella panel), c.1617-19
Oil on oak, 68 × 100 cm
Marseille, Musée des Beaux-Arts
Rubens received the commission for the altarpiece for the church of St John at Malines late in December 1616 and delivered it in 1619. This is the left-hand predella panel.

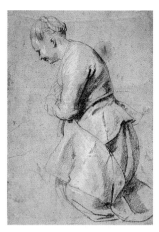

40. *Study for a Kneeling
Woman, c.*1617
Black chalk, with white high-
lights, on paper, 41.9 × 29.5 cm
Vienna, Graphische Sammlung
Albertina
Study for a figure in the
*Adoration of the Shepherds*
(Plate 39).

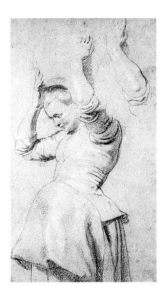

41. *Study for a Standing
Woman, c.*1617
Black chalk, with white high-
lights, on paper, 49 × 26.9 cm
Berlin, Staatliche Museen,
Preußischer Kulturbesitz,
Kupferstichkabinett
Another study for the *Adoration
of the Shepherds* (Plate 39).

woman is milking one of the fat and healthy cows. All the animals are sleek and well-fed: there is a drawing in black and red chalk and pen in the Albertina in Vienna made from life for the ox in the middle distance (Plate 34). There can be no doubt that Rubens has set out to create an image of rural contentment and prosperity. It is a prosperity which flourishes under the protection of the Virgin and the benevolent rule of the Archdukes.

The painting reflects Rubens's devotion both to the Catholic Church and to the Archdukes. The Archdukes were very conscious of the value of their court artists, of whom Rubens was one, in creating an image of a prosperous country with its own proud history – distinct from that of the Dutch Republic – quasi-independent of Spain, intensely Catholic and wisely governed by Albert and Isabella.[56] *The Farm at Laeken* takes its place as an affirmation of this nationalistic vision alongside Jan Brueghel's scene of a country wedding feast attended by the Archdukes (Madrid, Prado), Denijs van Alsloot's depiction of the festival at the Diesdelle (Madrid, Prado) and Nicolas van der Horst's depiction of the Archduchess's pilgrimage to Laeken (Plate 38).

It is tempting to speculate that *The Farm at Laeken* was commissioned by the Archdukes themselves but there is no evidence for such an idea. It is first mentioned in the inventory of Arnold Lunden, who died in 1656.[57] Lunden, a wealthy Antwerp merchant, had married Susanna Fourment, an elder sister of Rubens's second wife, in 1622 and the picture remained in the possession of his descendants until 1817. It seems most likely that the painting was a gift from Rubens to Arnold and Susanna Lunden, and was therefore an essentially private expression of his fervent support for the Archdukes' vision of a peaceful, prosperous and Catholic Flanders.

In attempting to date *The Farm at Laeken* there is an important point of reference in two drawings by Rubens which are in Vienna and Berlin (Plates 40 and 41).[58] One shows a standing woman carrying a pitcher on her head and the other a kneeling woman: they were used by Rubens for two figures in a predella panel of *The Adoration of the Shepherds* (Plate 39), from the altarpiece of *The Adoration of the Magi* painted for the church of St John in Malines (Mechelen) in 1617–19. The figures of the two milk-maids in the foreground of *The Farm at Laeken* are strikingly similar and Rubens may also have based them on the drawings. It is possible, of course, that Rubens re-used the drawings after a lapse of several years, but as the style of the painted figures is also very close it seems reasonable to think that the landscape dates from about the same time as *The Adoration of the Magi*, which establishes the one relatively secure date around which to group Rubens's early landscapes.

In *The Farm at Laeken* Rubens lingers on the foreground details, not just the vegetables in the barrow and the small, brightly coloured birds but also the grasses and nettles on the left and the tangled creepers on the right. Farther off, he shows a countryman watering two horses in a stream and, on the left-hand side, a distant vista of an extensive plain. It is typical of Rubens's early efforts as a landscape painter that he creates a hilly middle ground which he cuts away to reveal a view to the horizon. It is a device which enables him to avoid the perennial difficulty of the landscape painter, the transition from middle ground to background. It is a problem with which Rubens was always to struggle, even in his most accomplished landscapes like the *Landscape with Het Steen* (Plate 58).

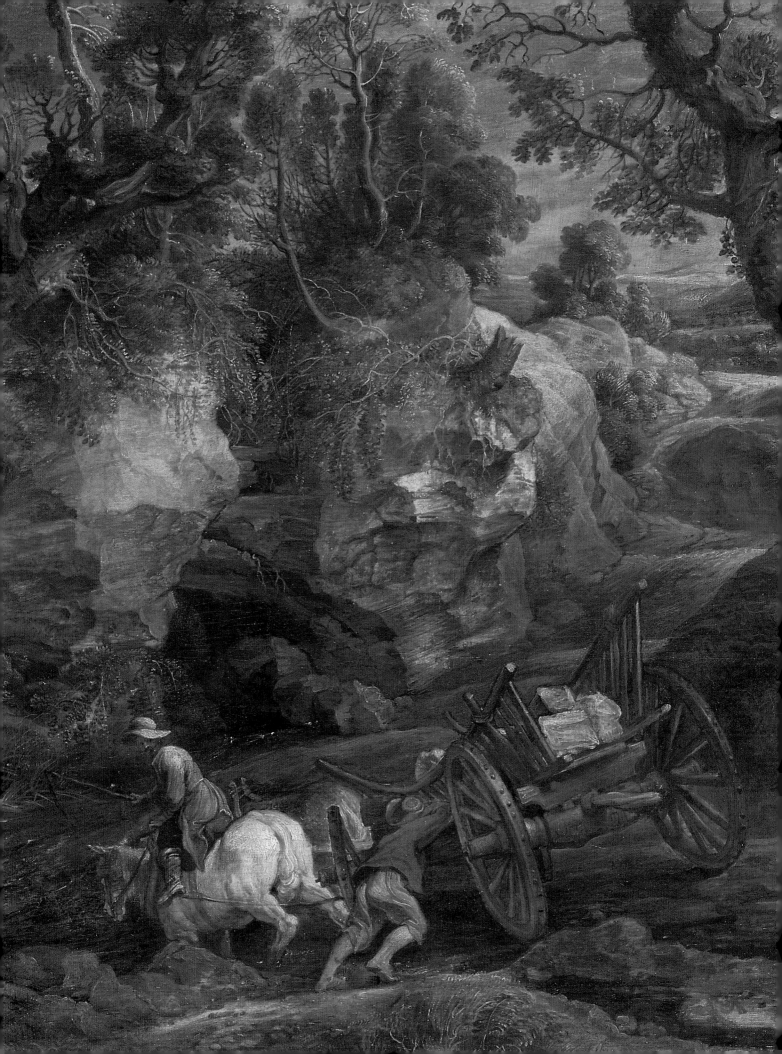

## CHAPTER 4

# 'La Charrette Embourbée' and The Watering Place

ONLY A FEW YEARS after he painted *The Farm at Laeken*, that is, about 1620, Rubens depicted another scene from rural life, the *Landscape with a Cart crossing a Ford* (Plate 44), which has long been known by the name given to it by Descamps in 1753 '*La Charrette Embourbée*'.[59] It shows two men trying to manoeuvre a wooden cart laden with heavy quarried stones down a river bank and across a ford. The cart is of a distinctively Southern Netherlandish design: Rubens made a careful black chalk drawing of a cart of this type (Plate 43), which he then used in a painting of harvesters returning from the fields (Plate 99).[60] The cart is unusually long with single bowed poles supporting the panels or slats within which the load is placed. The driver sits astride a white horse, holding in his left hand the reins of this horse and a second one (which can only just be made out) and raising a whip in his right. He looks anxiously over his shoulder as his colleague leans his weight against the side of the cart to prevent its falling to the left as it descends the slope to the ford.

The single most striking feature of the painting, however, is not this everyday predicament but the natural drama of the great fissured rock which rises up in front of the men. Clinging tenaciously to the top and sides of this extraordinary rock with an intricate tangle of roots and tendrils is a rich variety of trees. Though less sheer and bare, the rock is a distant heir to those of Patinir. The mass of the rock has the effect of dividing the landscape: on the right is an extensive view across rolling, wooded hills which are still in sunlight, while on the left the river bordered by trees is in the shadow of the

42. (opposite) Detail of '*La Charrette Embourbée*' (Plate 44)

43. *Two Wagons, one laden with Sheaves*, c.1635
Black chalk, 22.4 × 37.5 cm
Berlin, Staatliche Museen, Kupferstichkabinett
A study for *Return from the Harvest* (Plate 99)

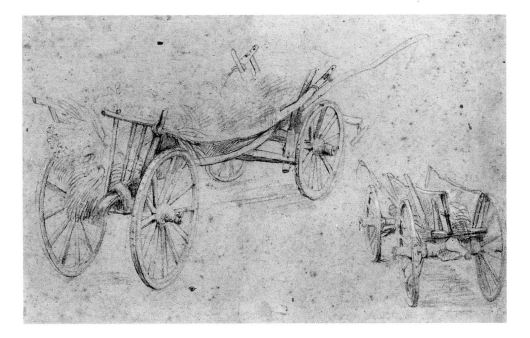

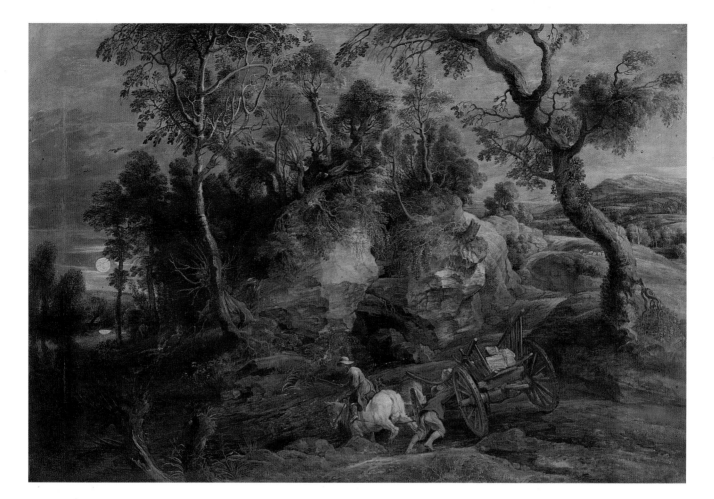

rock and illuminated by the moon. A bat hovers in the air and on the shadowed side of the rock a man and a woman have lit a fire and sit together, their features picked out by the firelight. Although the landscape on the right is far higher than that on the left, there is no reason to think that it is not continuous.

It has been argued that in this painting Rubens is presenting two distinct scenes on either side of the rock, a morning and evening, or a day and night landscape which is related to a late medieval symbolic convention for the depiction of life and death.[61] In the medieval tradition one landscape is barren and the other fertile, which is not the case here. This interpretation of Rubens's landscape is far-fetched, and yet the fact that one part of the landscape is lit by the sun and the other by the moon may at first seem to defy a naturalistic explanation. It may, however, be significant that no surprise at this apparent dualism was registered before Evers discussed it in 1942: John Smith, describing the painting in 1830, wrote that 'a twilight effect, produced by the departure of the sun and the rising of the moon, pervades the scene.'[62] The landscape was painted on a complex oak panel and the paint layer was transferred from this panel to a canvas in 1823. It is possible that this process or the build-up of layers of discoloured varnish has caused the paint surface to darken and so give a misleading impression. The cart may seem to be passing from day to night but the setting could simply be an evening in late summer when the sun has not yet fully set and the moon is already in the sky. Bats, which are associated with the evening rather than the night (a bat is a *vespertilio* in Latin,

44. *Landscape with a Cart crossing a Ford: 'La Charrette Embourbée', c.*1620
Oil on canvas (transferred from panel), 86 × 126.5 cm
St Petersburg, The State Hermitage Museum

that is, a creature that comes out in the *vesper*, evening), are out but stars are not yet in the sky.

The *Landscape with a Cart crossing a Ford* is a study of an everyday human situation played out in front of, and dwarfed by, a remarkable natural phenomenon. It displays the insignificance of man when faced by the power of nature. In this sense it refers back to the world views of Patinir and Pieter Bruegel. Rubens was evidently fascinated by the rock with its gaping cleft and the trees which cling to it as if in desperation. His contemporary Roelandt Savery (1576–1639) was also intrigued by such natural phenomena.[63] In 1604 Savery settled in Prague in the service of the Emperor Rudolf II, who sent him to the Tyrol to make drawings of the mountainous landscape and the flora and fauna of the region. It is possible that Rubens saw and was inspired by drawings made by Savery or the paintings and prints based on them which he made after his return to the Netherlands, probably in 1613 (Plate 45). More certainly, the moonlit landscape on the left-hand side of the rock is testimony to Rubens's study of Elsheimer: it is strikingly similar in composition and specific details – such as the reflection of the moon in the water and the way in which its light shines through the trees – to the *Flight into Egypt* (Plate 22) which Rubens referred to in his letter to Faber mourning Elsheimer's death.[64]

Rubens was to return to the motif of a horse-drawn cart manoeuvring down a steep slope in order to ford a river in two paintings, one on paper and a second on panel, almost twenty years later (see Plates 69 and 70). In these paintings, the landscape is more obviously naturalistic, the monstrous rock is absent and the river bank lined with clumps of tall trees.

45. Roelandt Savery, *The Goatherd between the Trees* Etching, 20.5 × 26.1 cm London, British Museum

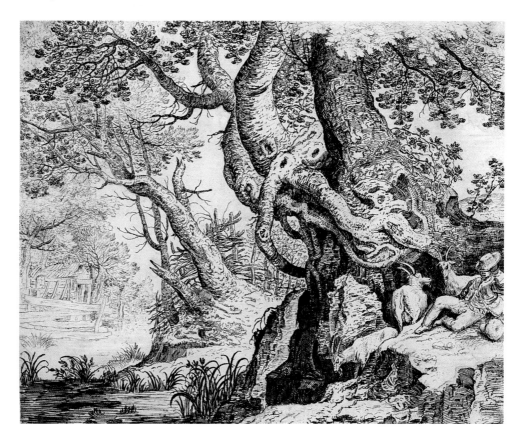

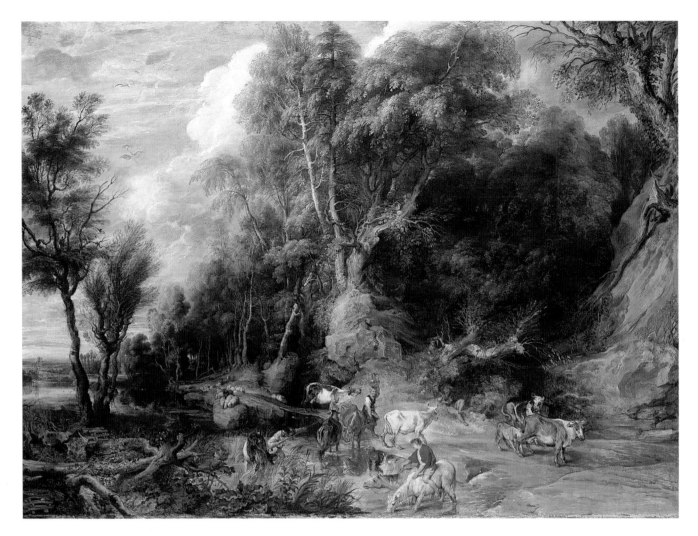

The Watering Place (Plate 46)[65] is closely related in style and subject matter to the *Landscape with a Cart crossing a Ford*: both were probably painted in about 1620. *The Watering Place* is also dominated by a huge Patiniresque rock, to which trees cling. In the foreground is a group of cows, accompanied by a milkmaid carrying a brass pitcher on her head; a rider, perhaps the driver of a cart, allows his horses to drink and a herdsman vigorously prods a cow which is reluctant to leave the water and rejoin the herd. In a shadowed hollow in the rock a shepherd reclines cross-legged, playing his pipe, a pastoral figure taken over from the Venetian landscape tradition which Rubens was to employ on numerous occasions to suggest the idyllic side of life in the countryside. On a small rocky promontory in the background sheep graze. The entire scene is set against a backdrop of a dense, dark forest. This screen of trees tapering off into the distance on the left once again recalls Elsheimer's *Flight into Egypt* (Plate 22).

There is in the National Gallery a second, smaller landscape which is intimately connected with *The Watering Place*: the *Shepherd with his Flock in a Woody Landscape* (Plate 48). It shows the same grazing sheep on a rock above the water's edge, this time with a shepherd leaning on his crook. The close relationship of the two paintings is underlined by the discovery in *The Watering Place* of the shepherd in exactly this pose and position, as can clearly be seen in the X-ray photograph. Rubens subsequently

46. *Peasants with Cattle by a Stream in a Woody Landscape: 'The Watering Place', c.*1620
Oil on oak, 99.4 × 135 cm
London, National Gallery

47. (opposite) Detail of Plate 46

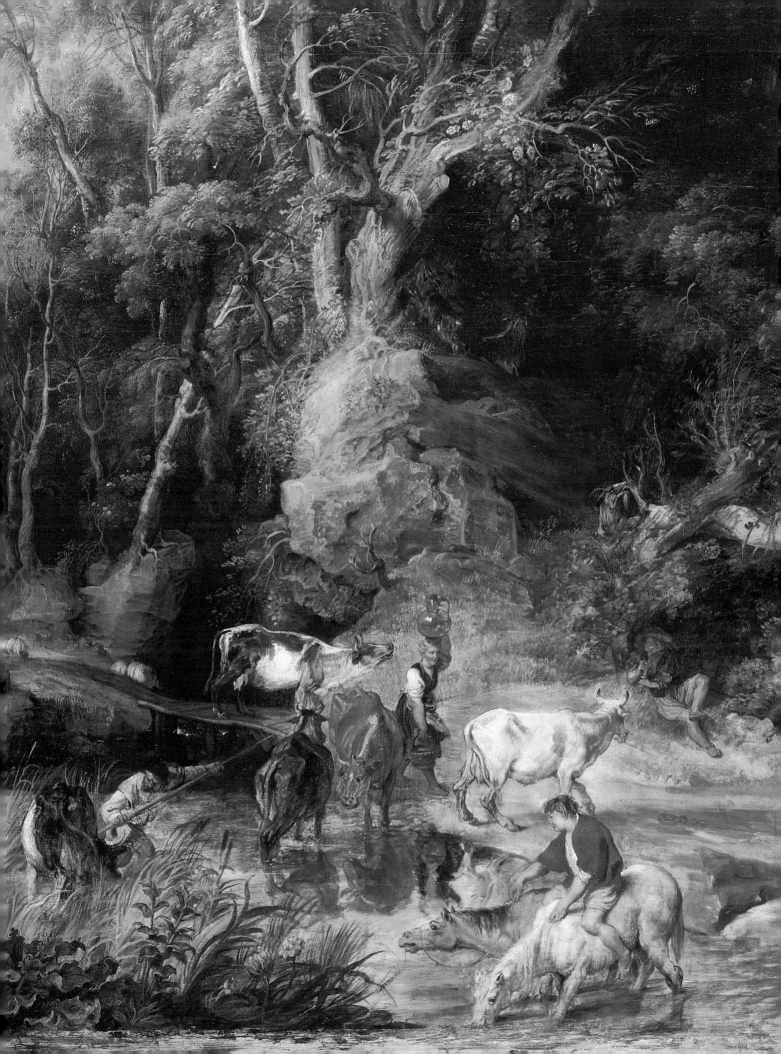

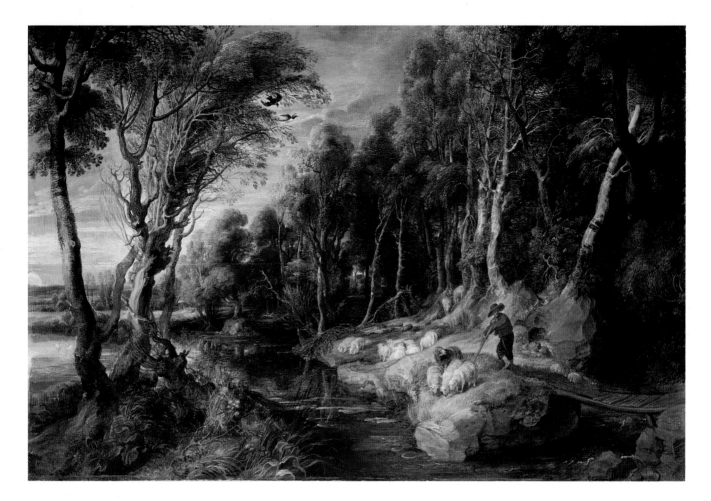

painted him out, presumably because he felt that the shepherd's presence would distract the viewer from the foreground scene. There are slight variations but essentially the core section of *The Watering Place* is a free copy of *A Shepherd with his Flock in a Woody Landscape*.

How can this be explained in terms of Rubens's working practice? Rubens often reused and adapted individual figures and motifs in his work. He also had his studio assistants make copies of particularly successful works which he sometimes retouched himself. However, the phenomenon which we encounter here – the incorporation of an entire composition within a larger one – is otherwise unknown. There are no other cases of such free copies of sections of landscape. *The Watering Place* was painted on a very complex panel and the largest central section corresponds to the composition of *A Shepherd with his Flock in a Woody Landscape*. It has been suggested that Rubens began by painting a second version of the smaller painting and then, wishing to expand the composition, asked his panelmaker to add more pieces of wood around it so that he could do so. As many of Rubens's landscapes are painted on complex, composite panels of this kind, this question is best considered as part of a more general discussion of Rubens's working methods when he was painting landscapes and the particular features of the oak panels on which they are painted. It is the subject of Chapter 8.

The nineteenth-century Rubens scholar Max Rooses believed *The Watering Place* to be a collaboration between Rubens and Lucas van Uden[66] and more recently it has

48. *A Shepherd with his Flock in a Woody Landscape, c.*1620
Oil on oak, 64.4 × 94.3 cm
London, National Gallery

been proposed that the 'core panel' of *The Watering Place* is by Van Uden.[67] Lucas van Uden (1595–1672) was a specialist landscape painter and etcher, who made copies after Rubens's landscape paintings under the master's direction in the 1630s. He made, for example, etched copies of *The Farm at Laeken* and *The Watering Place*.[68] It is true that there is in the 'core panel' of *The Watering Place* a precise, detailed rendering of trees and sheep which contrasts with the rest of the picture which is more broadly painted. But the 'core panel' seems too accomplished for Van Uden, even working under Rubens's supervision, if we compare it with his painted copy after Rubens's *Landscape with Odysseus and Nausicaa* (Plate 49). It is possible, however, that Rubens so extensively reworked this section as part of his expansion of the composition that any underlying copy by Van Uden can no longer be separated from Rubens's more elaborate design. Careful study of the painting under the stereo microscope combined with X-ray and infra-red photography provides evidence for at least three stages of development – the 'core panel', additions on all four sides of that panel, and the addition of panels on the top, botton and right-hand side. This process may have taken place over several years which would explain the stylistic differences within *The Watering Place*, as well as shifts in underlying tonality which have become more apparent with time. *A Shepherd with his Flock in a Woody Landscape* also underwent a process of enlargement. It appears to have been painted in two distinct stages as can be adduced from the presence of different grounds on the central section and its additions, as well as the reworking of passages in the trees and sky to disguise the joins of the expanded support. Therefore, the most likely sequence of events in the creation of the two paintings seems to have been that Rubens painted the 'core panel' of *A Shepherd with his Flock in a Woody Landscape*; expanded it to its present dimensions with four additional pieces of wood; either made a copy of it himself or commissioned a copy from Van Uden; and then used that copy as the 'core panel' of *The Watering Place*. It must be remembered, however, that this close relationship between the two landscapes is a unique occurrence and cannot be considered typical of Rubens's procedure in painting landscapes.[69]

Both *The Watering Place* and *A Shepherd with his Flock in a Woody Landscape* belong to the Flemish tradition of forest landscape which has its origins in the work of Pieter Bruegel the Elder and was developed by his son Jan the Elder and artists like Abraham Govaerts and Gillis van Coninxloo. These artists were fascinated by dense forests of dark, massed trees with interlacing branches and knotted roots, which blocked out the sun and formed small tunnels through which flashes of sunlight can be glimpsed. Yet these forests rarely seem hostile. There is no suggestion that terrifying wild animals or bands of brigands are lurking. Rubens's is essentially an optimistic, even idyllic view of nature: it displays a town-dweller's belief in the intrinsic docility of nature.

The *Pond with Cows and Milkmaids* and *The Farm at Laeken* are conscious celebrations of the fecundity of Flanders and Brabant in a time of peace. *The Watering Place* and *A Shepherd with his Flock in a Woody Landscape* also partake very strongly of this mood of the celebration by Rubens of the beauties of his own countryside but there is also, noticeably in the figures of the two shepherds, one piping, the other resting contentedly on his crook, a pastoral atmosphere which derived not only from his careful study of Venetian painting but also from Rubens's personal pleasure in the rural idyll.

During the 1620s as his own life became busier and the demands upon him became greater, the ease of country life must have seemed ever more attractive to Rubens and

this could have been one reason for his purchase of the estate at Eeckeren in 1627. Such feelings correspond with a profound current in Latin poetry, of which Rubens with his extensive knowledge of classical literature was very well aware. Although irony is never far away in Horace's poetry, his bucolic lines are very close in mood to *A Shepherd with his Flock in a Woody Landscape*:

> Iam pastor umbras cum grege languido
>
> rivumque fessus quaerit et horridi
>
> dumeta Silvani, caretque
>
> ripa vagis taciturna ventis.

(The weary shepherd with his spent flock makes for / shadow and water and the shaggy wood-god's / thickets; the river bank / dumbly endures the absence of the breeze.[70])

This sense of the idyllic country life, admired by classical authors and modern poets, was to become increasingly important to Rubens and culminate in the painting of a group of pastoral landscapes consciously inspired by classical literature in the last years of his life.

Rubens painted two subjects from classical literature set in extensive landscapes in the late 1620s. The *Landscape with Odysseus and Nausicaa* (Plate 49) tells the story from the *Odyssey* of Odysseus' sudden appearance to Nausicaa and her maids after his shipwreck on the coast of her father's kingdom of Phaeacia. While the maids are terrified by the unexpected sight of the naked man, Nausicaa retains her royal dignity. In the sky Athena, Odysseus' protectress, implores Zeus to be merciful to him. The landscape in which Rubens sets this dramatic encounter is rocky, with a view of the royal palace

49. *Landscape with Odysseus and Nausicaa*, c.1627
Oil on panel, 126.5 × 205.5 cm
Florence, Palazzo Pitti

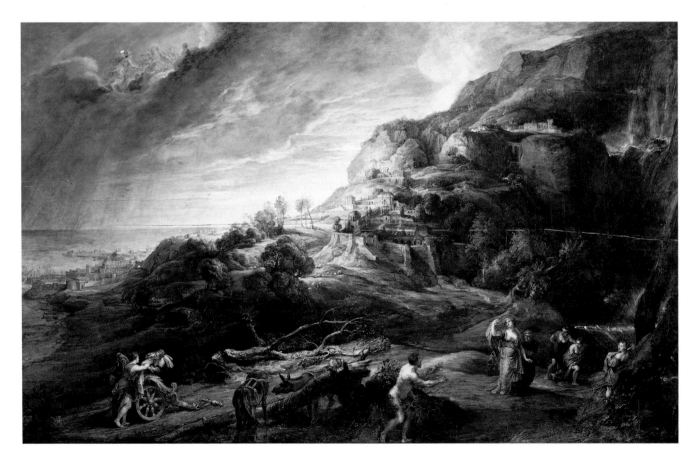

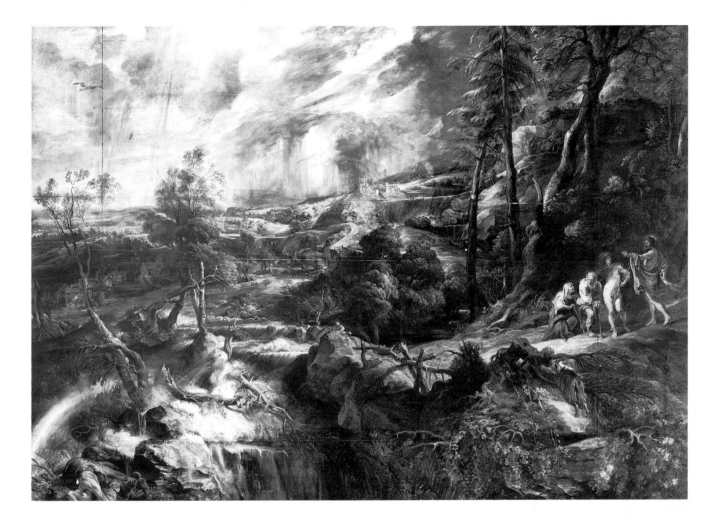

50. *Stormy Landscape with
Philemon and Baucis, c.1627*
Oil on panel, 147 × 209 cm
Vienna, Kunsthistorisches
Museum

perched on the hillside, and a port at the edge of the sea. The composition is loosely
based on Elsheimer's *Aurora*. Lucas van Uden painted a small-scale copy of the *Landscape
with Odysseus and Nausicaa* under Rubens's supervision in 1635 (see Plate 105).

Rubens painted a second scene from classical literature set in landscape at about the
same time, the *Stormy Landscape with Philemon and Baucis* (Plate 50). The subject is from
Ovid's *Metamorphoses* and enjoyed great success in the seventeenth century when Ovid's
account was translated by, among others, Karel van Mander.[71] Jupiter and Mercury
were travelling in disguise in Phrygia and, having been refused hospitality elsewhere,
were entertained by the virtuous old couple Philemon and Baucis. Jupiter told them to
climb a nearby mountain in order to avoid the imminent flood which was to sweep
away their wicked neighbours. Later they served together at Jupiter's temple, died at
the same time and were transformed into interwined trees. This subject provides
Rubens with the opportunity to paint a highly dramatic scene of Jupiter showing
Mercury and Philemon and Baucis the swollen, flooded river which wreaks havoc as it
cascades through the landscape, tearing down trees and drowning the inhabitants. This
painting, like so many of the 'pure' landscapes, remained in Rubens's possession until
his death.[72]

# CHAPTER 5

# *The Landscape with Het Steen:*
# Rubens in Antwerp and Elewijt

O N HIS RETURN FROM ITALY in 1608 Rubens enjoyed immediate success in
Antwerp. He received a series of prestigious commissions for altarpieces for
the churches of the city and for paintings, like the *Samson and Delilah* ordered
by Nicolaas Rockox, Burgomaster of Antwerp,[73] to hang in private houses. Rubens's
work began to command high prices and this considerable income enabled him in 1610
to move with his wife Isabella Brant from her father's home into a large house with a
substantial garden on the Wapper, a canal which was in the centre of the city just off its
principal street, the Meir. The artist extended the original late medieval building,
adding a special 'Pantheon' for the display of his collection of antiquities, and also built
a free-standing studio connected to the older house by a three-arched screen. Beyond
the screen Rubens created a formal garden with shady walks between the flower beds
and a grotto containing a fountain. Today the reconstructed Rubenshuis is a museum
(Plate 53), which gives its visitors a real sense of the atmosphere of Rubens's Antwerp.

We know relatively little of the exact lay-out and planting of Rubens's Antwerp
garden except for the views of it in the painting of the artist, his second wife and eldest
son walking there (Plate 52) and in a pair of engravings by Jacob Harrewijn which show
the house and garden in 1684.[74] Although the attribution of the painting to Rubens has

*52. Rubens, his Second Wife
Hélène Fourment and his Eldest
Son in the Garden, c.1631*
Oil on oak, 98.5 × 131 cm
Munich, Alte Pinakothek

*51. (opposite) Detail of An
Autumn Landscape with a View
of Het Steen in the Early
Morning (Plate 58)*

53. View of the Rubenshuis, Antwerp
Modern photograph
This is the street façade of the original late medieval house purchased by Rubens in 1610 and later substantially enlarged.

54. View of the Garden of the Rubenshuis, Antwerp
Modern photograph.

recently been doubted, it is contemporary and likely to be accurate in its details. During the last forty years, using these guides, the garden has been replanted with flowers, shrubs and herbs available in the early seventeenth century (Plate 54). We know that Rubens had in his library[75] the famous *Hortus Eystettensis*,[76] the lavishly illustrated account of the remarkable garden created by the Bishop of Eichstätt which was published in Nuremberg in 1613. Rubens obtained his copy – one of the most expensive books he ever bought – two years later from his friend the Antwerp printer and book-seller Balthasar Moretus. The *Hortus Eystettensis* has been used as a guide for the planting of the garden. The only reference to the garden in Rubens's correspondence is in a letter to his pupil Lucas Fayd'herbe written at Het Steen on 17 August 1638. He asks Fayd'herbe, who was looking after the Antwerp house in Rubens's absence in the country, to 'remind William the gardener that he is to send us some Rosile pears as soon as they are ripe, and figs when there are some, or any other delicacy from the garden.'[77]

Rubens returned from England in 1630, which marked the end of the most hectic phase of his diplomatic career. In the same year, at the age of fifty-two, he married the

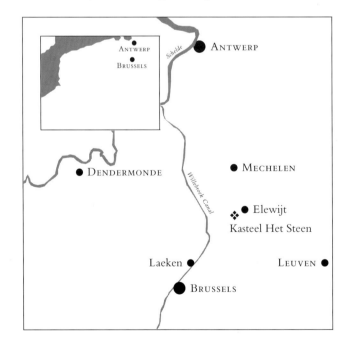

55. Map showing location of Het Steen

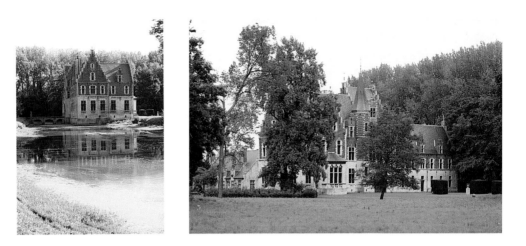

56. View of Het Steen
Modern photograph
This shows the façade of Het Steen which can be seen in the *Landscape with Het Steen* and is the part of the house which best preserves its appearance in Rubens's lifetime.

57. View of Het Steen
Modern photograph
The other side of the house which was extensively changed and enlarged in the 19th century in the 'Flemish Renaissance' style.

sixteen-year-old Hélène Fourment. Determined to spend more time with his young wife and growing family outside the city, on 12 May 1635 Rubens bought the estate of Het Steen at Elewijt for 93,000 guilders from Jean de Cools, Seigneur de Corbais, who had purchased it thirteen years earlier.[78] Het Steen stands within a bend of a stream called the Baerebeek near the village of Elewijt, roughly halfway between Brussels and Malines (Mechelen) and about three hours' ride from Antwerp (Plate 55). The estate was extensive and gave Rubens the right to style himself *Heer van Steen* (Lord of Steen). The inscription on his tombstone in the Sint Jacobskerk in Antwerp,[79] composed by his friend Gaspar Gevartius, begins: Petrus Paulus Rubenius Eques, Joanni hujus urbis Senatoris filius, Steini Toparcha ... (Peter Paul Rubens knight, son of Jan, Alderman of this city, Lord of Steen ...). Rubens constructed a number of new outbuildings on the estate and gradually acquired neighbouring parcels of land. He bought, for example, the adjoining estate Het hoff te Attevoorde on 25 September 1638 and in the same year added the watermill on the Baerebeek to the estate.

Het Steen may well have been brought to Rubens's attention by his friend Frederick de Marselaer, who acquired the neighbouring estate of Perck through his wife in 1626.[80] De Marselaer was a lawyer who became Treasurer of Brussels in 1622 and served many times as a burgomaster of that city. He was the author of the *Legatus*, a book about the conduct and responsibilities of an ambassador, which was first published in 1618 and appeared in a third edition in 1666 with a title-page by Rubens.[81] From a letter of 6 March 1638 to Balthasar Moretus,[82] in which De Marselaer expresses his pleasure at having received Rubens's design, we know that it was ordered three years earlier, in the year in which Rubens became De Marselaer's near neighbour.

When the estate of Het Steen was put up for sale by Rubens's children in 1682, the very elaborate description of it ran to six printed pages. It begins: 'A manorial residence with a large stone house and other fine buildings in the form of a castle, with garden, orchard, fruit trees and a draw-bridge, and a large hillock, on the middle of which stands a high, square tower, having also a lake and a farm ... the whole surrounded by moats.'[83]

The house still stands and although it was substantially remodelled in the eighteenth and again in the nineteenth century, the façade which can be seen in the *Landscape with Het Steen* (Plate 58), with a bridge over the moat, is largely unchanged (Plate 56). Unfortunately the tower which was such a prominent feature of the house

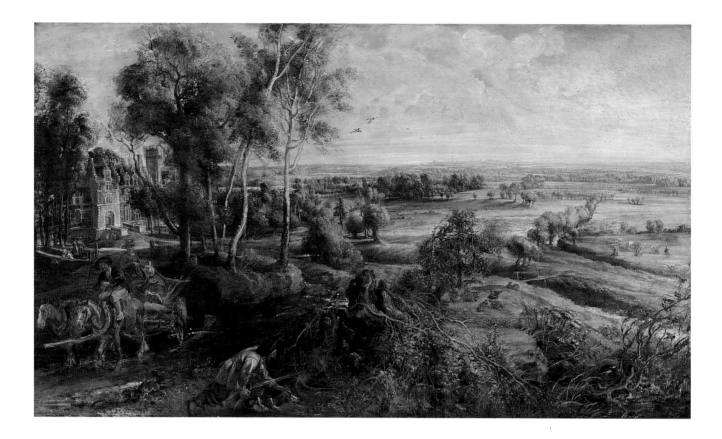

58. *An Autumn Landscape with a View of Het Steen in the Early Morning,* probably 1636
Oil on oak, 131.2 × 229.2 cm
London, National Gallery

does not survive: according to Max Rooses, writing in 1890, its foundations could be seen in the late nineteenth century three metres to the north-west of the house.[84] It was the oldest building on the site, a defensive stone structure surrounded by a moat: the stone of the tower presumably gave the estate its name. The tower must have provided Rubens with an excellent vantage point from which to survey his estate and the surrounding countryside.

Although Rubens's purchase of the estate was confirmed by the Council of Brabant in May 1635, he does not appear to have occupied the house until November of that year. The *Landscape with Het Steen* was presumably painted after he moved in. The hedgerow in the foreground is mostly made up of a rambling blackberry bush – very similar to that drawn by Rubens in the *Wild Cherry Tree with Brambles and Weeds* (Plate 85) – which is partly in flower and partly bearing fruit. Behind it is a species of chrysanthemum, to the right of which are species of achillea and arctium, all autumn-flowering plants. Since they are seen in bloom, the season must be autumn but the still-green leaves indicate that it is not as late in the year as November. As the style of the painting is not that of Rubens's very last years, it is reasonable to think that it was painted in the autumn of 1636.[85] We know that Rubens had been at Het Steen for some months when he wrote from there to his friend the French antiquarian Nicholas-Claude Fabri de Peiresc on 4 September 1636.[86] He was certainly back in Antwerp, at work on the Torre de la Parada commission for Philip IV, by mid-November.

The time of day in the *Landscape with Het Steen* is early morning. The sun is in the east, rising, and the view is therefore due north, towards the town on the horizon which is probably Malines (Mechelen) rather than Antwerp, as has been suggested. The

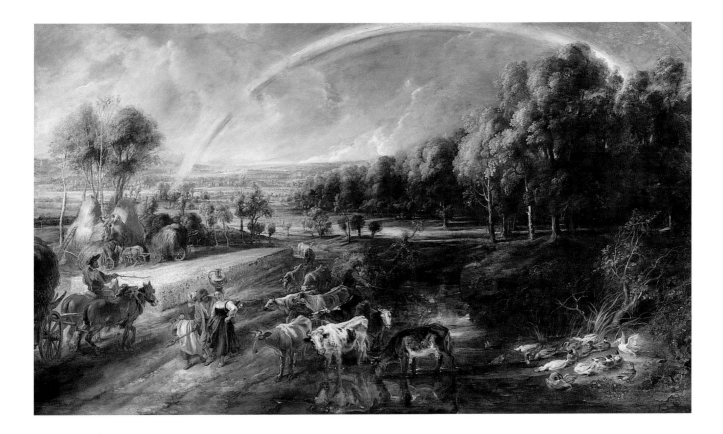

59. *Landscape with a Rainbow,* probably 1636
Oil on oak, 135.5 × 233.5 cm
London, Wallace Collection

prominent tower would be that of the Cathedral of St Rombout. This also accords with the position of the tower next to the house, as recorded in the late nineteenth century. The farm wagon is on its way to market with a calf and the hunter is out stalking the birds who warm themselves in the early morning sunshine. There is a covey of partridges behind the foreground flowers and on a branch in the right foreground are two goldfinches. A kingfisher flies in front of the hedgerow and there are two magpies in the sky. Milkmaids are milking cows in the distance on the right. Three well-dressed figures have emerged from the house for an early morning walk.

The *Landscape with Het Steen* belongs to the Flemish world-view tradition. Rubens surveys the surrounding countryside, as if from the tower adjoining the house. He looks across the Baerebreek, the stream that crosses the countryside in the middle ground, over low-lying meadows and copses towards the town in the distance. In the foreground is Rubens's own estate but the view extends far beyond his own land. The point of view and the overall composition – with trees grouped on the left and an extensive vista towards the town – is strikingly similar to an earlier landscape by Rubens. *Summer* (Plate 60) was painted in about 1618 with substantial studio participation – Rooses suggested that Lucas van Uden was Rubens's principal assistant[87] – and may have been one of the landscapes by Rubens in the collection of the Duke of Buckingham.[88]

At about the time when Rubens was working on the *Landscape with Het Steen* he used the same viewpoint to look across the same countryside in *Landscape with an Avenue of Trees* (Plate 61) and *Landscape in Flanders* (Plate 62). In the former the flat land-scape of Brabant stretches to the horizon, criss-crossed by streams lined with willows. In the meadow in the foreground harvesters are baling the hay. A country house –

appropriately known as a *lusthof*, literally a 'pleasure court', in Flemish – is seen in the distance on the right. It is painted in oil on paper which has later been pasted onto an oak panel. The small original painting by Rubens was later given a high cloud-filled sky in the manner of Dutch seventeenth-century painters like Philips Koninck and Jacob van Ruisdael, presumably in order to make it more saleable. This also involved giving the trees on the right bushy heads. The artist who made these changes also added a strip of foreground to further extend the composition. It is difficult to know when these additions were made, although it is unlikely to have been before the end of the seventeenth century as the painting was in the collection of a renowned connoisseur, the Cologne banker Evrard Jabach, who could well have obtained the picture directly from Rubens himself.[89]

By contrast the *Landscape in Flanders* (Plate 62) is painted on an oak panel and is entirely the work of Rubens. The panel had previously been used for another painting: various figures and, most clearly, a horse can be seen with the naked eye and, in greater detail, with infra-red reflectography, beneath the landscape (see page 120). Rubens must have begun a hunting scene or possibly a subject such as *The Conversion of Saint Paul* which he subsequently abandoned,[90] and then reused the panel. The line of trees snakes its way across the landscape, leading the viewer's eye towards the distant wood. The countryside is flat and punctuated by streams, river banks and hillocks crowned by small groups of trees. It is interesting to compare the picture with the engraving made after it by Schelte à Bolswert (Plate 63), which adds a row of large trees in place of the

60. *Summer, c.*1618
Oil on canvas, 143 × 223 cm
London, The Royal
Collection

small trees on the left which zigzag into the distance. This 'correction' by the engraver gives a more conventional aspect to the landscape.

The tower at Het Steen is the principal feature of a small landscape in Berlin (Plate 64). It is a tall thin tower of three storeys with a crenellated parapet. Behind it is another building. The tower is approached by a low, three-arched bridge over a river and beyond it is the flat terrain of Brabant, described with the direct strokes of a brush heavily loaded with paint. In the Ashmolean Museum in Oxford is a version of this composition, once thought to be by Rubens himself (Plate 65). In fact, the carefully drawn outlines of the tower, the dry and precise handling of the trees and the simplification of the curve of the bridge reveal the hand of a copyist. It could well be the work of Lucas van Uden, produced under Rubens's supervision in the studio.[91]

Rubens was fascinated by the medieval character of his new house and in the *Tournament in front of a Castle* (Plate 66) he developed the composition of the Berlin painting to create a vision of Het Steen as it might have been in the Middle Ages. In the foreground is a tournament in which three pairs of heavily armoured knights are jousting, accompanied by their squires and a trumpeter. The whole scene is illuminated

61. *Landscape with an Avenue of Trees, c.1636*
Oil on paper mounted on panel, 56 × 71.8 cm
Boston, Museum of Fine Arts

62. *Landscape in Flanders,*
*c.*1636
Oil on panel, 89.8 × 133.8 cm
University of Birmingham,
Barber Institute of Fine Arts

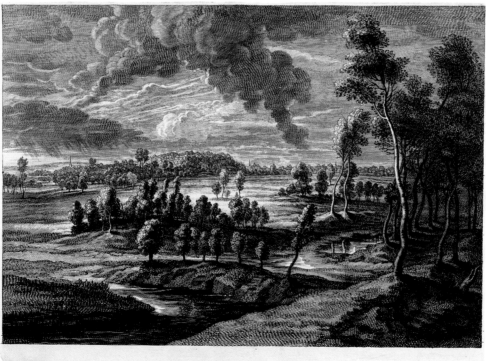

63. Schelte à Bolswert (after
Rubens),
*Flat Landscape with Clouds*
Engraving, 31 × 45.5 cm
London, British Museum

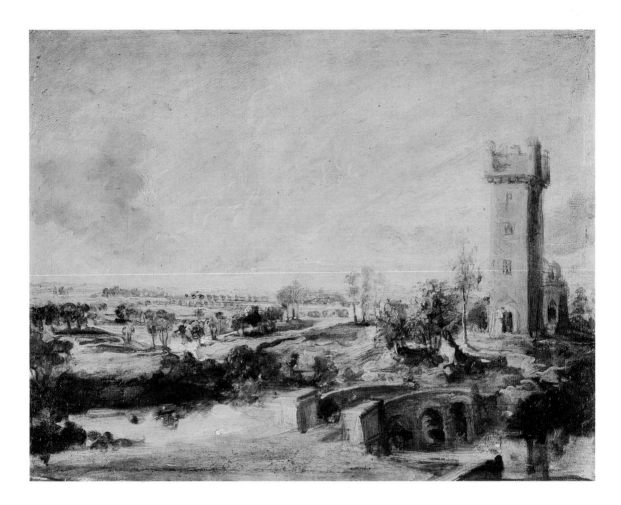

64. *Landscape with a Tower,*
*c.*1636
Oil on panel, 24 × 30.8 cm
Berlin, Staatliche Museen,
Gemäldegalerie

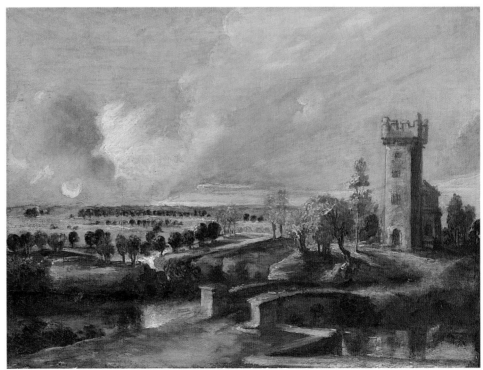

65. After Rubens, *Landscape*
*with a Tower, c.*1636-40
Oil on panel, 28 × 37 cm
Oxford, Ashmolean Museum.
A copy of the Berlin painting
(Plate 64), which may have
been painted by Lucas van
Uden in Rubens's studio.

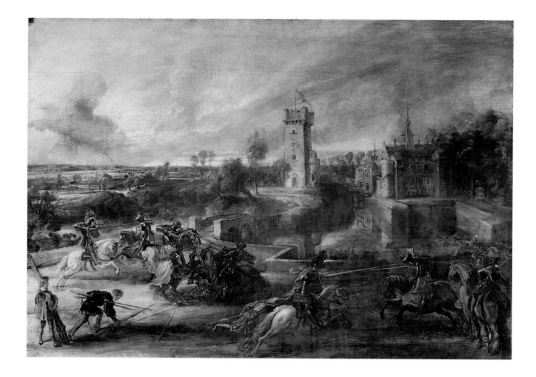

66. *Tournament in front of a Castle, c.*1636
Oil on panel, 72.5 × 106 cm
Paris, Musée du Louvre

by a dramatic red sunset. Het Steen has been transformed in the artist's imagination: all that is recognisable is the entrance archway and the bridge across the moat. In every other respect Rubens has 'medievalised' his house: the painting is a vision of the Middle Ages created by a historically minded artist of the seventeenth century.

The *Landscape with Het Steen* remained in Rubens's possession. It is number 135 in the *Specification* made in 1640 to advertise for sale the works of art he owned at the time of his death: 'un grand paysage au naturel avec des petites figures, sur fond de bois' or in its contemporary English version, ' A great Landschap after the life, with littel figures in't uppon a bord'.[92] (It may be thought surprising that the view is not identified, but such lack of detail is not unusual in inventories of this period.) The following item, number 136, is: 'Un grand paysage avec une pluye', or 'A great Landschap where it raines with little Cowes in it'.[93] These two large landscapes were still together in Palazzo Balbi in Genoa in 1758 and were sold as a pair to James Irvine and Arthur Camperdowne, agents of the British art dealer William Buchanan, in 1802.[94] They were both brought to England and the *Landscape with Het Steen* was acquired by Sir George Beaumont in 1803; twenty years later he presented it to the nation for the proposed National Gallery. The second painting, the *Landscape with a Rainbow* (Plate 59), passed through several British collections before being given by the 3rd Marquess of Hertford to his son, Sir Richard Wallace. Wallace's widow bequeathed the painting as part of the Wallace Collection to the nation in 1900. It was in this way that the two greatest landscapes painted by Rubens came to rest, after spending many years in Italy, within a mile of one another in central London. Unfortunately the terms of Lady Wallace's will do not permit the loan of *Landscape with a Rainbow* for public exhibition outside the Wallace Collection, so the two pictures cannot be hung together.

The *Landscape with a Rainbow* lacks any specific topographical features:[95] there are a few, unidentifiable buildings in the distance on the left-hand side. However, there can

be no doubt that this is the flat, wooded landscape of Brabant. The time of year is late summer – the harvest is being gathered in – and the time of day is late afternoon. The sun is hidden by clouds but it is low in the sky in the west. In the foreground a bare-foot milkmaid with a brass pitcher on her head returns from the fields with two companions. The driver of a hay wagon calls out a greeting, while behind him other hay wagons are being loaded. In the centre the cattle are being driven home and ducks are enjoying the last warmth of the sun. The whole scene is dominated by a broad, iridescent rainbow which arches from the extensive plain on the left to the dark wood on the right.

There can be no doubt that the *Landscape with Het Steen* and the *Landscape with a Rainbow* are a pair. Not only are they recorded together throughout the seventeenth and eighteenth centuries but they are almost identical in size: the *Het Steen* is 131.2 × 229.2 cm, while the *Landscape with a Rainbow* is 135.5 × 233.5 cm.

One of the first questions to arise is how these large paintings were displayed and where. It has been suggested that they were hung on a single long wall with *Het Steen* on the left and the *Landscape with a Rainbow* on the right. This would at first sight seem to present a satisfactory whole, with the house on the far left balanced by the dark wood of the *Landscape with a Rainbow* on the right and a continuous landscape in the centre. In November 1995 the *Landscape with a Rainbow* made a short visit to the National Gallery for conservation treatment and technical photography which provided an opportunity to try this arrangement. When this was done, it became obvious that the central landscape, though at about the same height in both paintings, is *not* continuous and the compositions do *not* balance. In particular, the diagonal in the *Landscape with a Rainbow* created by the edge of the field of corn and the track alongside it has the effect of leading the eye away from *Het Steen* rather than towards it.

However, an even more important objection to this arrangement came to light when the paintings were brought together. In *Het Steen* the sun rises in the east – that is, on the right side of the painting – throwing shadows towards the left. It is, for example, in this shadow that the hunter waits for his chance to surprise the partridges. In the *Landscape with a Rainbow* the sun is in the west, throwing shadows to the right, as can be seen in the trees in the middle ground on the left and the figures and animals in the foreground. *Het Steen* shows early morning and the *Landscape with a Rainbow* late after-noon. A far more satisfactory way in which to display these two large paintings would be on facing walls, so that the viewer would have the impression of the sun moving from the right-hand side of *Het Steen* across the room to the left-hand side of the *Landscape with a Rainbow*. If the two paintings originally hung together, we may imag-ine them being in a room with a window in the end wall so that the sun would have fallen on *Het Steen* in the morning and on the *Landscape with a Rainbow* in the afternoon, imitating its position in the paintings.

Sadly we have no record of the location of the two paintings during Rubens's life-time. Although the *Specification* lists paintings 'trouvées à la maison mortuaire du feu Messire Pierre Paul Rubens...' (in the English version, 'Pictures found in the howse of the late Sr Peter Paul Rubens..', that is, the house in Antwerp),[96] the sheer quantity – there are 314 numbered items – suggests that they were also hung at his other princi-pal residence, Het Steen.

At first, it might be thought that Rubens would have hung the *Landscape with Het*

*Steen* and the *Landscape with a Rainbow* in Antwerp in order to remind himself of the beauty of his country estate. There are, however, three reasons why it is more likely that the paintings hung at Het Steen. In the first place, it seems that in 1645 *Landscape with Het Steen* was hanging at Het Steen and the *Landscape with a Rainbow* was in his son Albert Rubens's house in Brussels.[97] Rubens's widow, Hélène Fourment, could have moved the *Het Steen* from Antwerp but there is no reason to think that she did. Secondly, it is very difficult to imagine where these two large landscapes could have hung in the Antwerp house which is essentially a late medieval house with many small rooms whose short walls are pierced by small windows. They could only have hung in the 'Pantheon', which was designed for the display of antique sculpture, or the studio, which was a practical space into which the current commissions, often on a very large scale, had to be fitted. Finally, the display of the two landscapes at Het Steen would accord with a classical and Italian tradition of estate views hung in the country house. That classical villas were decorated with such views was well-known in the Renaissance and this provided the inspiration for many similar depictions of the surrounding land-scape.[98] Outstanding examples include the frescoed views at Villa Farnese at Caprarola and Villa Maser in the Veneto. Rubens would certainly have known of this tradition.

Support for the idea that Rubens painted the two landscapes to hang at Het Steen would come from the identification of a room or rooms in the house large enough to accommodate them. Unfortunately, the house was so substantially rebuilt in the nine-teenth century that the original ground-plan can no longer be recreated and no early plan seems to have survived.[99] Indeed, while there are detailed seventeenth-century engravings of De Marselaer's house at Perck and many other *lusthoven*, the only known view of Het Steen in the seventeenth century is the painting in the National Gallery. However, in view of the size of the house, which is far larger than Rubens's town house, it seems likely that the paintings could have been displayed in a ground or first-floor room. If this hypothesis is correct, Rubens could have surveyed his property there with considerable pride. He had acquired the estate as a result of many years of hard work. It should be remembered that Rubens was not a precocious genius like his former assistant Anthony van Dyck, whose success came swiftly and almost effortlessly. Van Dyck had established an independent studio at sixteen, joined Rubens as his prin-cipal assistant at eighteen or nineteen, was spotted by the Earl of Arundel's secretary as a rising star at twenty and was in England working for the King at twenty-one. Rubens, by contrast, had to study long and hard in order to develop and refine his great natural gifts. His earliest paintings are often tentative and even clumsy, and it is only towards the end of his stay in Italy, when he was already almost thirty, that Rubens's true stature became apparent.

Rubens took particular pleasure in his subsequent success, both social and financial. His fierce desire to rebuild the family fortunes after the disaster of his father's flight from Antwerp and subsequent imprisonment in Siegen is a key thread which runs through Rubens's career and cannot be overemphasised as a motivating force behind his driving ambition. Rubens wanted to re-establish the position of the Rubens family among the leading families of Antwerp and lay a lasting basis of wealth for succeeding generations. He was always a very careful business man. Acutely conscious of the unreliability of aristocratic patrons after his unsatisfactory period of service with the Gonzaga, he would not, for example, release the canvases for the Banqueting House in London from his

67. Detail of *Landscape with a Rainbow* (Plate 59)

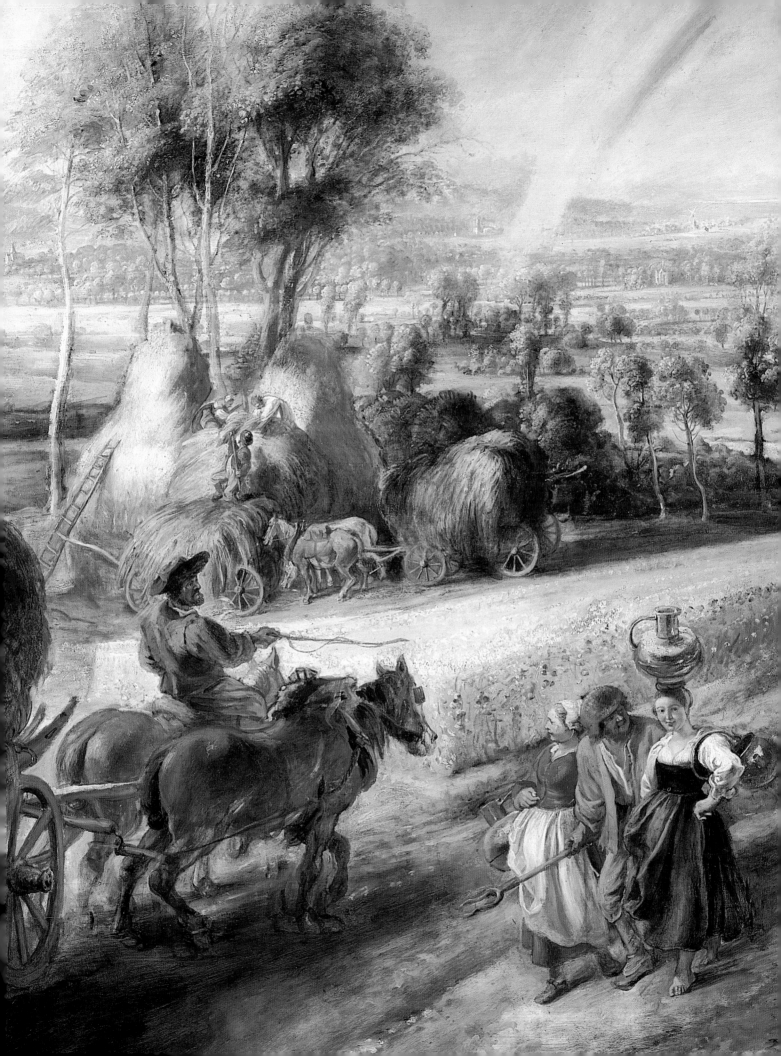

Antwerp studio until he had been paid by Charles I. Rubens was well aware of the revenues to be earned from prints made after his compositions and made great efforts to control the privileges or copyrights. In 1618 Rubens negotiated the exchange of a group of paintings by himself and his studio for a collection of classical sculpture assembled in Venice by Sir Dudley Carleton, the British Ambassador in The Hague. The correspondence survives and Rubens can be seen as a hard-headed businessman, who appears to have got the better of the deal. He sold much of his collection to the Duke of Buckingham in 1626 for the enormous sum of 100,000 guilders and then planned to go to Italy to buy more classical sculpture. According to Philippe Chifflet, the Archduchess's chaplain, 'Rubens only wishes to buy them [the sculptures] in order to sell them at a profit'.[100]

Looking at Rubens's tomb in the Sint Jakobskerk on which his lordship of Steen is recorded so prominently alongside the honours accorded to him by the Archdukes and the Kings of England and Spain, we might reasonably conclude that he aspired to an aristocratic style of life and that his purchase of a country estate was part of that aspiration. But in fact, Rubens always remained a member of the *haute bourgeoisie* of Antwerp. His father had been an alderman (*schepen*) of the city from 1562 until 1568, his beloved brother Philip had held one of the most important posts in the municipal administration and his closest friends, Jan Woverius, Gaspar Gevartius and Balthasar Moretus, were drawn from Antwerp's intelligentsia. Although he was appointed a court artist shortly after his return from Italy, Rubens did not move to Brussels, maintaining both a physical and a psychological distance from the court. He was deeply attached to the Archduchess Isabella, who commanded his respect and affection, and for whom he created one of his greatest and most sophisticated religious works, the designs for the *Triumph of the Eucharist* tapestries, which the Archduchess presented to the nunnery of the Descalzas Reales in Madrid. He also admired individual aristocrats like the Genoese nobleman Ambrogio Spinola, who was a general in the service of Spain. However, unlike his near-contemporaries Van Dyck and Velázquez, he did not have a burning desire to emulate all aspects of the aristocratic style of life. When the leading Flemish nobleman, the Duke of Aerschot, criticised the Archduchess's employment of a mere painter, a man who earned his living by the work of his hands, as an emissary to the courts of Madrid and London, Rubens was exasperated rather than distressed.[101] What he wanted above anything else was peace for his war-torn country and he considered it a tiresome distraction that questions of aristocratic precedence should impede the peace negotiations.

Rubens's clearest statement of his commitment to the bourgeois life of Antwerp was made in the letter he wrote to Peiresc on 18 December 1634.[102] He said that it was with the greatest difficulty that he had obtained his release from diplomatic service from the Archduchess:

> Since that time I have no longer taken any part in the affairs of France, and I have never regretted this decision. Now, by God's grace, as you have learned from M. Picquery, I am leading a quiet life with my wife and children, and have no pretension in the world other than to live in peace.
>
> I made up my mind to marry again, since I was not yet inclined to live the abstinent life of the celibate, thinking that, if we must give the first place to continence, *fruimur licita voluptate cum gratiarum actione* [we may enjoy legitimate pleasures with thankfulness]. I have taken a young wife of honest but middle-class family,

although everyone tried to persuade me to make a Court marriage. But I feared *commune illud nobilitatis malum superbiam praesertim in illo sexu* [Pride, that inherent vice of the nobility, particularly in that sex],[103] and that is why I chose one who would not blush to see me take my brushes in hand. And to tell the truth, it would have been hard for me to exchange the priceless treasure of liberty for the embraces of an old woman.

Rubens's purchase of a country estate was not an attempt to ape the aristocratic style of life, but rather a logical development in his prosperous bourgeois life in Antwerp.[104] Before he developed crippling gout in his last years, Rubens walked and rode over his land at Elewijt but, as far as we know, never indulged in that *sine qua non* of aristocratic life, the hunt. He was happy to supply hunting scenes to his aristocratic patrons and in these paintings to dramatise and even heroicise their dangerous sport, but he had no desire to emulate them. Rather Rubens took real pleasure in the life of the country and its people, in the changing seasons of the year, in the gathering in of the harvest and in country festivals. In his *Peasant Dance* (Plate 68) he observes country people not from the feudal or patronising perspective of the aristocrat, as in Jan Brueghel's scenes of Albert and Isabella's attendance at country festivities, nor with the objectivity of the impartial outsider, but with a simple, immediate and infectious pleasure in the rituals and celebrations of country life. It might be objected that Rubens's view of country life was unduly rosy and it is certainly true that his country people, though often barefoot, are well-fed and smiling. He does not show poverty, famine and disease. His is undoubtedly a wealthy town-dweller's view of the countryside and its inhabitants. And yet the countryside of Brabant *was* rich and prosperous, the envy of English travellers of the period,[105] and the historical evidence suggests that the period after the

68. *The Peasant Dance, c.*1635–8
Oil on oak, 149 × 261 cm
Paris, Musée du Louvre

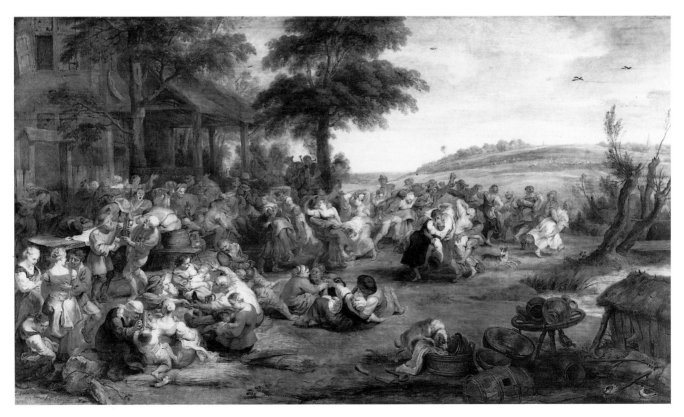

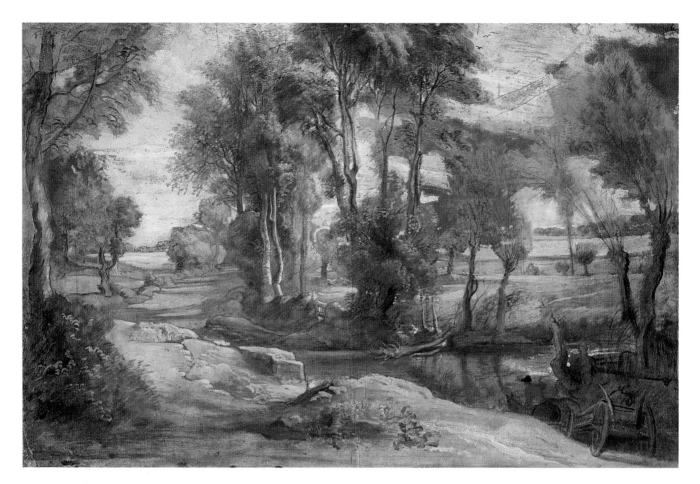

declaration of the Twelve Years' Truce was one of steady reconstruction and gradually increasing agricultural yields.[106]

69. *A Wagon fording a Stream,* c.1635
Black chalk and oil on paper stuck on canvas, 47 × 70.5 cm
London, National Gallery

Rubens moved into Het Steen in November 1635 and died in Antwerp on 30 May 1640 and so enjoyed its pleasures for less than five years. During those years, as his second family grew and he was troubled by gout and arthritis, Rubens chose to spend more and more time at Het Steen. Its beauty and calm gave him great comfort in his last years.

At about the same time as Rubens painted his monumental landscapes of his estate of Het Steen, he returned to the subject of a wagon negotiating its way down a steep slope which he had first treated in the *Landscape with a Cart crossing a Ford* (Plate 44) almost twenty years earlier. At that time he was fascinated by the great fissured rock which looms up above the human predicament. In the mid-1630s, by contrast, he places the wagon and its driver in an expansive Brabant landscape. He painted two versions of this composition at this time. The first, which is in the National Gallery, was sketched in black chalk on paper and then gone over in oil paint (Plate 69). It is in a horizontal landscape format. The second, which is in the Museum Boymans-van Beuningen in Rotterdam (Plate 70), was painted in an upright format in oil on a single oak panel stamped with the mark of the panelmaker Michiel Vriendt and branded with the arms of Antwerp. In view of the evident care with which the second landscape is made, it is likely that the version on paper is, despite the different format, a preparatory sketch for it.

The landscape is undoubtedly that of the area around Het Steen and the bold, direct touches of the brush used, for example, in the treatment of the trees on the right of the Rotterdam painting are very similar to those in *Landscape with Het Steen*. The foreground is broadly brushed in, but Rubens lingers to touch in the details of the studs on the wagon's wheels. The time of day is sunset with the sun seen through the trees, illuminating leaves, branches and tree-trunks, and causing the wooden gate to throw long shadows across the river bank.

One of the most beautiful of all Rubens's small landscapes is the *Forest at Dawn with a Deer Hunt* (Plate 71) recently acquired by the Metropolitan Museum of Art in New York.[107] Its style places it in the mid-1630s. This small panel is a study of sunlight bursting through the darkness and dank gloom of the forest and irradiating the trees, the

70. *Landscape with a Wagon at Sunset, c.*1635
Oil on panel, 49.5 × 54.7 cm
Rotterdam, Museum
Boymans-van Beuningen

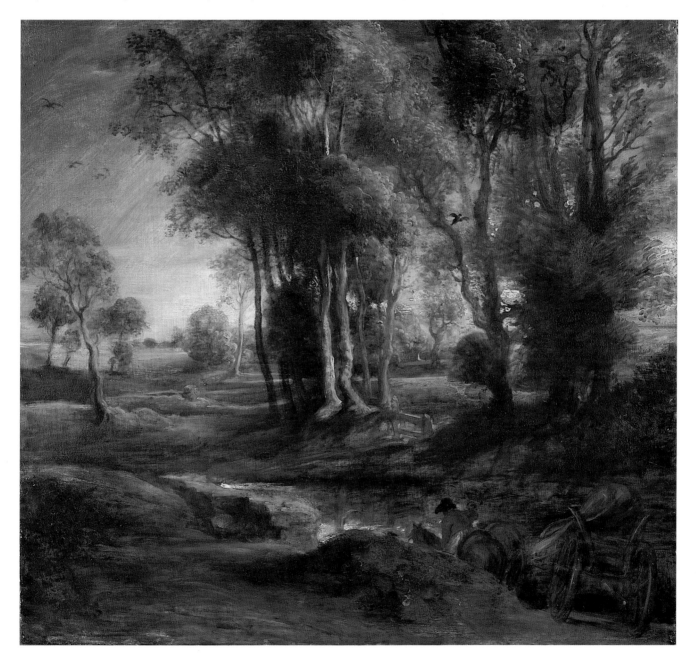

forest floor as well as the huntsman, his dogs and the fleeing deer. It is an intensely observed moment, captured with an absolute immediacy and sureness of touch. A comparison with the engraving made after the painting by Schelte à Bolswert points up the difficulty of reproducing the glistening highlights and the dabs and whorls of the paint in any other medium.

The *Landscape with Moon and Stars* (Plate 72)[108] is also intensely atmospheric. It shows a wood beside a meandering river: a horse drinks at the water's edge. It is night and the sky is dotted with stars which are dabs of pure yellow pigment. The moon is reflected in the surface of the water. Originally, as can be seen clearly in the X-ray photograph, there was a group of figures seated beneath the largest tree in the centre of the foreground. They were painted out by Rubens himself.

In painting a night-time landscape Rubens is returning – in 1637 or 1638 – to his intense admiration for Elsheimer: the nocturnal sky is based on that of the *Flight into Egypt* (Plate 22). Rubens also reveals his familiarity with the work of Adriaen Brouwer, the Antwerp painter of genre scenes and landscapes, whose paintings Rubens collected. Rubens owned a moonlit landscape by Brouwer, which may be the painting today in Berlin (Plate 73).[109] The freedom of Rubens's brushwork, the bold highlights, the reflections in water and the subtle differentiation of tones of brown and black are all features of Brouwer's nocturnal landscapes which Rubens admired.

71. *A Forest at Dawn with a Deer Hunt, c.*1635
Oil on panel, 61.6 × 90.2 cm
New York, Metropolitan Museum of Art

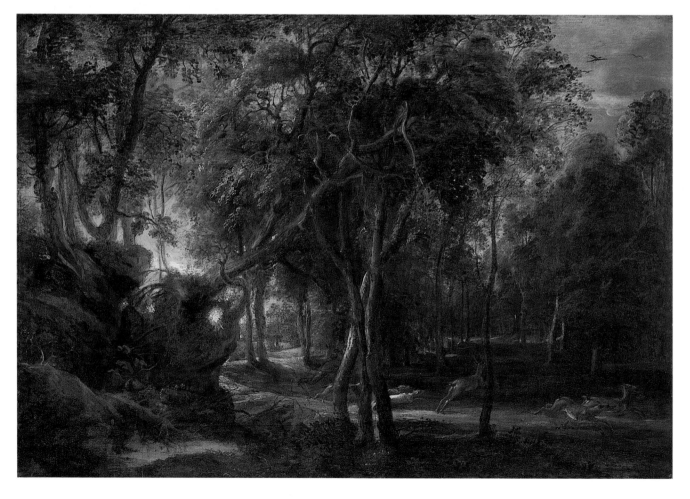

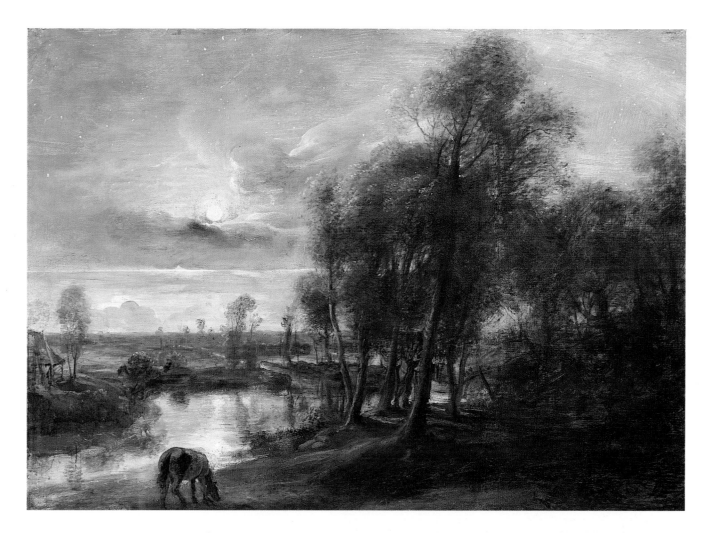

72. *Landscape with Moon and Stars, c.*1637-8
Oil on panel, 64 × 90 cm
London, Courtauld Institute
Galleries, Princes Gate
Collection

73. Adriaen Brouwer, *Dune Landscape by Moonlight, .*1635-7
Oil on oak, 25 × 34 cm
Berlin, Staatliche Museen,
Gemäldegalerie
This may be the moonlit
landscape by Brouwer which
was no. 288 in the *Specification*.

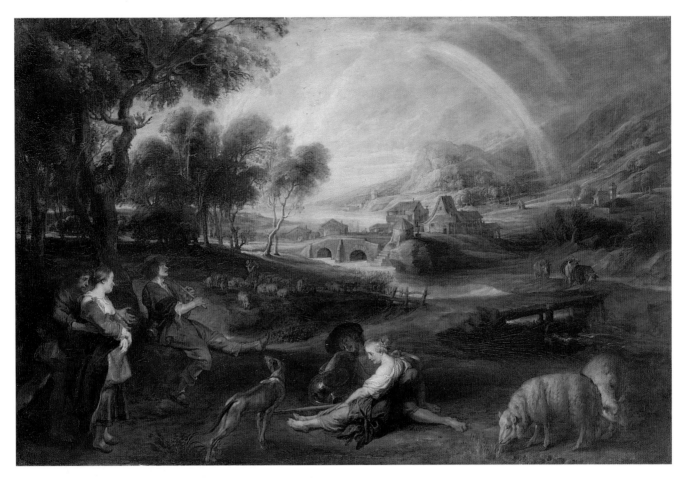

74. *Pastoral Landscape with Rainbow, c.1635.*   Oil on canvas, transferred from panel, 81 × 129 cm
St Petersburg, The State Hermitage Museum

## CHAPTER 6
# The Pastoral Landscapes

RUBENS PAINTED a number of distinct landscape types: generalised Flemish landscapes, which are loosely based on the landscape of his own country but render it in a idealised fashion; landscapes with hunts; landscapes with mythological figures; and landscapes based firmly on the countryside of Brabant, which he knew well and loved. There is also a small group of landscapes painted in the 1630s which follows the well-established convention of pastoral landscape.

Rubens's pastoral landscapes belong to a long tradition in which artists sought to evoke the poetic idylls of Virgil. Virgil's *Eclogues* are set in Arcadia, the home of love and song, a countryside in which shepherds sing of their lovers and accompany themselves on pipes. The First Eclogue opens with a beautiful speech:[110] 'You, Tityrus, are practising rustic music on your Pan-pipe, stretched out beneath a spreading beech; I am leaving my country and the fields I love, I am in flight from my country – while you, Tityrus, at ease in the shade, are making the woods resound to your love for Amaryllis.' Virgil concludes the *Eclogues* with the setting of the sun, which brings a natural end to the song of the shepherd, who has sat with his sheep until it is time to return home with them.

*75. Shepherd and Shepherdess*
Pen and brown ink and wash, over black chalk, 27.1 × 35.8 cm
Paris, Institut Néerlandais
A study for the seated shepherd on the left in *Pastoral Landscape with Rainbow*
(Plate 74)

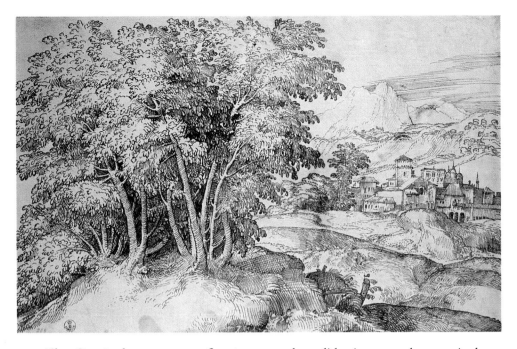

76. Domenico Campagnola,
*Landscape with Wooded Slope
and Buildings*
Pen and brown ink on paper,
22.5 × 35 cm
Florence, Gabinetto Disegni e
Stampe degli Uffizi

The *Georgics*, by contrast, at first appears to be a didactic poem about agriculture and begins with a description of tools and farming equipment. Virgil praises the hard work of the countryman, the simple virtue of his life and the timelessness of his occupations. The fourth and final book of the *Georgics* closes with the poet comparing this idyllic world with the actual world of the Roman civil war and the triumph of Octavian, later Caesar Augustus:[111]

> This song of the husbandry of crops and beasts
> And fruit-trees I was singing while great Caesar
> Was thundering beside the deep Euphrates
> In war, victoriously for grateful peoples
> Appointing laws and setting his course for Heaven.
> I, Virgil, at that time lay in the lap
> Of sweet Parthenope, enjoying there
> The studies of inglorious ease, who once
> Dallied in pastoral verse and with youth's boldness
> Sang of you, Tityrus, lazing under a beech-tree.

Virgil's great pastoral poems found frequent echoes in literature and art. In Venice in the years around 1500 Giorgione and Titian, followed by Giulio and Domenico Campagnola (Plate 76), created a particularly effective and influential evocation of Virgil's rural idyll. Theirs was a more erotically charged world in which, in its most famous example, the *Concert Champêtre* in the Louvre (Plate 77), painted in Venice in about 1510 and attributed both to Giorgione and to Titian, musicians sit with naked girls in a landscape in which a shepherd can be seen with his flock.

There are intriguing analogies between the lives of Virgil and Rubens. Virgil's father had been evicted from his property after the battle of Philippi – just as Rubens's father had been forced to leave Antwerp – and it was only after Virgil's appeal to Pollio and Octavian that the farm was returned to him. The *Georgics* praise the future Augustus and his supporters for ending the long civil war, encouraging the agricultural revival of

Italy and promoting the old religion. It is impossible to be sure that Rubens was struck by similarities between Virgil's praise of Octavian and his own support for Albert and Isabella, but he was a careful and thoughtful reader and it is unlikely that they passed him by. Certainly Rubens's landscapes are all to a greater or lesser degree permeated by the spirit of the *Georgics* whose central message is 'work, and honour nature and the gods'.[112]

Rubens, whose knowledge both of Venetian painting and of classical literature was profound, was fascinated by this pastoral world and painted his own evocation of it which is deeply indebted to the Venetians. In his *Pastoral Landscape with Rainbow* (Plate 74), which was probably painted in the mid-1630s, Rubens shows shepherds and shepherdesses listening to one of their number play the flute in a landscape dotted with sheep and cattle. In the middle ground is a group of picturesque farm buildings beside a bridge taken from a print by Domenico Campagnola,[113] while beyond is a range of hills, more like the foothills of the Dolomites as seen by Titian than anything in Rubens's topographical landscapes. The whole scene is dominated by a rainbow whose sudden appearance has caused the flute-playing shepherd to look up and pause momentarily in his music-making. There is a lively pen drawing for the figures of the flute player and a shepherdess (Plate 75) on which Rubens has written 'met een groot slegt lantschap' (with a large, flat landscape).

The *Pastoral Landscape with a Rainbow* seems to have been considered by Rubens to have been in a different category from the other landscapes. He did not keep it in his own collection and it is known to have been owned by an Antwerp merchant in 1654. A second version with slight variations was painted (on canvas) by Rubens with considerable assistance from members of his studio: this picture (Plate 78) entered Louis XIV's collection before 1683.[114]

77. Giorgione (or Titian),
*Concert Champêtre,* c.1510
Oil on canvas, 105 × 136.5 cm
Paris, Musée du Louvre

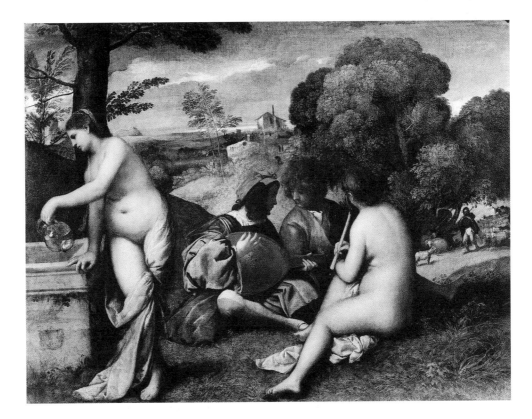

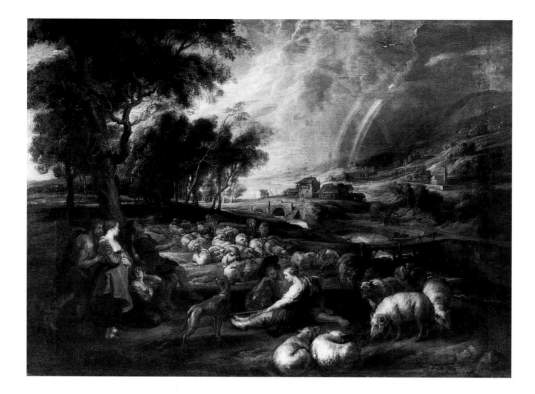

78. Rubens and his workshop, *Pastoral Landscape with Rainbow*, c.1635
Oil on canvas, 123 × 172 cm
Valenciennes, Musée des Beaux-Arts (on loan from the Musée du Louvre)

In the *Sunset Landscape with a Shepherd and his Flock* (Plate 79), one of the very last pictures painted by Rubens, he drew together the two strands of Brabant and pastoral landscape. The setting is unmistakably Brabant: it is the familiar meadow landscape dotted with trees and criss-crossed by streams. There is a small, bold oil sketch in the Ashmolean Museum, Oxford (Plate 80), which shows the same landscape and it has been suggested that it is a sketch for the painting, which seems very likely. The house with its stepped gable and onion spire is certainly not Het Steen but it is not unlike one of the nearby manor houses such as the Castle of Ribaucourt, close to De Marselaer's house at Perck, which had a hexagonal tower with a bulbed spire.[115] The *Sunset Landscape with a Shepherd and his Flock* could have been a gift to the neighbour, whose house is shown on the right, and Rubens might well have made a rough sketch in order to establish the main features of the composition which he then developed and refined. In the Oxford painting the house is very freely drawn, without any architectural detail, whereas the roofs and towers of the house and church are precisely described in the finished painting.

In the foreground of the *Sunset Landscape with a Shepherd and his Flock* a shepherd plays his pipe in the evening sunlight. It is an image of great simplicity and contentment, an image which seems to reflect the peace and happiness which Rubens found in his last years with Hélène Fourment and their young children at Het Steen. In a letter of 17 August 1638 Rubens wrote from Het Steen to his assistant and friend Lucas Fayd'herbe in Antwerp asking him to send or bring a picture on panel,[116] a clear indication that he was still working despite his gout. In October, however, he fell seriously ill, the beginning of a long and debilitating sickness, which ended in his death on 30 May 1640.

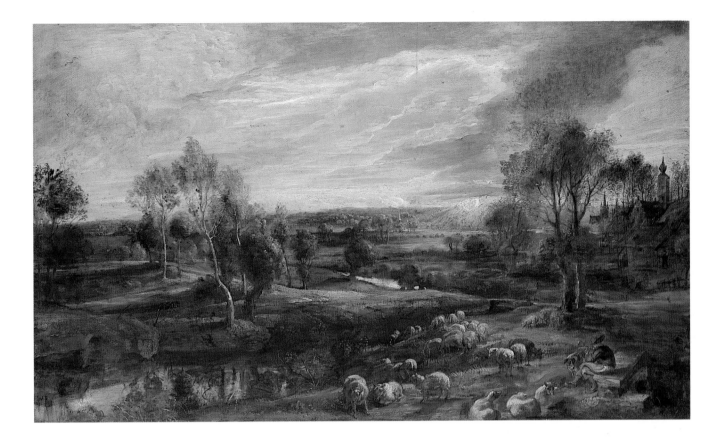

79. *Sunset Landscape with a Shepherd and his Flock*, c.1638
Oil on oak, 49.4 × 83.5 cm
London, National Gallery

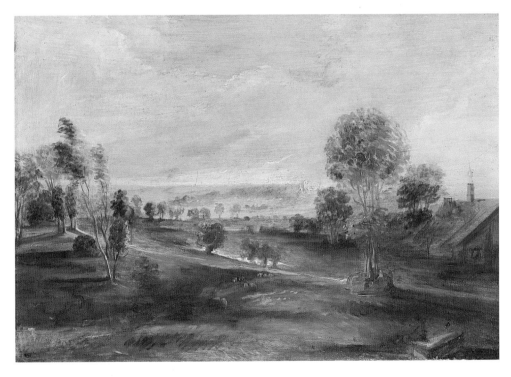

80. *Landscape with Farm Buildings at Sunset*, c.1638
Oil on panel, 27 × 39 cm
Oxford, Ashmolean Museum

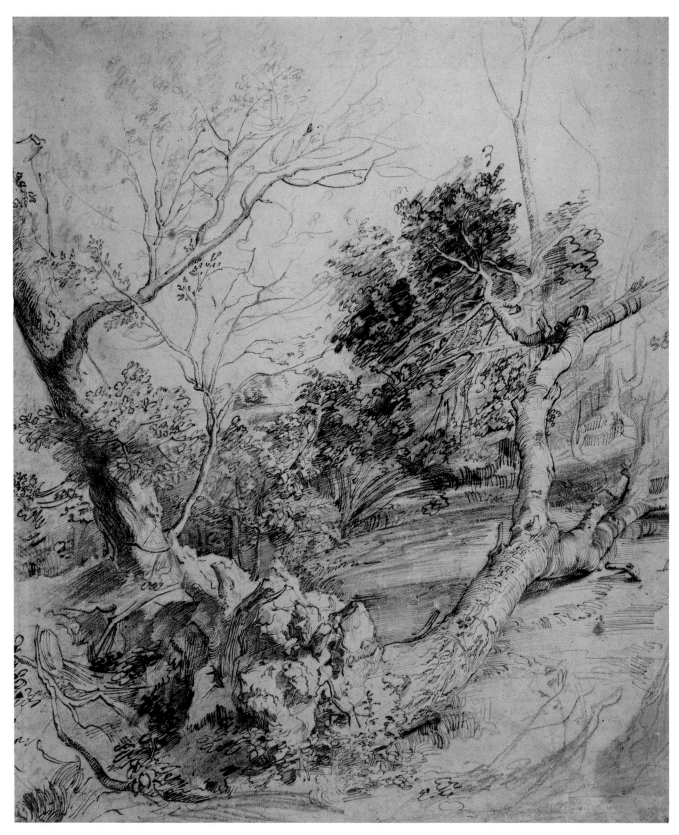

81. *Study of a Tree, c.*1615. Pen and wash on paper, 60 × 50.1 cm. Paris, Musée du Louvre
A study for the tree on the left-hand side of *Landscape with a Boar Hunt* (Plate 82)

## CHAPTER 7
# Drawings and Oil Sketches

RUBENS'S USUAL PROCEDURE when painting scenes from the Bible or classical literature was to make a compositional drawing in pen, studies for individual figures in black chalk and then a sketch of the whole composition in oil on a small oak panel, which would be shown to the patron for approval. Once this had been given, Rubens would begin the full-size canvas or panel. Because of their private character, this was not his procedure when painting landscapes.

Few of the drawings or oil sketches of landscape by Rubens which are known today relate directly to paintings. There *may* have been large compositional drawings for the *Landscape with Het Steen* and the *Landscape with a Rainbow* but it is equally likely that such a mature and experienced artist could paint these scenes without needing to work out the composition on paper first. The fact that Rubens made preliminary drawings only rarely may be one reason why some of the paintings have such complex constructions. What does survive is a small group of drawings made from nature. These are drawings of individual motifs – trees, bushes, a pathway – which were then used in an adapted form for paintings. A few of the oil sketches are preparatory to paintings and

82. *Landscape with a Boar Hunt, c.*1616-18
Oil on panel, 137 × 168.5 cm
Dresden, Gemäldegalerie Alte Meister

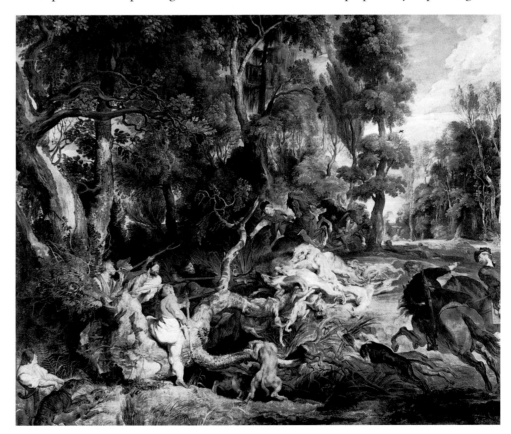

this may be the relationship between the Oxford sketch (Plate 80) and the *Sunset Landscape with a Shepherd and his Flock* (Plate 79), and also that between the sketch of *A Wagon fording a Stream* (Plate 69) and the painting of the same subject in Rotterdam (Plate 70). In that case Rubens must have wished to work out the composition on paper before starting to paint the panel, or he may have abandoned a first version. With two or three exceptions, however, the landscape sketches should probably be considered simply as small paintings executed quickly and in a bold manner. Many are instinctual responses to the beauty of the landscape of Flanders and Brabant.

Only twelve drawings from nature by Rubens are known; and in view of the fact that other types of drawing – drawings after the antique, figure studies, compositional sketches – have survived in far greater numbers, it is reasonable to assume that Rubens made relatively few studies from nature. Unlike Rembrandt, for instance, who deliberately set out on walks in search of motifs to record in his sketchbook, Rubens was occasionally struck by certain details in nature as he walked or rode through the countryside – a tree or group of trees, a pathway, a wattle fence – of which he made a quick sketch. He may well have been looking out for particular natural phenomena that related to painted landscapes which he knew: the *Trees reflected in Water* (Plate 90) recalls one of Elsheimer's imposing screens of trees, but observed from nature. The finding of motifs in nature which were known to him in paintings is reminiscent of his practice of putting models in poses taken from antique sculpture. Sometimes Rubens must have noted a particular feature of the landscape with a view to incorporating it in a painting he was planning. What is important to remember is that Rubens did not bring an even remotely 'innocent eye' to the countryside of Flanders and Brabant. He brought a very sophisticated and highly trained eye which caused him to pick and choose individual landscape motifs, often for very particular reasons. We should not imagine him wandering through the Flemish countryside, sketchbook in hand, waiting for inspiration to strike.

The few contemporary theoretical discussions in the Netherlands about how a landscape should be painted clearly recommend that having made drawings from nature, the artist should return to the studio and construct a landscape which incorpo-

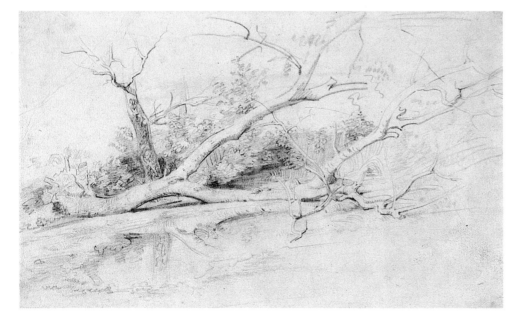

83. *Study of a Fallen Tree,*
*c.*1615
Black chalk with slight touches of watercolour on paper,
18.4 × 30.9 cm
Chatsworth, Devonshire
Collection

84. *Tree-trunk and Brambles,*
*c.*1615
Red, blue and black chalk,
pen and brown ink and water-
colour on paper, 35.2 × 29.8 cm
Chatsworth, Devonshire
Collection

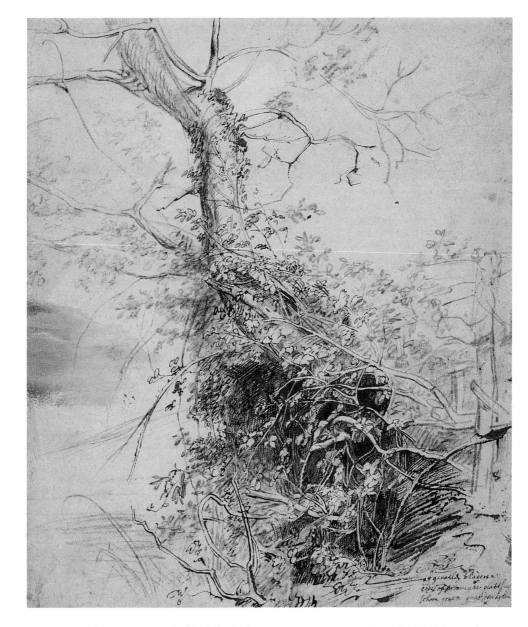

rated these features.[117] Indeed, the ideal was to create a complete *denkbeeld* – an image
in the mind – of the finished landscape painting before laying a brush on the panel or
canvas. Landscape paintings should never be made in the open air but in the studio, and
they should be elaborately planned in the mind of the artist rather than being created
on the panel or canvas, with his ideas developing and changing as the work progressed.
There was never any question that they should be a literal transcription of an actual
landscape. This manner of working, which may seem unfamiliar or even unduly calcu-
lating to a post-Romantic sensibility, was common to all Flemish painters of this period.

In the Southern Netherlands, landscape paintings, just as much as altarpieces and
portraits, were constructed according to compositional and colour formulae which had
been established by tradition. Even Rubens himself was severely constrained by these
traditional formulae. Consciousness of the great sixteenth-century landscape tradition
of Patinir and Bruegel bred a reluctance to attempt radical experiment. In terms of the

future development of landscape painting, far more innovative ideas were being explored in the North Netherlands, and in particular in Haarlem in the 1610s and 1620s when a group of young Dutch painters and printmakers forged a new landscape style based on the direct observation of nature.[118] Their experimentation was to culminate in the achievement of the greatest Dutch landscape painter, Jacob van Ruisdael, whose intense and dramatic scenes make Rubens's landscapes, for all their beauty and vigour, seem overly dependent on long-established conventions.

In about 1615 Rubens made a drawing in black chalk, which he subsequently went over in pen, of a fallen copper beech whose roots cling to a rocky mound which also supports an upright, living tree (Plate 81). It is the kind of tangled mass of roots which Bruegel and Savery had favoured and which Rubens included as a prominent feature in the *Landscape with a Cart crossing a Ford* (Plate 44) and in *The Watering Place* (Plate 46). This marvellously lively and precise drawing is, in fact, a study for the tree at the centre of the *Landscape with a Boar Hunt* (Plate 82), which was probably painted shortly before the *Landscape with a Cart crossing a Ford*, that is, about 1616–18. The hunt is set in a dense

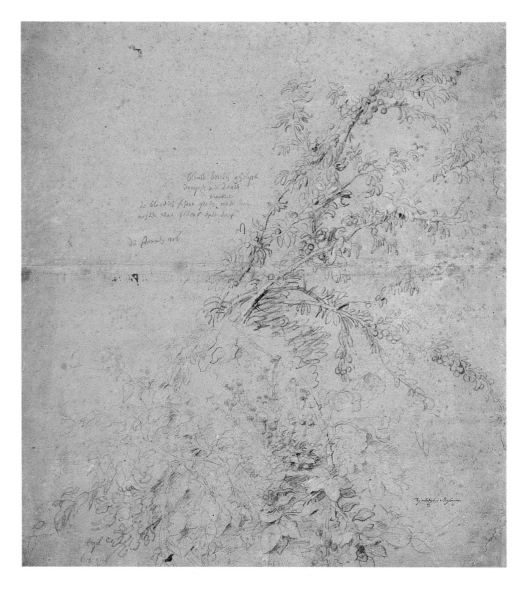

85. *Wild Cherry Tree with Brambles and Weeds, c.*1615
Black, red and white chalks and yellow watercolour on light brown paper,
54.5 × 49.5 cm
London, Courtauld Institute Galleries, Princes Gate Collection

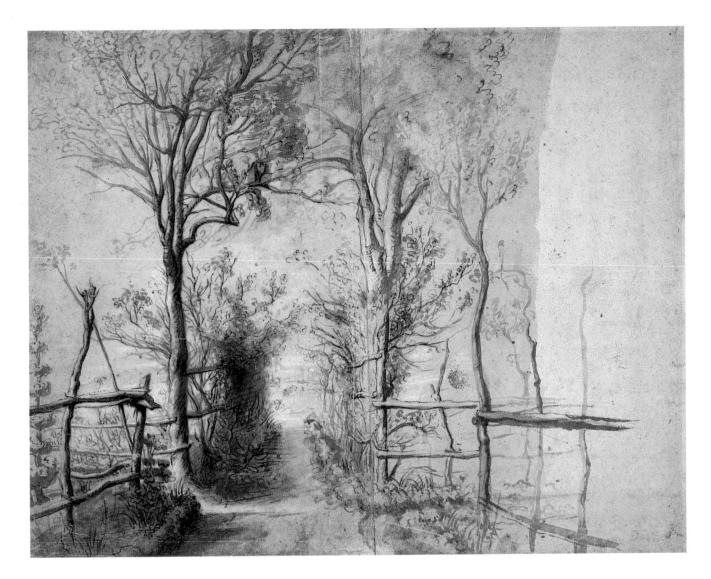

86. *Path through an Orchard,*
*c.*1615–18
Pen over black chalk on paper,
31.3 × 40.3 cm
Cambridge, Fitzwilliam
Museum

forest landscape very similar to that of *The Watering Place*. In 1615 and 1616 Rubens had painted a series of four hunting scenes for the Elector Maximilian of Bavaria, and the Dresden painting is a development of *The Boar Hunt* in that series (Marseille, Musée des Beaux-Arts) which focuses on the group of huntsmen and dogs finishing off the boar.

There is a second drawing by Rubens of a fallen tree (Plate 83), but in this case the black chalk has not been gone over in pen and the drawing is far simpler and less precise. Rubens was to use this study for the beech tree lying in the foreground of the *Landscape with Odysseus and Nausicaa* (Plate 49), a painting which dates from about 1627; the study itself seems to have been made perhaps as long as twelve years earlier. It would appear to be the same tree as in the Paris drawing seen from a different angle and so may well have been made at the same time, that is, about 1615.

Rubens's other drawings from nature cannot be closely related to painted landscapes. They are sketches made in the open air in front of the subject: on some he added descriptive and colour notes. Rubens does not seem to have made them with particular paintings in mind: they were details of nature which caught his eye and which he recorded, thinking they might be used at some time in the future. *Tree-trunk and*

*Brambles* (Plate 84) was drawn in black chalk and then worked up in detail with pen and touches of red and blue chalk. On the left Rubens added a patch of grey bodycolour. In the lower right-hand corner he inscribed in Flemish: *afgevallen bladeren ende op sommighe plaetsen schoon gruen grase door kyken* (fallen tree-trunks and in several places beautiful green grass can be seen through). Stylistically the drawing is very close to the Louvre *Study of a Tree* (Plate 81) and was presumably made at about the same time, around 1615, or even on the same occasion. A study of the same type, though this time in black, red, white and yellow chalks, is *Wild Cherry Tree with Brambles and Weeds* (Plate 85) which also has notes in Rubens's hand.[119] Similar trees can be found in various painted landscapes, for example in *Polder Landscape with Eleven Cows* (Munich, Alte Pinakothek)[120] and *Landscape with Het Steen* (Plate 58) and its pendant *Landscape with a Rainbow* (Plate 59) but in none is it reproduced precisely. The drawing was presumably kept by Rubens in his studio and referred to on several occasions. It probably dates from about 1615, at around the same time as the *Tree-trunk and Brambles*.

The *Path through an Orchard* (Plate 86), which also belongs to this early group of drawings, is a far more ambitious sheet. It was begun in black chalk but then entirely reworked in brown ink on the tip of a brush. Subsequently Rubens went over it in pen and applied brown wash. It shows a country lane over which trees are arching to form a canopy of leaves. It was not used by Rubens in any painted landscape but it does recall the leafy covered walks which Rubens created in the garden of his Antwerp house, which can be seen in the background of the view of the garden with the artist, his second wife and eldest son (Plate 52).

The bold black drawing of a pollarded willow (Plate 87) may well have been at Rubens's elbow when he painted the *Landscape with a Cart crossing a Ford* (Plate 44), in which willows line the edge of the water. Willows, a very common sight along the streams and rivers of Brabant, occur in many of Rubens's landscapes. The drawing belongs to the early group and probably dates from about 1618.

There is a second, small group of drawings which were made in the second half of the 1630s when Rubens was spending more and more time at Het Steen. They are all on large pieces of paper. The *Entrance to a Wood* (Plate 88) is drawn in black chalk with touches of red chalk and white bodycolour. It shows a path which crosses a stone bridge over a stream and continues between rows of willows. The landscape with its low-lying fields prone to flooding, criss-crossed by streams bordered by willows, is that of the area of Het Steen.

The *Landscape with a Wattle Fence* (Plate 89) shows exactly the same type of landscape and is also sketched in black chalk with a few touches of red. The third sheet in this group is the *Trees reflected in Water* (Plate 90), a delicate, almost ghostly sketch of a group of trees ranged along the water's edge. The trees and their reflections are viewed as if through a morning mist. Rubens has inscribed on the sheet: *de boomen wederscheyn in het Waeter bruynder ende veel perfecter In het Waeter als de boomen selve.* (The trees are reflected in the water browner and more perfect in the water than the trees themselves.) This is freely translated beneath in an eighteenth-century English hand, probably that of Jonathan Richardson the Elder, who owned the drawing: 'thee shadow of a tree is greatter in ye watter and more perfect than ye treess themselves, and darker.' Such a careful observation of a natural phenomenon by Rubens is intriguing: similar reflections in water can be seen in the *Landscape with Moon and Stars* (Plate 72).

87. *Pollard Willow, c.*1618
Black chalk on paper,
39.2 × 26.4 cm
London, British Museum

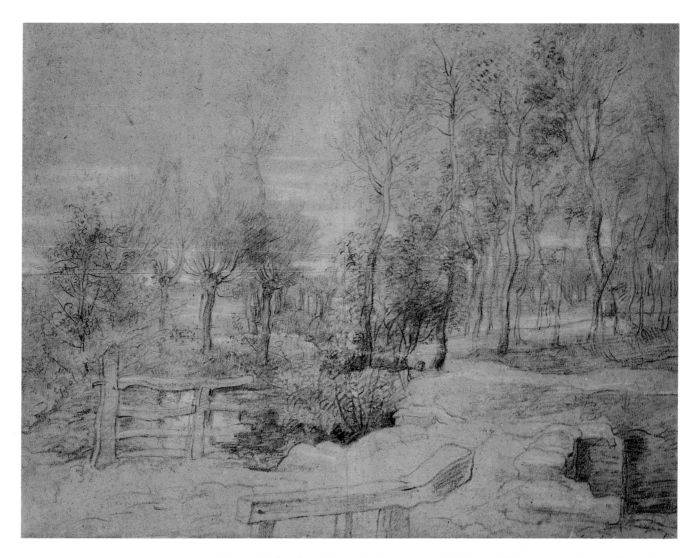

88. *Entrance to a Wood, c.*1635-8
Oiled charcoal with chalks on
paper 38.3 × 49.9 cm
Oxford, Ashmolean Museum

Two oil sketches from the last years of Rubens's life are *Landscape after a Storm* (Plate 92) and *Willows* (Plate 91). The former is painted thinly and in several places the light brown priming of the panel can be seen through the paint layer. The storm is moving off into the distance behind the trees on the right and the wood is lit by a ray of sunshine. Two women with bales of hay on their heads are walking across the field on the left. This view of a Brabant landscape glistening after a rainstorm appears to belong to the group of paintings and sketches made in the mid-1630s shortly after Rubens had bought Het Steen. *Willows* is a freshly observed oil sketch of a group of trees at the edge of a meadow, bathed in morning sunlight. Sitting between the trees with his back to the viewer is a shepherd whose sheep are grazing in the meadow. This sparkling sketch celebrates the beauty of the landscape of the region in which Rubens was to spend so much of his time in his last years.

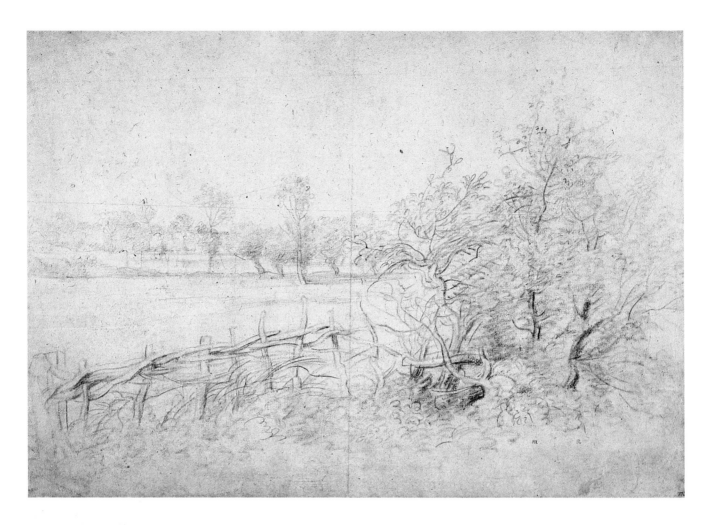

89. *Landscape with a Wattle
Fence, c.*1635–8
Black chalk on paper,
35.3 × 51.4 cm
London, British Museum

90. *Trees reflected in Water,*
*c.*1635–8
Black, red and white chalk on
paper, 27.3 × 45.4 cm
London, British Museum

91. *Willows, c.*1636
Oil on panel, 18.5 × 33.3 cm
Private Collection

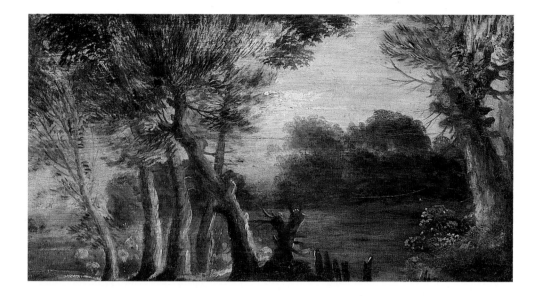

92. *Landscape after a Storm,*
*c.*1636
Oil on panel, 49 × 64.6 cm
London, Courtauld Institute
Galleries, Princes Gate
Collection

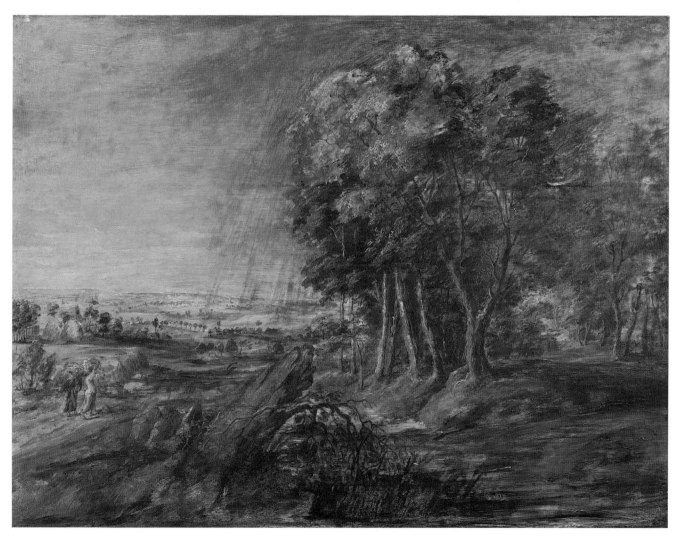

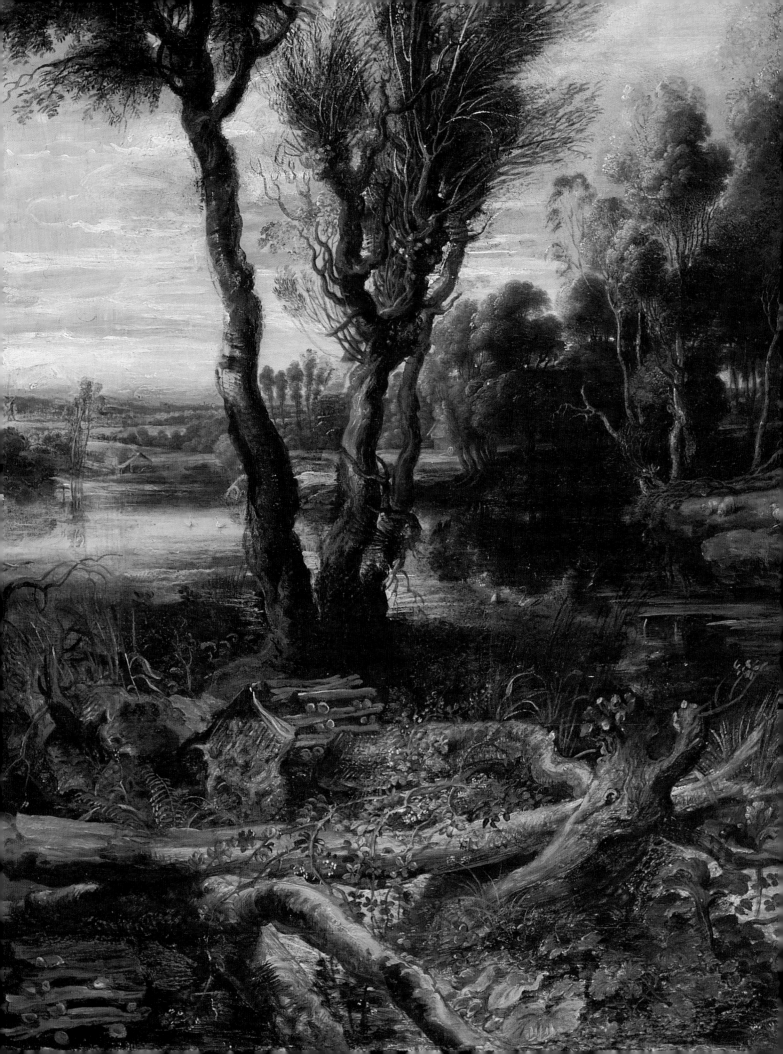

# CHAPTER 8
## The Making of the Landscapes

ALMOST ALL RUBENS'S LANDSCAPES are painted in oil on oak panels. A group of pastoral landscapes, which have been discussed above, and a small number of other landscapes such as the *Landscape with Atalanta and Meleager pursuing the Calydonian Boar* (Plate 94) are on canvas, and there are a few on paper, but these are the exceptions. Rubens conventionally used oak panels for his oil sketches and so it is not in any way surprising that he should use this support for his landscape sketches. His decision, however, to use panel for large landscapes like *The Watering Place*, *Landscape with Het Steen* and *Landscape with a Rainbow* requires explanation, because canvas was far cheaper and Rubens used it for religious and mythological paintings of this size. But the reason is not hard to find. Panel, with its smooth even surface, enabled the painter to achieve far more precise, detailed effects than on the open weave of even the finest primed canvases, and Rubens wished to have a high degree of detail and finish in his landscapes.

Traditionally, altarpieces had been painted on panel and Rubens's early master-pieces, *The Raising of the Cross* and *The Descent from the Cross*, as well as *The Assumption of the Virgin* in Antwerp Cathedral, are all on panel, but later Rubens preferred canvas for large religious and mythological works. The Marie de Médicis series, the Banqueting House ceiling and the Torre de la Parada pictures were all painted on canvas because they were large and had to be transported from Antwerp to their final destination, and because they would be seen from a distance. In his landscapes,

94. *Landscape with Atalanta and Meleager*, *c.*1635
Oil on canvas, 160 × 260 cm
Madrid, Museo del Prado

93. (opposite) Detail of *The Watering Place* (Plate 46)

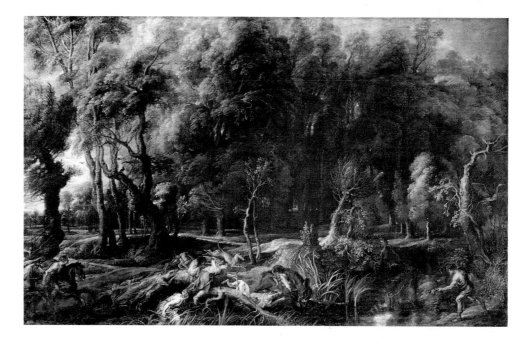

however, Rubens wished to describe details like the plants in the foreground of *Het Steen* (Plate 104) and the ducks in the foreground of the *Landscape with a Rainbow* which could not have been painted with such clarity and precision on canvas, as can be seen if we compare these passages with similar ones in *Summer* (Plate 60).

A surprising feature of Rubens's large and not-so-large landscapes painted on panel is that the oak panels themselves are made up of many individual pieces of wood. This can be seen in its most extreme form in *Het Steen* and the *Landscape with a Rainbow* which are both made up of about twenty separate pieces, but it is also seen in *The Watering Place* which is composed of eleven pieces and even in a small painting like the *Forest with a Deer Hunt* which is made up of eight. (The precise details of the make-up of these landscapes can be found in the Appendix.) Interestingly, another discrete group of paintings which are constructed in this way are the portraits of members of his family: the portrait of Rubens's first wife, Isabella Brant, in the Cleveland Museum of Art is painted on four different pieces of wood[121] and the panel of the '*Chapeau de Paille*' in the National Gallery, London (Plate 95), which is a portrait of Susanna Lunden, the sister of his second wife Hélène Fourment, and was in her husband Arnold Lunden's collection (with *The Farm at Laeken*), is composed of four individual pieces.[122] The full-length portrait of Hélène Fourment leaving the house and about to enter a waiting carriage (Paris, Louvre) also has a remarkably complicated construction.[123] These portraits, like the landscapes, were not commissioned in the conventional sense and were presumably given rather than sold to the sitters. It may be their private quality that explains the exceptional nature of the paintings' supports.

The preparation of panels for artists was a highly professional undertaking in Antwerp in the seventeenth century.[124] There was a long tradition of fine panels made for Antwerp artists by local panelmakers. The panelmakers' skills were greatly respected and they were members of the Antwerp Guild of Saint Luke alongside the artists. A panelmaker would buy timber from a timber merchant, who imported it from the Baltic: Karel van Mander writes of landscape painters using 'canvas or solid Norwegian oak panels'.[125] In fact, he was wrong about the precise source of the oak: the timber came from the area that is now Poland and the Baltic Republics and the principal town for the export of oak was Gdansk. The wood would have been seasoned for several years and then split or sawn into large planks. The panelmaker would cut it into suitable sizes for painters' panels and join the individual planks together, either to the purchaser's specifications or to create a series of standard sizes which could then be sold 'off the shelf'. He would then plane the panel so that it was smooth on the side to which the paint was to be applied. Many panelmakers were also *witters* (literally, whiteners), in other words, they also applied the whitish ground, which was made up of chalk and glue. This would provide a smooth surface for painting.

In 1617 the Antwerp Guild introduced strict new guidelines for the production of panels. The wood must be seasoned for two to five years. Only hardwood could be used and panelmakers using sap wood, which could be weaker and more prone to attack by insects, would be fined. When the panelmaker had a sufficient number of panels ready in his workshop he would ask the dean of the guild or one of the *keurmeesters* (inspectors) appointed by the dean to make a visit to inspect them. However, if he only had a few panels, he could take them to the dean or *keurmeester*. This had to be done before the panel was grounded. If the panels were in any way

95. *Portrait of Susanna Lunden ('Le Chapeau de Paille'), c.*1622
Oil on oak, 79 × 54.6 cm
London, National Gallery

96. Coat of arms of the city of Antwerp

97. Brand of the Antwerp guild and the stamp of Michiel Vriendt on the reverse of *'Le Chapeau de Paille'* (Plate 95), photographed in raking light

unsatisfactory, the dean or *keurmeester* was empowered to break them over his knee but if they were approved for sale he would brand the panels on the back with the coat of arms of Antwerp, the two severed hands and the citadel (Plate 96). (According to legend, sailors on the Scheldt who refused to pay a tribute to Druon Antigonus, the giant of Antwerp, had their hands cut off by him.) Then the panelmaker himself would be able to apply his own mark, a stamp rather than a brand, close to the city brand. These were usually the initials of the panelmaker, MV for Michiel Vriendt, for example, but a star and other symbols were also used by Antwerp panelmakers.[126]

Like all other Antwerp artists, Rubens had his panels prepared by Antwerp panelmakers. For example, the oil sketch of a *Lion Hunt* (Plate 100) bears on the reverse the brand of the coat of arms of Antwerp and a stamp of a six-pointed star, an unidentified panelmaker's mark.[127] The *'Chapeau de Paille'* has on the reverse the coat of arms and the MV stamp (Plate 97). A particularly fine panel made for Rubens by an Antwerp panelmaker is that for the *Samson and Delilah*, painted in about 1609 for Nicolaas Rockox. This is composed of six horizontal oak planks, carefully planed and jointed. The grain runs parallel in all six pieces, which are butt-jointed. The parallel grain ensures that when exposed to changes in humidity the wood expands and contracts without restriction. If the grain of the planks is not parallel, changes in humidity will cause cracking of the wood and of the paint layer. There may have been dowels, although none are visible today, and the planks are glued together, using an animal glue. The *Samson and Delilah* panel was planed down to a thickness of about three millimetres and set into a new blockboard panel before it was acquired by the National Gallery

in 1980[128] and so no trace of a panelmaker's mark can be found; however, it was made before the new guild regulations were introduced and although some panels were marked before 1617, many were not.

Butt-joints were the most common type of joint. A number of variations can be found: in the '*Chapeau de Paille*', for example, Michiel Vriendt used a butt-joint with a wedge insert on a previously chamfered edge and in a portrait of Hélène Fourment (Mauritshuis, The Hague) he used a Z-shaped joint.[129] Hans van Haacht, another Antwerp panelmaker, used a V-shaped joint in the panel of Rubens's *Elevation of the Cross* in Antwerp Cathedral.[130] Oak battens were sometimes added at stategic points on the backs of large panels to provide extra support and canvas strips or animal hair (strengthened with animal glue) were occasionally placed over joints to reinforce them. A ground layer is sometimes found over the entire back of the panel which has the effect of sealing the wood against changes in relative humidity. Later in the panel's life, if cracks appeared, 'butterfly' buttons or additional battens have sometimes been added but these have often caused further restriction of the wood's natural movement and have accelerated cracking.

In contrast to a panel like the *Samson and Delilah*, carefully made from a small number of planks in all of which the grain runs parallel, many of the panels on which Rubens's landscapes are painted are extremely fragile and prone to splitting. Those in the National Gallery have been among the most troublesome of all the panels in the Collection. In a number of cases, the grain in one piece of wood runs at right angles to that of its neighbour, which has caused cracking. Before its treatment fourteen years ago, *The Watering Place* had often cracked and individual pieces of wood had moved, creating uneven 'steps' within the painting which can be seen clearly in a photograph taken in raking light (Plate 98).[131]

We must therefore ask the question why Rubens used panels which were inherently unstable for these paintings made for himself and his friends and special patrons. It has been argued that the landscapes take this particular form because of the 'organic' way in which they developed in the artist's imagination. According to this theory, Rubens began by painting a small landscape which he then decided to expand and in order to do this he asked the panelmaker to graft on additional planks. The prime example is provided by the two related paintings in the National Gallery, *A Shepherd with his Flock in a Woody Landscape* and *The Watering Place*, which have been discussed above. Both these paintings were made in several stages, which involved the expansion of the original panel with additional planks. *The Watering Place* had at least three stages in its construction. This theory, first articulated in detail by Gregory Martin in the catalogue of the Flemish School at the National Gallery,[132] has been widely accepted by subsequent art historians, who have considered that the two National Gallery paintings provide the paradigm for Rubens's usual procedure in painting landscapes. In a recent article on the *Landscape with Moon and Stars* (Plate 72), for example, it has been argued that this medium-sized panel was created in several distinct stages.[133]

This theory deserves, however, to be re-examined. In the first place, it must be remembered that the repetition of the composition of *A Shepherd and his Flock in a Woody Landscape* in *The Watering Place* is unique among Rubens's forty-odd landscapes. In addition, there is a powerful counter-argument provided by the *Landscape with Het Steen* (Plate 58) and the *Landscape with a Rainbow* (Plate 59). These are the largest of Rubens's landscapes and are painted on the two most complex panels. A careful study of the two paintings reveals that none of the individual panels can have provided a core landscape of the type in *The Watering Place*. Furthermore, the completeness of the compositions and the freedom with which the paint is applied make it likely that the pictures were not made over a substantial period but in a single campaign of work. The same applies to other landscapes whether on a large scale like the *Return from the Harvest* (Plate 99) or on a smaller scale like the *Forest with a Deer Hunt* (Plate 71).

*99. Return from the Harvest,*
*c.*1635
Oil on oak, 122 × 195 cm
Florence, Palazzo Pitti

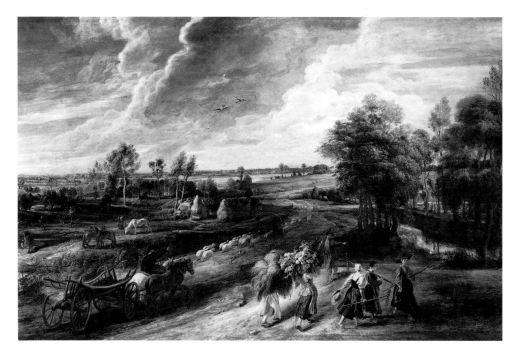

It must be borne in mind how unconventional the 'organic' growth of landscape paintings is in terms of seventeenth-century working practices. No contemporary of Rubens worked in this way, whether in Flanders, or the Dutch Republic, Germany, France, Italy or Spain. The invariable procedure for seventeenth-century landscape painters was that outlined by Van Mander:[134] the artist would make drawings from nature and then return to the studio where, having formed in his mind the general idea of the composition, he would put it down on the panel or canvas. Details could, of course, be altered during the course of work in the studio.

If we seek an alternative explanation for the complex panels on which the landscapes are painted, we find a simple one close at hand: the paintings were to be kept by Rubens or given away and so the cost of the panels was his own. The artist was, as we have seen, very careful with money. The answer in many cases may be that the panels are complex because they were cheap; Rubens presumably did not want to pay for expensive panels for pictures that were to hang in his own houses or which were to be given to relatives and friends. And yet, it could be objected, surely Rubens was not so mean that he would have painted on panels which he knew would soon crack and flake. In a book by Wilhelmus Beurs on the techniques of painting, *De groote waereld in 't klein geschildert, of schilderagtig tafereel van 's Weerelds schilderijen* (The Whole World painted in small format, or a painterly picture of the World's paintings), published in Amsterdam in 1692[135] but codifying long-established practice, the author notes that the way in which to stabilise composite panels was to apply a thick layer of ground to the back of the panel which has the effect of sealing it and so preventing damp affecting the wood. The *Landscape with Het Steen* has just such a thick layer of ground on the back and presumably the *Landscape with a Rainbow* also had one before the panel was planed down to allow a cradle to be fitted.

We may imagine that Rubens asked the panelmaker to provide inexpensive panels of a certain size. The panelmaker made up the panel, beginning sometimes with a standard-size panel, probably already grounded, to which he would then join other pieces of wood, many of them offcuts which were lying in the workshop. Some of these offcuts may also have been already grounded. In other cases he would not have begun with a standard-size panel but with an irregularly sized piece of wood to which the others would be joined. Once the panel had been completed the parts which had not already been prepared would have the ground applied to them. The application of a ground to some members of a panel when they had been intended for a different purpose, and the subsequent application of a second ground, may provide the explanation for apparent differing densities of paint – and perhaps different underlying tonalities – which can be seen in some places today when the landscapes are carefully studied. Such effects have become more visible as the overlying paint layers have become increasingly translucent with age.

After the ground had been applied on the front of the panel, it was not uncommon to apply a ground over the entire back in order to balance the stresses in the construction of the panel caused by fluctuations in temperature and humidity. The entire process would have provided apprentices in the workshop with experience in joinery and the application of grounds. We might even imagine that such panels were supplied to Rubens very cheaply or even free as a way of thanking him for his continuing custom. They would not, of course, have met the rigorous standards of the guild

100. *A Lion Hunt* (detail),
*c.*1616-17
Oil on oak, 73.6 × 105.4 cm
London, National Gallery
This detail from the upper
right-hand side shows the
*imprimatura* applied both
horizontally and vertically.

inspectors. However, these transactions would, in the first place, have been entirely private and in the second place, Rubens as a court artist was exempt from the rules of the guild. This simpler explanation for the complexity of many of Rubens's landscape panels answers the questions which have been raised here.

*A Shepherd with his Flock in a Woody Landscape* and *The Watering Place* certainly represent an example of 'organic' development and there are other cases in which Rubens elaborated his initial landscape composition. The *Landscape with Moon and Stars* has already been mentioned and the *Sunset Landscape with a Shepherd and his Flock* has a simple addition on the right-hand side with a note in Flemish revealed by infra-red photography – 'soo veel gebracht' or 'gebrekt' (literally, 'this much used' or 'missing') – written over the sky, apparently instructing the panelmaker to widen the panel.[136] Examination of the layer structure shows that Rubens then reworked the sky over the addition. These paintings, however, do not provide the model for Rubens's procedure when painting landscape.

When he received the grounded panel from the panelmaker, one of Rubens's studio assistants would have applied a layer of *imprimatura*, or, as it is known in Flemish, *primuersel*. This is a thin layer of paint washed onto the bright white ground in order to tone it down without sacrificing its luminosity. The *imprimatura* is usually light brown in colour, close to umber, but occasionally it is more yellow or greyish. This layer was applied in bold strokes with a broad brush or could have been applied with a sponge. It is usually put in with horizontal strokes and can often be seen as a striated brown or grey layer. Occasionally the *imprimatura* is not applied consistently: in certain cases, it is applied both in a horizontal and vertical direction on the same panel. One example is *The Lion Hunt* in the National Gallery, in which three-quarters of the *imprimatura* on this single-member panel was brushed on horizontally and for no apparent reason other than covering the entire panel, the right-hand quarter was applied vertically (Plate 100).

After the application of the *imprimatura* Rubens sometimes sketched certain features of the landscape in charcoal or black chalk. We can occasionally make out this drawing with the naked eye and more can be seen in infra-red photographs and

101. (above left) Detail of Plate 46 showing the three different positions of the sun, one drawn and two painted.

102. Detail of Plate 69 showing the drawing and undermodelling.

reflectograms. In *The Watering Place*, for example, there are three different positions for the sun on the far left-hand side, two painted and the third drawn (Plate 101). Drawing can also be seen in the *Forest with a Deer Hunt* (Plate 71) and in the *Landscape with Moon and Stars* (Plate 72). In the latter, figures on the right-hand side were drawn in and later painted out by Rubens.

In an ambitious composition such as the *Landscape with Het Steen*, Rubens then blocked in the principal features using a warm red-brown on a thick brush, sometimes stressing outlines or particular elements in a darker, blackish pigment. This layer is often allowed to show through in the finished painting to serve as shadows and for the half-tones under areas of flesh. In the theoretical textbooks this blocked-in design is referred to as 'dead colour' (*doodverf*).[137] It is clear, however, that in his more spontaneous landscape compositions Rubens was not bound by theoretical conventions and did not find it necessary to block in the composition in any detail. Rubens then painted his main colour layers in broad and fluid brushstrokes. In light areas such as the skies the pale ground and *imprimatura* show through in many places.

Despite the personal character of the landscapes, the materials Rubens used are comparable to those employed in his commissioned works.[138] He used linseed oil as his binder, occasionally with the addition of pine resin to give increased lustre. The foliage greens are based largely on mixtures of blue mineral azurite, yellow lakes, earth pigments, black and small amounts of lead white; the lighter impastoed greens also contain lead-tin yellow. Rubens, in common with other seventeenth-century landscape painters, avoided the use of pure green pigments and the painting treatises of the time (notably that compiled by Theodore de Mayerne)[139] warned against the use of traditional greens such as verdigris. For the intense pure blues of the skies such as those of *The Watering Place* and *Landscape with Het Steen* Rubens used lapis lazuli ultramarine; for greyer skies, as in *Sunset Landscape with a Shepherd and his Flock*, he employed the blue cobalt glass pigment, smalt. The green-tinged pigment azurite was used by Rubens in the sky of *A Shepherd and his Flock in a Woody Landscape*. Foreground browns are

103. Detail of Plate 58 showing
the sky modelled around the
trees.

usually composed of earth pigments such as umber, Cassel earth, lakes and a variety of
blacks. The sun is painted in lead-tin yellow and high-key touches such as the shep-
herd's jacket in *A Shepherd and his Flock in a Woody Landscape* and the bright red berries
in *Landscape with Het Steen* are painted in vermilion.

Rubens's order of working in his landscape paintings can be studied in the unfinished
sketch on paper, *A Wagon fording a Stream* (Plate 69). The drawing and sketchy under-
modelling can clearly be seen (Plate 102). The main landscape features such as groups of
trees and the structure of the foreground were then broadly painted in their intended
colours and patches of sky painted around and between the trees. Rubens's next stage, not
carried out in this painting, would have been to develop the structure of the trees and
other features of the landscape, adding details, highlights and shadows.

This method of working can be seen in its completed form in finished landscapes
such as *The Watering Place*. Here, the central group of trees is painted directly on top of
its blocked-in form on the *imprimatura*, the sky is then painted around it and the final
details of leaves and branches are elaborated over the edges of the paint of the sky.
Similarly in the *Landscape with Het Steen* the main groups of trees were painted before the
sky, which is modelled around them (Plate 103); in the foreground, the group on the left
including the wagon and its occupants is undermodelled and painted directly on the
*imprimatura* and the foreground filled in around it. The final high-toned touches such as
the birds, brambles and flowers were added with great freedom and immediacy. Almost all
the landscapes, and particularly the larger, more ambitious compositions, contain
significant modifications to the design worked over finished paint layers. Clear *pentimenti*
of this kind can be seen in the X-ray photograph of the *Landscape with Het Steen* on the
right-hand side, where Rubens painted out a tall tree in the foreground, and in the
*Landscape with a Rainbow*, where, in the X-ray photograph, the rainbow can be seen in
two earlier positions. In his letters Rubens mentions the time taken for pictures to dry
before sending them to his clients,[140] but he never once mentions varnish or varnishing,
and it is unlikely that he added a layer of varnish before paintings left the studio.[141]

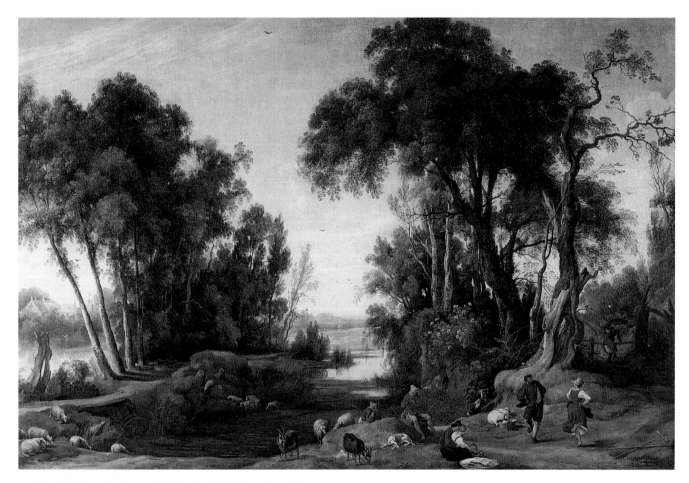

104. Jan Wildens, *Landscape with Dancing Shepherds,* 1631. Oil on canvas, 137 × 204.3 cm
Antwerp, Koninklijk Museum voor Schone Kunsten

# Rubens's Studio and the Reputation of the Landscapes

THERE ARE TWO ARTISTS who are closely associated with Rubens as a landscape painter. The first is Jan Wildens,[142] a specialist who worked in Rubens's studio painting landscape passages in large religious and mythological paintings; the second is Lucas van Uden, who made painted and etched copies of Rubens's landscapes.[143] In the *Iconography* both Wildens and Van Uden are described as *Pictor Ruralium Prospectuum Antverpiae* (Painter of Country Views from Antwerp).

Wildens was born in about 1585. He was a pupil of Pieter Verhulst and became a master in the Antwerp guild in 1604. He was in Italy for three years from 1613 until 1616 and entered Rubens's studio shortly after his return. He painted landscapes in, for example, the cartoons for the Decius Mus tapestries (Vaduz, Liechtenstein Princely Collections), the *Rape of the Daughters of Leucippus* (Munich, Alte Pinakothek), *Diana and her Nymphs* (Cleveland Art Museum) and *Cimon and Iphigenia* (Vienna, Kunsthistorisches Museum). Wildens was a close friend of Rubens and one of his executors. The period of the artists' closest collaboration was at the end of the second decade of the century but Wildens seems to have continued to paint landscapes in Rubens's history paintings for some time after that. He made copies after Rubens's work – for example the full-size copy after the Dresden *Boar Hunt* which is today in the Glasgow Art Gallery – and when painting landscapes in Rubens's pictures worked in a style very close to that of the master himself. The landscape passages in *The Piety of Count Rudolf of Habsburg* (Madrid, Prado), which are certainly by Wildens, are very similar to *The Farm at Laeken*. As an independent landscape painter, in, for example, *Landscape with Dancing Shepherds* of 1631 (Plate 104), Wildens is a delicate and attractive artist but shows little of the drama and vigour which make Rubens's landscapes so effective. He fits easily within the Antwerp tradition, more naturalistic than De Momper, but essentially decorative, providing topographical views and undemanding country scenes with riders, hunters and shepherds to the prosperous citizens of Antwerp. He died in 1653.

Lucas van Uden was born in Antwerp in 1595 and trained by his father. He entered the guild as a master in 1627 and seems to have worked for Rubens making painted and etched copies of the landscapes in the mid-1630s: one of the painted copies, after the *Odysseus and Nausicaa*, is signed by him and dated 1635 (Plate 105). Careful study of this precise, small-scale copy, now in the Bowes Museum, reveals that lines have been ruled on the *imprimatura* so that the original could be copied square by square. Van Uden's *Odysseus and Nausicaa* and his unsigned view of the Escorial (Plate 31) were presumably made under Rubens's supervision in his studio directly from the original. The style of the latter, with its precise, even finicky treatment of detail, is recognisably Van Uden's.

Van Uden also made etched copies of *The Farm at Laeken* and *The Watering Place*. They are not dated and it is unclear whether these were made under Rubens's super-

vision or after his death. Van Uden is a very delicate etcher, with a light, almost feath-ery touch, and does not follow the originals very closely. Schelte à Bolswert's forceful and accurate engravings are far closer not just to the letter but also to the spirit of the powerful originals. The only one of Bolswert's engravings which bears a date is from 1638 (Plate 106), two years before Rubens's death, and so presumably was commis-sioned by Rubens himself from the engraver.

It is possible that Rubens commissioned Van Uden to make etched copies of the landscapes and, finding them unsatisfactory, turned the job of reproducing them over to one of his favourite engravers. Van Uden seems to have made the etchings from his own painted copies. In the case of *The Watering Place* the etching shows a branch later painted out by Rubens, which suggests that Van Uden was in Rubens's studio at the time *The Watering Place* was on the easel, that is, about 1618 when he was in his early twenties and before he joined the guild as a master. Alternatively, Van Uden may have made the etchings after Rubens's death in an attempt to cash in on the success of Bolswert's engravings. He lived until 1672, enjoying a successful career specialising in topographical views and decorative landscapes.

Despite the fact that for Rubens landscape painting was essentially a private activ-ity, he came to realise its commercial potential in the 1630s. He commissioned painted copies from Van Uden and at least one engraving from Schelte à Bolswert, which were

105. Lucas van Uden (after Rubens), *Odysseus and Nausicaa*, 1635
Oil on panel, 52.1 × 74.3 cm
Barnard Castle, The Bowes Museum
A reduced copy of Rubens's large panel (Plate 49) made in Rubens's studio by Lucas van Uden. A grid drawn on the *imprimatura* layer to enable Van Uden to copy the original square by square can just be made out with the naked eye.

sold for profit. There is, however, no firm evidence that he ever planned a series of engraved landscapes from throughout his career. The only dated engraving after a Rubens landscape is the *Landscape with a Draw Well* from 1638 (Plate 106): the painting which it reproduces probably dates from the same year or shortly before. Its success may have encouraged the publisher, Gillis Hendricx, to embark on the first series of six engravings – five by Bolswert and one by Pieter Clouwet – in the last year of Rubens's life or shortly after his death. The second series, of ten smaller engravings by Bolswert, which was also published by Hendricx, almost certainly dates from after 1640.

The publication of the engravings by Bolswert played a crucial role in the gradual recognition of Rubens's achievement as a landscape painter. His landscapes were relatively little known in his lifetime as so many of the most important of them remained in his own possession. The sale of the collection shortly after Rubens's death naturally gave them far wider currency. As we have seen they were praised by Norgate in 1648 and by Philip Rubens some thirty years later.[144]

Since that time Rubens's supreme achievement as a landscape painter has been widely recognised and nowhere more than in Britain. Richelieu[145] and Mazarin[146] had owned important landscapes by Rubens but most of them found their way to Britain at the end of the eighteenth century, and by 1841 the auctioneer of Marquess Camden's collection (which included *Landscape with a Wagon at Sunset*, Plate 70) could truthfully

106. Schelte à Bolswert (after Rubens), *Landscape with a Draw Well,* 1638
Engraving, 27.9 × 41.9 cm
London, British Museum
The original painting is in the Louvre. This engraving is the only one of the series of engraved landscapes by Schelte à Bolswert after Rubens's compositions to bear a date.

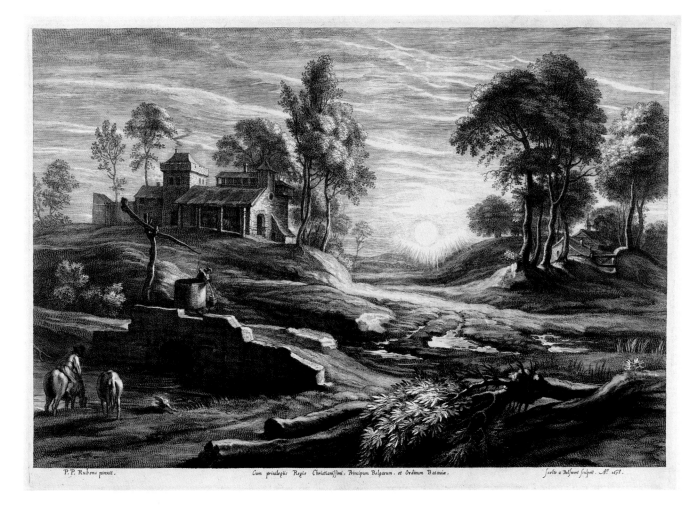

P. P. Rubens pinxit.    Cum priuilegiis Regis Christianiſſimi, Principum Belgarum, et Ordinum Batauia.    ſcelte a Bolſwert ſculpſit. Aº 1638.

state that 'There are no works of Rubens so scarce on the Continent as his landscapes, the greater portion of them being in England.'[147] Gainsborough was a passionate admirer of Rubens's landscapes, praising *The Watering Place*, which he saw in 1768 in the collection of the Duke of Montagu, in a letter to David Garrick.[148] He painted his own tribute to it, which he exhibited at the Royal Academy in 1777: today it hangs in the National Gallery (Plate 107), not far from Rubens's original.[149] However, the greatest painted tribute to the spirit of Rubens's landscapes, also in the National Gallery, is Constable's *Hay-Wain* (Plate 108). In its sympathy for the artist's native country, its power and immediacy and the bold application of paint, it is a profound meditation upon – as well as a reinterpretation of – the *Landscape with Het Steen*, which Constable had had the opportunity to study in the collection of Sir George Beaumont. In his lectures on landscape painting delivered in Hampstead in 1833 Constable said:

> In no other branch of art is Rubens greater than in landscape; – the freshness and dewy light, the joyous and animated character which he has imparted to it, impressing on the level monotonous scenery of Flanders all the richness which

107. Thomas Gainsborough, *The Watering Place*, c.1774–7 Oil on canvas, 147.3 × 180.3 cm London, National Gallery

108. John Constable, *The Hay-Wain*, 1821
Oil on canvas, 130.2 × 185.4 cm
London, National Gallery

belongs to its noblest features. Rubens delighted in phenomena – rainbows upon a stormy sky, – bursts of sunshine, – moonlight, – meteors, – and impetuous torrents mingling their sound with wind and wave.

Constable concluded his praise of Rubens's landscapes by singling out the *Landscape with Het Steen*, which entered the National Gallery during his lifetime, and its pair, *Landscape with a Rainbow*, as being among Rubens's finest works.[150]

## NOTES

1. Norgate 1919, p. 46. The editor argues that the treatise was completed between December 1648 and October 1650. (Jeffrey Muller, who is presently preparing a new edition of the *Miniatura*, dates the manuscript between 1648 and January 1649.)

2. Glück 1940 was the first authoritative modern study of Rubens's landscapes. Adler 1982 is the volume on the landscapes in the complete catalogue of Rubens's work which is currently in preparation, the *Corpus Rubenianum Ludwig Burchard*. The relevant number in Adler's catalogue, where the pre-1982 literature can be found, is given in the list of works in the Exhibition.

3. This list is published and extensively annotated in Muller 1989, pp. 89–146 (cat. 1).

4. For Lundens's collection, see Vlieghe 1977.

5. For Buckingham's collection, see R. Davies, 'An Inventory of the Duke of Buckingham's Pictures, Etc., at York House in 1635', *Burlington Magazine*, 10, 1906–7, pp. 376–82. In the Great Chamber of York House in 1635 was: 'Reuben A great Landskip' as well as 'Reuben A little Landskip: A Morning' and (the following item) 'Reuben A little Landskip, an Evening'. (Dimensions are not given.)

6. For Jabach and his collection, see Vey 1967 (with previous literature).

7. For Philip Rubens's life of his uncle, see Ruelens 1883.

8. Francisco de Hollanda, *Four Dialogues on Painting*, Oxford and London, 1928, p. 16.

9. Francesco Lancilotti, *Trattato di pittura*, ed. Filippo Raffaelli, Ancona, 1885, p. 4 (quoted by Gibson 1989, p. 40).

10. Paolo Pino, *Dialogo di pittura*, Venice, 1548, fol. 29v (quoted by Gombrich 1971, p. 116).

11. For Patinir, see R. Koch, *Joachim Patinir*, Princeton, 1968, and the discussion in Gibson 1989, pp. 3–16.

12. Koch, op. cit., p. 3.

13. E. Panofsky, *The Life and Art of Albrecht Dürer*, 4th ed., Princeton, 1955, p. 230.

14. For Herri met de Bles, see Gibson 1989, pp. 26–34 (with previous literature).

15. This term and the tradition it denotes is the subject of Gibson 1989.

16. F. Grossmann, *Pieter Bruegel: Complete Edition of the Paintings*, 3rd ed., London, 1973; *Pieter Bruegel als Zeichner*, catalogue of an exhibition held at the Kupferstichkabinett, Berlin, 1975; O. von Simson and M. Winner, eds., *Pieter Bruegel und Seine Welt* (Proceedings of a Conference held in Berlin 1975), Berlin, 1979.

17. Miedema 1994 fol. 233r.

18. *The Princes Gate Collection*, catalogue of an exhibition held at the Courtauld Institute Galleries, London, 1981, no.8.

19. See note 3.

20. Recently discussed by C. van de Velde in *Von Bruegel bis Rubens*, catalogue of an exhibition held at the Wallraf-Richartz-Museum, Cologne, the Koninklijk Museum voor Schone Kunsten, Antwerp, and the Kunsthistorisches Museum, Vienna, 1992–3, p. 73.

21. This group of drawings was brought back into the Bruegel oeuvre by K. Arndt, 'Pieter Bruegel der Ältere und die Geschichte der Waldlandschaft', *Jahrbuch der Berliner Museen*, 14, 1972, pp. 69–121. See also *Pieter Bruegel als Zeichner*, op. cit. (note 16), cat. nos. 41–9.

22. Quoted in London 1986, p. 20.

23. K. Ertz, *Jan Brueghel der Ältere (1568–1625): Die Gemälde mit kritischem Oeuvrekatalog*, Cologne, 1979.

24. G. Crivelli, *Giovanni Brueghel pittor fiammingo e sue lettere e quadretti esistenti presso l'Ambrosiana*, Milan, 1868, and S. Bedoni, *Jan Brueghel in Italia e il Collezionismo del Seicento*, Florence and Milan, 1983, pp. 103–46.

25. K. Ertz, *Josse de Momper der Jüngere (1564–1635): Die Gemälde mit kritischem Oeuvrekatalog*, Freren, 1986.

26. M. Mauquoy-Hendrickx, *L'Iconographie d'Antoine van Dyck: Catalogue Raisonné*, 2nd ed., 2 vols., Brussels, 1991.

27. Outstanding examples are the drawings in the Institut Néerlandais, Paris (Inv. no. 1495), and the Pierpont Morgan Library, New York (Inv. no. 1957.5).

28. For Bril, see G.T. Faggin, 'Per Paolo Bril', *Paragone*, 16/185, 1965, pp. 21–34, and A. Berger, *Die Tafelgemälde Paul Brils*, Münster and Hamburg, 1993. I am very indebted to Luuk Pijl of the University of Groningen, who is preparing a dissertation on Bril, for discussing the artist's work with me.

29. Giovanni Baglione, *Le vite de' pittori, scultori, et architetti dal pontificato di Gregorio XIII, fino a tutto quello d'Urbano VIII*, Rome, 1649, p. 297.

30. Giulio Mancini, *Considerazioni sulla Pittura*, ed. A. Marucchi, Rome, 1956, vol. 1, pp. 260–1 (fol. 88v, 89): 'qual da molti anni in qua in simil sorte di pittura par che habbia tenuto il primo luogo et invero meritamente.'

31. Professor Justus Müller-Hofstede has informed me that he believes this painting to be entirely by Rubens.

32. Muller 1989, no. 26.

33. For Elsheimer, see K. Andrews, *Adam Elsheimer*, 2nd ed., Munich, 1985.

34. Magurn 1955, no. 21.

35. Ovid, *Heroides*, 17: 263.

36. Virgil, *The Aeneid*, 6: 869: 'ostendent terris hunc tantum fata, nec ultra / esse sinent.' ('Him, the fates shall but show to earth, nor longer suffer him to stay.' Virgil, vol. 1, Loeb Classical Library, pp. 568–9.) Rubens frequently expanded, contracted or misquoted his classical sources.

37. For Goudt and Elsheimer, see Andrews, op. cit. (note 33), pp. 40–2.

38. Muller 1989, nos. 32, 33, 34 and 35.

39. Adler 1982, cat. no. 16.

40. For the artistic patronage of Albert and Isabella, see M. de Maeyer, *Albrecht en Isabella en de schilderkunst: bijdrage tot de geschiedenis van de XVIIe-eeuwse schilderkunst in de Zuiderlijke Nederlanden*, Brussels, 1955.

41. Magurn 1955, nos. 246 and 249.

42. See note 5.

43. Magurn 1955, no. 238 ('the engraving of the antique landscape...') and nos. 246 and 249.

44. See note 1.

45. See note 7.

46. Glück 1940.

47. Adler 1982, cat. no. 37.

48. Adler 1982, cat. no. 38.

49. Adler 1982, cat. no. 35.

50. A drawing in the Print Room of the Hamburg Kunsthalle

which is said to be a study for this painting was published in Winner 1981. If it is by Rubens, it would be a unique study of this type. I have not seen the drawing and so have thought it best not to include it in this discussion. Konrad Renger has informed me that he considers the drawing, although it is severely worn, to be by Rubens.

51. The *Staetmasse* is published in full in Genard 1865, pp. 69–179.

52. For the house at Eeckeren, see Georges Soyer, *Comment Rubens devint Paysagiste ou le vrai 'Steen' du Maître*, Antwerp, 1939. (Soyer sought to prove that Eeckeren was of crucial importance to Rubens's development as a landscapist and published the key documents concerning the purchase of the estate.)

53. J. B. Descamps 1753–63. Descamps's life of Rubens is in vol. I, pp. 297–326. He discusses *The Farm at Laeken* on page 324.

54. A. Sanderus, *Chorographia sacra Brabantiae* (1st ed., Brussels, 1659), vol. 3, The Hague, 1727, p. 257.

55. For the church at Laeken, see Wauters 1972, vol. 6, pp. 22–61.

56. For Albert and Isabella's use of art in their creation of a sense of their independence from Spain, see De Maeyer, op. cit. (note 40).

57. Vlieghe 1977.

58. G. Glück and F.M. Haberditzl, *Die Handzeichnungen von Pieter Paul Rubens*, Berlin, 1928, nos. 111 and 112.

59. Descamps, op. cit. (note 53), vol. I, p. 316.

60. Adler 1982, cat. no. 48.

61. Evers 1942, p. 392. This idea of a 'binary composition' was taken up and developed by Vergara 1982, pp. 43ff.

62. John Smith, *A Catalogue Raisonné of the Works of the Most Eminent Dutch, Flemish and French Painters*, vol. 2, London, 1830, p. 157, no. 547.

63. K.J. Müllenmeister, *Roelant Savery: Die Gemälde mit kritischem Oeuvrekatalog*, Freren, 1988 (with previous literature).

64. Magurn 1955, no. 21; quoted above, pp. 29–30.

65. The treatment and physical make-up of *The Watering Place* is discussed in Brown and Reeve 1982. The account there is, however, slightly different from that given in this catalogue which is based on further research and analysis of the painting.

66. Rooses 1890, vol. 4, no. 1196.

67. A. Balis, '"Fatto da un mio discepolo": Rubens's Studio Practices Reviewed', in Nakamura 1994, pp. 97–127, esp. p. 117.

68. See Martin 1968.

69. I am particularly grateful to Ashok Roy for the painstaking care with which he examined the paintings with me.

70. Horace, *Odes*, Book 3, no. 29, 6th stanza (trans. by James Mitchie, *The Odes of Horace*, Penguin Classics, Harmondsworth, 1973).

71. The third section of Karel van Mander's *Het Schilder-Boeck* (1604), after the Lives of the Artists of 'Ouden, en Nieuwen Tyds', is devoted to '...d'Wtlegghinghe op den Metamorphoseon Pub. Ovidij Nasonis' ('...an explication of the Metamorphoses of Ovid').

72. Muller 1989, cat. 1, no. 137.

73. National Gallery, London, Inv. no. 6461.

74. These engravings are illustrated by Muller 1989 as Figs. 4–5.

75. For Rubens's library, see S. MacRae, 'Rubens's Library', MA Thesis, Columbia University, New York, 1971 (unpublished).

76. Beslerus, *Hortus Eystettensis sive diligens et accurata omnium plan- tarum, florum, stirpium...delineato et ad vivum repraesentatio*, Nuremberg, 1613.

77. Magurn 1955, no. 244.

78. Rooses 1904, vol. 2, pp. 571–2.

79. For Rubens's tomb in the Sint Jacobskerk, see U. Söding, *Das Grabbild des Peter Paul Rubens in der Jakobskirche zu Antwerpen*, Hildesheim, 1986.

80. For De Marselaer, see C. van de Velde 1981, pp. 69–82.

81. J.R. Judson and C. van de Velde, *Corpus Rubenianum Ludwig Burchard, Part XXI: Book Illustrations and Title-pages*, 2 vols., Brussels, 1977, vol. 1, cat. no. 84.

82. Quoted in Judson and Van de Velde, op. cit., vol. 2, Appendix 1, p. 408.

83. 'In de eersten een Hof-stadt met de groote steene Huysinghen ende andere schoone Edificien in forme van een Casteel daerop staende, met den Hof, Boomgaert, Fruyt-boomen, op treckende Brugghe, met een groote Motte, ende den grooten hooghen vierkantighen Thoren in 't midden van deselve Motte rontsomme syne Vyvers gheleghen, met oock het Neer-hof met syne appaerte Pachters-wooninghen, Schueren, diverse Stallinghen, ende alle hunne andere toe-behoorten, t'saemen groot vier-Bunderen 50 Roeden rontsomme in syne Water-grechten. Item de Plantagien, diverse Dreven ende Warande wel beset soo met schoone groote op-gaende Eycken als andere, rontsomme de voorsz. ende naervolghende Goederen staende.' Rooses 1910, p. 152.

84. Rooses 1890, vol. 4, cat. no. 1204.

85. Martin 1970, p. 139.

86. Magurn 1955, no. 239.

87. Rooses 1890, vol. 4, cat. no. 1199.

88. See notes 5 and 42.

89. The painting was no. 152 in the inventory of Jabach's estate, 17 July 1696, Paris ('Mémoires, Etats, Inventaires et Règlements de droit dans la famille du feu sieur Evrard Jabach et de dame Anne Marie de Groot, sa veuve, du 17 juillet 1696', *Mémoires de la société de l'histoire de Paris et de l'Isle de France*, vol. 21, 1894, p. 2.)

90. These underdrawings were first discussed by Jaffé 1989, cat. no. 1058.

91. Michael Jaffé has informed me that he believes this copy to be by Lucas van Uden.

92. Muller 1989, cat. 1, no. 135.

93. Muller 1989, cat. 1, no. 136.

94. Buchanan 1824, vol. 2, pp. 101–2.

95. Ingamells 1982.

96. Muller 1989, cat. 1, p. 94.

97. The evidence for the location of the paintings after Rubens's death is discussed by Martin 1970, p. 142, note 34. In the *Staetmasse* (op. cit., note 51), p. 88, item LXXIIII: 'De voors. Joncker Albert [Albert Rubens (1614–1657)], heeft noch gehadt eene groote landschappe, de wedergaey van dat tot Steene is, hem aengeschat voorde somme van....1250 [guilders].' The phrase 'de wedergaey van dat tot Steene is' presumably means 'the equal (or pendant) of that which is at Steen'. The implication must therefore be that the *Landscape with Het Steen* was still at Het Steen as part of the property of the artist's widow, and its pendant, the *Landscape with a Rainbow*, was at Albert's house in Brussels. It was probably the painting recorded after his death: 'Item een groot landscap

wesende een schouwstuck'. (See M. Rooses, *Rubens-Bulletijn*, vol. 5, 1910, p. 28 and note.)

98. This tradition is outlined by J. Ackerman, *The Villa: Form and Ideology of Country Houses*, London, 1990.

99. A ground-plan of Het Steen is, for example, given in E. Poumon, *Les Châteaux de Brabant*, Brussels, 1949, p. 6, but this shows it after the alterations of the nineteenth century.

100. These transactions are discussed (and the references given) by Muller 1989, pp. 57–8.

101. This incident is described by Magurn 1955, pp. 361, 388 and 503.

102. Magurn 1955, no. 235.

103. Sallust, *Jugurtha*, 68.

104. The phenomenon of country-house owning by the prosperous bourgeoisie of Antwerp is discussed in Baetens 1985 and 1991.

105. A particularly interesting account in this regard is a pamphlet entitled *A Discourse of Husbandrie used in Brabant and Flanders* by Samuel Hartlib, London, 1645.

106. J.A. van Houtte, 'Economie et société aux Pays-Bas à l'Epoque de Rubens', *Bulletin de l'Institut Historique Belge de Rome*, vol. 48–9 (1978–9), pp. 189ff.

107. Liedtke 1992, pp. 101–7.

108. Braham and Bruce-Gardner 1988 discuss the recent restoration of the painting.

109. Muller 1989, cat. 1, no. 288.

110. Virgil, *Eclogues*, 1: 1–5: 'Tityre, tu patulae recubans sub tegmine fagi / silvestrem tenui musam meditaris avena; / nos patriae finis et dulcia linquimus arva: / nos patriam fugimus; tu, Tityre, lentus in umbra / formosam resonare doces Amaryllida silvas.'

111. Virgil, *Georgics*, 4: 559–66: 'Haec super arvorum cultu pecorumque canebam / et super arboribus, Caesar dum magnus ad altum / fulminat Euphraten bello victorque volentis / per populos dat iura viamque adfectat Olympo. / illo Vergilium me tempore dulcis alebat / Parthenope, studiis florentem ignobilis oti, / carmina qui lusi pastorum audaxque iuventa, / Tityre, te patulae cecini sub tegmine fagi.'

112. This is not a literal quotation but summarises the spirit of the *Georgics*. See, for example, Book 1, line 145 ('labor omnia vincit / improbus') and Book 2, lines 472–3, 493–502, 510–12 and 532–5.

113. See, for example, figs. 31 and 32 in Vergara 1982.

114. It was this version of the composition which was copied by Lucas van Uden in a painting now in the Kunsthistorisches Museum in Vienna.

115. The identification of the castle as Ribaucourt is suggested in an annotation (not in Burchard's hand) on the reverse of the photograph in the file at the Rubenianum in Antwerp.

116. Magurn 1955, no. 244.

117. Van Mander, quoted in London 1986, pp. 35–43.

118. See London 1986 and Amsterdam 1993.

119. Adler 1982, no. 71. The inscription reads, anti-clockwise from the top left: blauw berien ghelijk druyven met dauw (blue berries like grapes covered with dew); de Blaederen schoon groen blinkende maer van achter wat bleeck ende doef (the leaves fine [very?] green shimmering but at the back a bit pale and dull); de stammen ros (the stems red); Lichte groene stelen (light geen stems); de bladeren gans groen (the leaves entirely green); naten (nuts); geel (yellow); dyck [or eyck] (oak); bruyn

groen (brown green); wit bister (white bistre); wit achter (white on the back, or behind); schoon donker (fine [very?] dark); het onderste oft achterste van de bladeren lichter (the backs of the leaves lighter).

120. Adler 1982, no. 27.

121. Vlieghe 1987, no. 75.

122. Martin 1970, Appendix 1 (no. 852).

123. Vlieghe 1987, no. 100.

124. The passage which follows is largely based on a paper given by Jørgen Wadum to a conference on the conservation of panel paintings held at the Getty Conservation Institute in Malibu in 1995 (Wadum 1996). I am immensely grateful to him for letting me consult this paper before its publication and also for discussing these matters with me and Tony Reeve on a number of occasions.

125. Miedema 1973, pp. 204–5 (Chapter VIII, verse 3, fol. 34v).

126. For Antwerp panelmakers' marks see Van Damme 1990 and Wadum 1996.

127. Martin 1970, pp. 182–7.

128. See Plesters 1983.

129. See Wadum 1996.

130. Masschelein-Kleiner 1992, pp. 55–61.

131. Brown and Reeve 1982.

132. Martin 1970.

133. Braham and Bruce-Gardner 1988.

134. London 1986, pp. 35–43.

135. My thanks to Jørgen Wadum for drawing this book to my attention.

136. My thanks to my colleague Rachel Billinge for providing a clear infra-red reflectogram of this inscription which is in the top right-hand corner of the painting (see p. 121).

137. Van de Graaf 1958, pp. 102–5, 142–3, 150–2 and 158. See also the discussion by E. van de Wetering, 'Painting materials and working methods', in J. Bruyn, B. Haak, S.H. Levie et al., *A Corpus of Rembrandt Paintings*, The Hague and London, 1982, vol. 1, pp. 11–33, esp. pp. 23–4.

138. My thanks to Ashok Roy and Raymond White who examined Rubens's materials for me.

139. Van de Graaf 1958.

140. Noted by Plesters 1983, p. 46.

141. Ibid.

142. For Wildens, see the monograph by Adler 1980.

143. For Van Uden, see Martin 1968 and Adler 1985.

144. See notes 1 and 7.

145. R. de Piles, *Le Cabinet de Monseigneur le Duc de Richelieu*, Paris, 1681, pp. 58–60.

146. Adler 1982, cat. no. 19.

147. Marquess Camden sale, London, 12 June 1841, lot no. 66.

148. M. Woodall, ed., *The Letters of Thomas Gainsborough*, London, 1963, p. 67.

149. J. Hayes in *The Landscape Paintings of Thomas Gainsborough*, Ithaca, 1982, vol. 2, cat. no. 117, notes that Horace Walpole annotated his catalogue of the Royal Academy Exhibition of 1777, in which Gainsborough's painting was no. 136, with the comments: 'In the Style of Rubens, & by far the finest Landscape ever painted in England, & equal to the great Masters.'

150. C. R. Leslie, *Memoirs of the life of John Constable*, London, 1951, p. 299.

# Select Bibliography

ADLER 1980
W. Adler, *Jan Wildens. Der Landschaftsmitarbeiter der Rubens*, Fridlingen, 1980.

ADLER 1982
W. Adler, *Corpus Rubenianum Ludwig Burchard*. Part XVIII, *Landscapes and Hunting Scenes 1: Landscapes*, London, 1982.

ADLER 1985
W. Adler, 'Das Interesse an Rubens' Landschaftskunst in seiner Zeit und ihre Bewertung durch die Kunstgeschichtsschreibung', in *Rubens and his World: Opgedragen aan R-A. d'Hulst*, Antwerp, 1985, pp. 319–29.

AMSTERDAM 1993
*Nederland naar 't leven: Landschapsprenten uit de Gouden eeuw*, catalogue of an exhibition held at the Rembrandthuis, Amsterdam, 1993/4.

BAETENS 1985
R. Baetens, 'La "Villa Rustica", Phénomène Italien dans le Paysage Brabançon au 16ème siècle', in *Aspetti della vita economica medievale* (Atti del Convegno di Studi nel X Anniversario della morte di Federigo Melis) (Università degli Studi di Firenze), Florence, 1985, pp. 171–91.

BAETENS 1991
R. Baetens, 'La "Bellezza" et la "Magnificenza": Symboles du Pouvoir de la Villa Rustica dans la région Anversoise aux Temps Modernes', in R. Baetens and B. Blonde, eds., *Nouvelles approches concernant la culture de l'habitat*, Turnhout, 1991, pp. 159–79.

BALIS 1986
A. Balis, *Corpus Rubenianum Ludwig Burchard*. Part XVIII, *Landscapes and Hunting Scenes 2: Hunting Scenes*, London, 1986.

BAUCH 1978
J. Bauch, D. Eckstein and G. Brauner, 'Dendrochronologische Untersuchungen an Eichenholztafeln von Rubens-Gemälden', *Jahrbuch der Berliner Museen*, 20, 1978, pp. 209–21.

BAUDOUIN 1977
F. Baudouin, 'The Rubens House at Antwerp and the Château de Steen at Elewijt', *Apollo*, 1977, pp. 181–8.

BRAHAM AND BRUCE-GARDNER 1988
H. Braham and R. Bruce-Gardner, 'Rubens's "Landscape by Moonlight"', *Burlington Magazine*, 1988, pp. 579–96.

BROWN AND REEVE 1982
C. Brown and A. Reeve, 'Rubens' The Watering Place: the Treatment of the Picture', *National Gallery Technical Bulletin*, vol. 6, 1982, pp. 27–39.

BUCHANAN 1824
W. Buchanan, *Memoirs of Painting*, 2 vols., London, 1824.

BURCHARD AND D'HULST 1963
L. Burchard and R. D'Hulst, *Rubens Drawings*, 2 vols., Brussels, 1963.

CAFRITZ 1988
R. Cafritz, L. Gowing and D. Rosand, *Places of Delight: The Pastoral Landscape*, Washington, 1988.

DE POORTER 1990
N. de Poorter, G. Jansen and J. Giltay, *Rubens en zijn tijd*, Museum Boymans-van Beuningen, Rotterdam, 1990.

DESCAMPS 1753–63
J.-B. Descamps, *La Vie des Peintres Flamands, Allemands et Hollandais*, 4 vols., Paris, 1753–63.

DREHER 1978
F.-P. Dreher, 'The Artist as Seigneur: Chateaux and their Proprietors in the work of David Teniers II', *Art Bulletin*, LX, 1978, pp. 682–703.

ELEWIJT 1962
*Rubens Diplomate*, catalogue of an exhibition held at Château de Steen, Elewijt, 1962 (catalogue by F. Baudouin et al.).

EVERS 1942
H.G. Evers, *Peter Paul Rubens*, Munich, 1942.

EVERS 1944
H.G. Evers, *Rubens und sein Werk: Neue Forschungen*, Brussels, 1944.

GENARD 1865
P. Genard, 'De nalatenschap van P.P. Rubens', *Antwerpsch Archievenblad*, vol. 2, 1865, pp. 69–179

GENARD 1877
P. Genard, *Aanteekeningen over den grooten meester en zijn bloedverwanten*, Antwerp, 1877.

GEPTS 1954–60
G. Gepts, 'Tafereelmaker Michiel Vriendt, leverancier van Rubens', *Jaarboek van het Koninklijk Museum voor Schone Kunsten*, Antwerp, 1954–60, pp. 83–7.

GIBSON 1989
W. Gibson, *Mirror of the Earth: the World Landscape in Sixteenth Century Flemish Painting*, Princeton, 1989.

GLÜCK 1940
G. Glück, *Die Landschaften von P. P. Rubens*, Vienna, 1940.

GOMBRICH 1971
E.H. Gombrich, 'The Renaissance Theory of Art and the Rise of Landscape', in *Norm and Form: Studies in the Art of the Renaissance*, 2nd ed., London and New York, 1971, pp. 107–21.

HAZLEHURST 1987
F. Hamilton Hazlehurst, 'A New Source for Rubens's Château de Steen', *Burlington Magazine*, 129, 1987, pp. 588–90.

HELD 1980
J.S. Held, *The Oil Sketches of Peter Paul Rubens. A Critical Catalogue*, 2 vols., Princeton, 1980.

HELD 1986
J. S. Held, *Rubens: Selected Drawings*, 2nd ed., Oxford, 1986.

HERRMANN 1933
A. Herrmann, 'Rubens y el Monasterio de San Lorenzo de El Escorial', *Archivio Español de Arte y Arqueología*, 27, 1933, pp. 237–46.

HERRMANN 1936
A. Herrmann, *Untersuchungen über die Landschaftsgemälde des Peter Paul Rubens*, Berlin and Stuttgart, 1936.

D'HULST 1981
R.-A. d'Hulst, 'Enkele anvullingen bij het oeuvre van Van Uden en Van Thulden', in *Kolveniershof en Rubenianum Feestbundel*, Antwerp, 1981, pp. 57–68.

INGAMELLS 1982
J. Ingamells, 'A Masterpiece by Rubens. The Rainbow Landscape Cleaned', *Apollo*, 116, 1982, pp. 288–91.

JAFFÉ 1957
M. Jaffé, 'A Sheet of Drawings from Rubens' Second Roman Period and his Early Style as a Landscape Draughtsman', *Oud Holland*, LXXII, 1957, pp. 1–19.

JAFFÉ 1966
M. Jaffé, 'Landscape by Rubens and another by Van Dyck', *Burlington Magazine*, 1966, p. 413.

JAFFÉ 1969
M. Jaffé, 'Rediscovered Oil Sketches by Rubens: 1', *Burlington Magazine*, 1969, pp. 435–44

JAFFÉ 1977
M. Jaffé, *Rubens and Italy*, Oxford, 1977.

JAFFÉ 1989
M. Jaffé, *Rubens: Catalogo Completo*, Milan, 1989.

KEISER 1926
E. Keiser, *Die Rubenslandschaft*, Rudolfstadt, 1926.

KEISER 1931
E. Keiser, 'Tizians und Spaniens Einwirkungen auf die späten Landschaften des Rubens', *Münchner Jahrbuch der bildenden Kunst*, VIII, 1931, pp. 281–91.

LIEDTKE 1992
W. Liedtke, 'Addenda to Flemish Paintings in the Metropolitan Museum of Art', *Metropolitan Museum Journal*, vol. 27, 1992, pp. 101–20.

LONDON 1986
*Dutch Landscape: The Early Years*, catalogue of an exhibition held at the National Gallery, London, 1986.

MACLAREN 1936
N. MacLaren, 'A Rubens Landscape for the National Gallery', *Burlington Magazine*, LXVIII, 1936, pp. 207–13.

MACLAREN 1946
N. MacLaren, *Peter Paul Rubens: The Château de Steen*, London, 1946.

MAGURN 1955
R.S. Magurn, ed., *The Letters of Peter Paul Rubens*, Cambridge, Mass., 1955.

MARTIN 1966
G. Martin, 'Two Closely Related Landscapes by Rubens', *Burlington Magazine*, 108, 1966, pp. 180–4.

MARTIN 1968
G. Martin, 'Lucas van Uden's Etchings after Rubens', *Apollo*, 1968, pp. 210–11.

MARTIN 1970
G. Martin, *The Flemish School 1600-1900*, National Gallery Catalogues, London, 1970.

MASSCHELEIN-KLEINER 1992
L. Masschelein-Kleiner, ed., 'Peter Paul Rubens's Elevation of the Cross: Study, Examination and Treatment', *Bulletin de l'Institut Royal du Patrimoine Artistique*, Brussels, vol. XXIV, 1992.

MIEDEMA 1973
H. Miedema, ed., *Karel van Mander: De Grondt der Edel Vrij Schilderkonst*, Utrecht, 1973.

MIEDEMA 1994
H. Miedema, ed., *Karel van Mander: The Lives of the Illustrious Netherlandish and German Painters...*, 2 vols., Doornspijk, 1994.

MILLAR 1977
O. Millar, 'Rubens's Landscapes in the Royal Collection: The Evidence of X-Ray', *Burlington Magazine*, 119, 1977, pp. 631–5.

MULLER 1989
J. Muller, *Rubens: The Artist as Collector*, Princeton, 1989.

MÜLLER HOFSTEDE 1966
J. Müller Hofstede, 'Zwei Hirtenidylen des späten Rubens', *Pantheon*, 1966, p. 38

NAKAMURA 1994
T. Nakamura, ed., *Rubens and his Workshop: The Flight of Lot and his Family from Sodom*, catalogue of an exhibition held at the National Museum of Western Art, Tokyo, 1994.

NORGATE 1650
M. Hardie, ed., *Edward Norgate. Miniatura or the Art of Limning (1650)*, Oxford, 1919.

PLESTERS 1983
J. Plesters, '"Samson and Delilah": Rubens and the Art and Craft of Painting on Panel', *National Gallery Technical Bulletin*, vol. 7, 1983, pp. 30–49.

RAUPP 1994
H.-J. Raupp, 'Zeit in Rubens' Landschaften', *Wallraf-Richartz-Jahrbuch*, LV, 1994, pp. 159–70.

RENGER 1993
K. Renger, 'Untersuchungen an Rubens-Bildern: Die Anstuckungen der Holztafeln', *Bayerische Staatsgemäldesammlungen, Jahresbericht* 1993, pp. 24–35.

RENGER 1994a
K. Renger, 'Rubens-Stücke: Die Anstuckungen von Münchner "Silen" und "Schäferszene"', *Wallraf-Richartz-Jahrbuch*, 1994, pp. 171–84.

RENGER 1994b
K. Renger, 'Anstuckungen bei Rubens', in E. Mai, K. Schutz and H. Vlieghe, eds., *Die Malerei Antwerpens – Gattungen, Meister, Wirkungen*, Cologne, 1994, pp. 157–67.

ROOSES 1890
M. Rooses, *L'Oeuvre de P.P. Rubens*, 6 vols., Antwerp, 1890.

ROOSES 1897
M. Rooses, 'Les Rubens de la Galerie du duc de Richelieu', *Rubens-Bulletijn*, 5, 1897, pp. 138–48.

ROOSES 1904
M. Rooses, *Rubens*, 2 vols., London, 1904.

ROOSES 1910
M. Rooses, 'De Plakbrief der Heerlijkheid van Steen', *Rubens-Bulletijn*, 5, 1910, pp. 149–57.

ROTTERDAM 1953
*Olieverfschetsen van Rubens*, catalogue of an exhibition held at the Museum Boymans-van Beuningen, Rotterdam, 1953 (catalogue by E. Haverkamp-Begemann).

RUELENS 1883
C. Ruelens, 'La Vie de Rubens par Roger de Piles', *Rubens-Bulletijn*, 2, 1883, pp. 157-75.
RUELENS AND ROOSES 1887–1909
C. Ruelens and M. Rooses, *Codex Diplomaticus Rubenianus*, 6 vols., Antwerp, 1887–1909.
SIEGEN 1977
*Rubens und die tradition der Niederländischen Landschaftskunst*, catalogue of an exhibition, Siegen, 1977 (catalogue by Hella Robels).
DE SMEDT 1990
H. J. De Smedt, 'Merktekens op enkele Antwerpse retabels', in M. Smeyers, ed., *Merken Opmerken: Typologie en Methode*, Louvain, 1990, pp. 145–83.
SMITH 1829-42
J. Smith, *A Catalogue Raisonné of the Works of the Most Eminent Dutch, Flemish and French Painters*, 7 vols., London, 1829–42.
SONNENBURG 1979
H. von Sonnenburg, 'Rubens' Bildaufbau und Technik', *Maltechnik- Restauro*, vol. 85, 1979, pp. 77–100 and 181–203.
THEUWISSEN 1966
J. Theuwissen, 'De Kar en de Wagen in het Werk van Rubens', *Jaarboek van het Koninklijk Museum voor Schone Kunsten*, Antwerp, 1966, pp. 199ff.
THIERY 1988
Y. Thiery, *Les Peintres Flamandes de paysage au XVIIe siècle: des précurseurs à Rubens*, Brussels, 1988.
VAN DAMME 1990
J. van Damme, 'De Antwerpse tafereelmakers en hun merken. Identificatie en betekenis', *Jaarboek van het Koninklijk Museum voor Schone Kunsten*, Antwerp, 1990, pp. 193–236.
VAN DE GRAAF 1958
J.A. van de Graaf, *Het De Mayerne Manuscript als bron voor de schilderkonst van de barok*, Mijdrecht, 1958.
VAN DE VELDE 1981
C. van de Velde, 'Rubens, Frederik de Marselaer en Theodoor van Loon', in *Kolveniershof en Rubenianum Feestbundel*, Antwerp, 1981, pp. 69–82.
VERGARA 1982
L. Vergara, *Rubens and the Poetics of Landscape*, London, 1982.
VERGARA 1995
A. Vergara, 'The "Room of Rubens" in the Collection of the 10th Admiral of Castile', *Apollo*, 1995, pp. 34–9.
VEY 1967
H. Vey, 'Die Bildnisse Everhard Jabachs', *Wallraf-Richartz- Jahrbuch*, 1967, pp. 157–88.
VLIEGHE 1977
H. Vlieghe, 'Une grande collection Anversoise du dix-septième siècle: Le Cabinet d'Arnold Lunden, beau-frère de Rubens', *Jahrbuch der Berliner Museen*, vol. 19 (Neue Folge), 1977, pp. 172–204.
VLIEGHE 1987
H. Vlieghe, *Corpus Rubenianum Ludwig Burchard*, Part XIX, 'Rubens Portraits', 2 vols., London, 1987.
WADUM 1993
J. Wadum, 'Recent Discoveries on Antwerp Panel Makers' Marks', *Technologia Artis*, vol. 3, 1993, pp. 96–100.
WADUM 1996
J. Wadum, 'Historical Techniques of Panel Painting in the Northern Countries', in K. Dardes and A. Rothe, eds., *The Structural Conservation of Panel Paintings: Proceedings of a Symposium held at the J. Paul Getty Museum, April 1995*. The Getty Conservation Institute and the J. Paul Getty Museum (Forthcoming 1996).
WAUTERS 1972
A. Wauters, *Histoire des Environs de Bruxelles* (1st ed. 1855), 20 vols., 2nd ed., Brussels, 1972.
WIJNGAERT 1940
F. van den Wijngaert, *Inventaris der Rubeniaansche Prentkunst*, Antwerp, 1940.
WINNER 1981
M. Winner, 'Zu Rubens' Eberjagd in Dresden (Landschaft oder Historienbild)', in *Peter Paul Rubens: Werk und Nachruhm*, Munich, 1981, pp. 16–65.

# *The Structure of Rubens's Landscapes*

### CHRISTOPHER BROWN AND ANTHONY REEVE

In Chapter 8 Rubens's use of complex supports for his landscapes is described. In this appendix the landscape panels which are considered there are shown in diagrammatic form with, where appropriate, notes on their make-up. The arrows on the individual planks show the direction in which the grain runs. In the case of those landscapes which are painted on single-member panels or for which (because of having been transferred to canvas) the original structure cannot be discovered, there is no diagram but there are short technical notes. Unless otherwise stated, all the paintings listed here are painted on oak and have a ground consisting of chalk and glue and an *imprimatura* or *primuersel* layer, which is usually grey or brown in colour.

The paintings are arranged in chronological order. Although not shown in the exhibition, *Landscape with a Rainbow* (London, Wallace Collection) has been included because of its importance as a pendant to the *Landscape with Het Steen*.

We have noted for each picture the technical data that were available at the time of writing. Many of the National Gallery paintings were examined and sampled during the course of their past conservation treatments and this accounts for a fuller report of the painting materials used by Rubens under those entries. A synthesis of the results of a broader survey of Rubens's landscape painting practice is in progress.

In compiling this appendix we are particularly grateful to those colleagues who provided information about paintings in their collections, in particular A. Kossolapov (St Petersburg), Jim Wright (Boston), Charlotte Hale and Hubert von Sonnenburg (New York), Annetje Boersma Pappenheim (Rotterdam), Robert Bruce-Gardner (London, Courtauld Institute), Viola Pemberton-Pigott (London, Royal Collection), Gisela Helmkampf (Berlin) and Uwe Wieczorek (Vaduz).

*Pond with Cows and Milkmaids, c.*1614
Vaduz Castle, Collections of the Prince of Liechtenstein (Plate 32)

1. Dendrochronological analysis gives a felling date of about 1614.
2. The *imprimatura* was applied vertically on the right-hand side and horizontally in the centre of the panel.
3. The paint layers range from thin, with *imprimatura* and ground showing as a middle tone, to thick impasto used for highlights and clouds. In some places sky can be seen to have been added around the trees.
4. Rubens uses the first, broadly brushed paint layer to create particular effects. The green layer, for example, is used to create shadow in the figures; with the thin red strengthening lines placed on top of the flesh tone, a three-dimensional effect was achieved not only from a distance but in the actual build-up of the paint. In the ring on which the woman supports the churn on her head, the green serves as a middle tone with shadows added on top. In her sleeves, green is used as a shadow and the form created with a few touches of white. The foliage was painted on top of the *imprimatura*, then sky added around the trees. To complete the trees, some branches were added over the sky and clouds, creating the desired three-dimensional effect.

*Milkmaids with Cattle in a Landscape: 'The Farm at Laeken'*, c.1618
London, The Royal Collection (Plate 33)

1. The painting was transferred on to a new oak panel in 1940.
2. Planks 3 and 5 appear to be half-lapped behind 1 and 2.
3. Lines of underdrawing are visible in the arm and face of the standing woman in the centre.

*Summer*, c.1618
London, The Royal Collection (Plate 60)

Canvas

1. An X-ray photograph reveals that the priming on the central section is different from that on sections 2, 3 and 4, all of which are primed in the same way.
2. The cart is painted over the seam joining sections 1 and 4. The trees on the left and the elderly couple on the right are on sections 2 and 3 respectively and these seem to have been added after the central section was painted.
3. There is a *pentimento* in the mill on the right where a small lean-to building has been painted out.

*Landscape with a Cart crossing a Ford ('La Charrette Embourbée')*, c.1620
St Petersburg, The State Hermitage Museum (Plate 44)

Panel transferred to canvas

1. The panel was transferred to canvas in 1823 by A. Mitrochin. Before the transfer the ground was probably chalk and glue. Lead white was used as a new ground in the transfer.
2. Lead-tin yellow, malachite and azurite pigments have been identified in the painting by A. Kossolapov.

*A Shepherd with his Flock in a Woody Landscape*, c.1620
London, National Gallery (Plate 48)

1. The brand of the coat of arms of Antwerp is on the reverse.
2. Planks 1, 4, 5 and 6 are half-lapped behind the central planks 2 and 3. Planks 2 and 3 are butt-jointed.
3. The X-ray photograph reveals that additional chalk filler or gesso was added to the back of the half-lap additions of planks 1, 4, 5 and 6, which were joined to the previously chamfered edges of planks 2 and 3.
4. The X-ray image suggests that the application of both the ground and the paint layers on planks 2 and 3 is thicker than on the other planks. The *imprimatura* layer is a light grey on planks 2 and 3 and a darker grey on the surrounding additions. This *imprimatura* was applied vertically on planks 5 and 6 and horizontally on the others.
5. The large tree second from the left, which is painted over the join of plank 5 with planks 1, 2 and 3, is painted over an earlier tree.

6. X-ray and infra-red photography reveal many *pentimenti*, particularly near the joins of planks 2 and 3 with plank 5, from left to right: the sun was first placed further to the right; a swan has been painted out on the left edge of plank 2; there are minor changes in the shepherd's hat and in the sheep; clouds have been painted out on the right-hand edges of planks 2 and 3; a small group of cottages was on the right-hand side behind the dogs on plank 6.

7. The addition of planks 1, 4, 5 and 6 resulted in substantial reworking in the area of the joins, most clearly on the left and upper join where the trees have been altered.

8. The sky is painted in azurite; azurite with other pigments, particularly yellow lakes, make up the greens of the foliage and landscape. The shepherd's jerkin contains vermilion.

## Peasants with Cattle by a Stream in a Woody Landscape ('The Watering Place'), c.1620

London, National Gallery (Plate 46)

1. On the reverse is a chalk and glue layer and over that a size layer and then a toning layer of red ochre and carbon black in a water-soluble medium.

2. The ground is chalk and glue with a thin greyish *imprimatura* on top in the central part; elsewhere the colour is warmer.

3. All planks are between 0.7 and 1 cm thick. Plank 10 is half-lapped over planks 6, 7 and 9. It was probably originally supported by two vertical battens, after which a chalk and glue layer was applied to the reverse. The panel was later judged to require more support and the ground layer was partially scraped away and grooves cut to accommodate three horizontal battens; plank 11 is supported by the lowest batten and therefore was probably added at that time. (For a detailed account of the recent restoration treatment see Brown and Reeve 1982.)

4. The oil medium is for the most part linseed oil, but walnut oil has been identified in a sample taken from the sky.

5. X-ray and infra-red photography reveal that the paint on plank 1 is more thickly applied than elsewhere.

6. The sky is painted in lapis lazuli ultramarine, mixed with white; the sunlit clouds at the horizon contain lead-tin yellow. The dark green translucent foliage paints are based largely on mineral azurite and yellow lake pigments; some of the duller greens also contain earths and black.

## Pastoral Landscape with a Rainbow, c.1635

St Petersburg, The State Hermitage Museum (Plate 74)

Panel transferred to canvas

1. The panel was transferred to canvas by A. Siderov in 1869 and it is not possible to establish how many planks made up the original panel.

2. Before the transfer there probably was a chalk and glue ground. Zinc white was used as a new ground in the transfer.

3. Lead-tin yellow has been identified. There is a bituminous substance present in the browns which has caused broad cracks in the paint surface.

## A Wagon fording a Stream, c.1635

London, National Gallery (Plate 69)

Paper mounted on canvas

1. Drawn in black chalk and painted in oils on a single piece of paper mounted on to canvas. There are some small areas of red chalk drawing near the centre.

2. The edges of the paper are ragged and there are some old nail holes visible.

3. The paper has discoloured, particularly in the centre on the left, perhaps because of absorption of varnish or glue from the reverse.

4. The trees (except those at both edges) along the stream and path, the banks (except at the right) and bushes were first drawn in black chalk.

5. Some areas of the sky were put in with brown wash before the application of white.

6. The painting appears to be unfinished, particularly in areas of foliage.

## Landscape with a Wagon at Sunset, c.1635

Rotterdam, Museum Boymans-van Beuningen (Plate 70)

1. Painted on a single oak plank, with the grain running vertically. On the reverse is the brand of the arms of Antwerp and the stamp of the panelmaker Michiel Vriendt (MV).

2. All four sides are chamfered. The top edge appears to have been cut by about 1 cm; as it is, the chamfer is shorter than the others and the edge rougher.

3. The ground has been applied in the direction of the grain of the panel.

4. There are spontaneous, freely applied dark transparent brush-strokes over the *imprimatura* in the foreground. The trees at the horizon are painted in greater detail: they are painted wet in wet over the pale tints of the sky. Two blue pigments – azurite and ultramarine – appear to have been used in the trees and sky.

## A Forest at Dawn with a Deer Hunt, c.1635
New York, Metropolitan Museum of Art (Plate 71)

1.It can be seen in Fig. 4 of Liedtke 1992 that three planks have been attached to the back of the painted panel in order to strengthen it.

## An Autumn Landscape with a View of Het Steen in the Early Morning, probably 1636
London, National Gallery (Plate 58)

1. The medium is linseed oil with some added pine resin; walnut oil was found in a sample of white impasto.
2. The reverse has been grounded with chalk and glue which has then been covered with a brown toning layer.
3. The thin *imprimatura* layer is brownish yellow and bound in linseed oil with a little pine resin.
4. Planks 1 and 3 have chamfered edges which have been made up with two half-layered horizontal planks (and the addition of some chalk filler or gesso), so enabling them to be butt-jointed on to planks 17 and 18. All the horizontal joints are butt-jointed and all the vertical joints half-lapped.
5. There are thought to be two later additions: one, of oak 5 cm wide, is along the bottom, and the second is a 1 cm addition of poplar applied to the left edge. (These are planks 20 and 21 in the diagram.) *Landscape with a Rainbow* in the Wallace Collection is probably a pendant to the painting and also has a 5 cm addition along the bottom edge; it is possible that both additions were put on

when the pictures were owned by the Balbi family in Genoa.
6. Battens which had been glued to the back of the panel restricted its movement and caused it to crack during the winter of 1947. The battens were subsequently removed.
7. The thin warm brown glazes of the foreground contain a variety of natural ochreous pigments and Cassel earth; vermilion is added where the paint is denser and hotter in tone. The foliage and landscape greens comprise mineral azurite, yellow lake, lead white, lead-tin yellow, earths and black pigments in a range of mixtures and relative proportions according to colour and translucency of the paint. The most saturated glaze-like foliage greens are largely azurite and yellow lake. The pure blue of the sky is painted in lapis lazuli ultramarine mixed with white.

## Landscape with a Rainbow, probably 1636
London, Wallace Collection (Plate 59)

1. There are two planks at the bottom (nos. 18 and 19), both about 5 cm wide, which were probably added later. The *Landscape with Het Steen* also has a 5 cm addition at the bottom and these additions may have been added at the same time, perhaps when the two paintings were hung as a pair in the Balbi collection in Genoa.
2. The X-ray photograph shows the ground overlapping where plank 18 joins plank 17.
3. There are numerous *pentimenti*: for example, the tree at the edge of the wood; the horses's legs have been redrawn; the man in the centre has been moved to the right; a cow has been painted out and another moved to the left.

## Landscape with an Avenue of Trees, c.1636
Boston, Museum of Fine Arts (Plate 61)

Paper mounted on plywood

1. The dotted lines show the paper joins. The paper appears to have been attached originally to three horizontal oak planks.
2. No priming is visible on piece 1. There is an ochre-coloured priming on pieces 2-6.
3. The brushwork is softer and more flowing on pieces 2–6 than on piece 1. Some brushstrokes cross from the outer pieces over piece 1 but in the opposite direction. This suggests that piece 1 was painted

first and then the others were added and the whole mounted on to oak planks. The paper was subsequently transferred to the cradled plywood support.

Detail of infra-red reflectogram showing underdrawing of a horse (lower right). (See note 5.)

## Landscape in Flanders, 1636
University of Birmingham, Barber Institute (Plate 62)

1. All the joints are butt-jointed.
2. There is a later, unpainted strip of mahogany 1 cm wide around all four sides.
3. X-ray and infra-red photography show that the ground on plank 6 seems to have been applied over the ends of planks 1–4 and the ground and perhaps some paint has also been scraped away here.
4. The *imprimatura* appears to be a grey striated layer on planks 1–4 and a brown layer on plank 6.
5. Extensive passages of drawing are visible to the naked eye (and revealed in greater detail by infra-red reflectography), particularly on the right-hand side. Under the shepherd and his flock the drawing shows a man on a bucking horse and other figures. Rubens presumably used this panel for a quite different composition, perhaps a hunting scene or a history subject such as *The Conversion of Saint Paul*. There are also lines drawn in the right-hand side of the sky and elsewhere.
6. The application of paint on plank 6 differs from the remainder. There are many cursory strokes of yellowish-green highlighting in the middle and foreground on the foliage and water, for example, which are not seen in the rest of the painting.
7. There is a substantial *pentimento* in the large tree on the left edge; in the finished composition this bends further inwards. The alteration may have been a consequence of the addition of plank 6 after the design of planks 1–4 had been laid out.

## Landscape with a Tower, c.1636
Berlin, Gemäldegalerie (Plate 64)

1. Painted on a single oak plank; the grain runs horizontally.
2. Dendrochronology has given a felling date of 1633 for the tree from which the panel was made.
3. The panel is chamfered on both sides.

## Willows, c.1636
Private collection (Plate 91)

1. Painted on a single oak panel; the grain runs horizontally.
2. Pigments thought to have been used are vermilion in the jacket and azurite in the sky.

## Landscape after a Storm, c.1636
London, Courtauld Institute (Plate 92)

1. Painted on three planks, all horizontal.
2. The tree stump centre left was originally further to the left.

## Landscape with Moon and Stars, c.1637–8
London, Courtauld Institute (Plate 72)

1. Two layers of ground seem to have been applied to planks 1 and 2 but only one layer to planks 3, 4 and 5. Planks 1 and 2 have a yellowish layer and planks 3, 4 and 5 a cooler, brownish-grey layer.
2. On plank 5 there is a drawing of a group of figures done in black chalk and brush and ink. One of the figures crosses the join with plank 2. These figures were subsequently painted out.
3. The composition seems to have been begun with planks 1 and 2, planks 3, 4 and 5 being added later. Planks 4 and 5 appear to have been half-lapped behind 1 and 2 to a depth of about 2 to 2.15 cm.
4. Major compositional changes have taken place in the trees at the right, and they are much more coarsely painted than the ones on planks 1 and 2. Small fragments of wood have been found embedded in the paint of the left-hand planks, suggesting that the extension was done while the paint was still wet. X-ray and infra-red photographs reveal the original composition to have consisted of figures around a fire. These figures were subsequently painted out. (For further discussion see Braham and Bruce-Gardner 1988.)

## Landscape with Farm Buildings at Sunset, c.1638
Oxford, Ashmolean Museum (Plate 80)

1. On the reverse is the panelmaker's mark DFB, probably the mark of François de Bout the Elder.
2. Painted on a single oak panel, the grain of which runs horizontally.
3. In the centre of the composition, under a layer of reddish paint, is a figure and a group of sheep which have been painted out.

## Sunset Landscape with a Shepherd and his Flock, c.1638
London, National Gallery (Plate 79)

1. There are canvas strips over the joins in the panels on the reverse. The reverse is covered with animal glue and hair (or tow).
2. Planks 3 and 4 are thicker than 1 and 2 and are half-lapped behind them.
3. The *imprimatura* differs in colour on the various sections: on planks 1 and 2 it is grey and on planks 3 and 4 it is yellow-brown.

Detail of infra-red reflectogram showing inscription. (See note 5.)

4. The ground has been applied horizontally on planks 1 and 2 and vertically on planks 3 and 4. The ground on 3 and 4 appears to overlap that on planks 1 and 2. This overlap of layers also occurs in the *imprimatura* layer and in the paint layer itself. There seems to have been a group of trees on the right-hand side of planks 1 and 2 before planks 3 and 4 were added; the present trees and buildings were then painted over the join.
5. There is an inscription in the top right-hand corner of plank 1 revealed by infra-red photographs: *so veel gebracht* (or *gebrekt*) (this much used, or missing), and an arrow marking a length. This appears to be an instruction to the panelmaker about the extension of the panel. A cross-section taken from this inscription shows that on top of the ground there is a first layer for the sky consisting of smalt and white, with the black material of the inscription on top. Over this, a second layer of sky has been painted in azurite mixed with white. This sequence suggests that the addition of planks 3 and 4 was made after the first version of the composition had been begun.
6. In addition to the inscription there are other small drawn lines in the sky.
7. The paint on planks 3 and 4 has a rather granular consistency and the craquelure is significantly different from that on planks 1 and 2. The paint to the right is very thinly applied and therefore transparent in the sky.
8. The warm dark brown glaze of the foreground, lower right, consists of red earth, black, azurite and some white in a medium-rich layer. Smalt forms the greyest blues of the sky, with azurite over it in the stronger blues. Azurite with yellow lake makes up the foliage greens; lead-tin yellow is used for the sunlit horizon.

# Lenders to the Exhibition

Her Majesty The Queen (14, 15, 17, 42, 49)

The Visitors of the Ashmolean Museum, Oxford (30, 36, 50)

The Trustees of the Barber Institute of Fine Arts, The University of
Birmingham (46)

Bowes Museum, Barnard Castle, Co. Durham (55)

The Trustees of the British Museum, London (2-6, 10, 29, 31, 32,
56-9)

Courtauld Institute Galleries (Princes Gate Collection), London (27,
39, 43)

The Duke of Devonshire and the Chatsworth Settlement Trustees
(25, 26)

Trustees of Dulwich Picture Gallery, London (53)

The Syndics of the Fitzwilliam Museum, Cambridge (23, 28)

Kedleston Hall, The Scarsdale Collection (The National Trust) (13)

Koninklijk Museum voor Schone Kunsten, Antwerp (54)

Collections of the Prince of Liechtenstein, Vaduz Castle (16)

Collection of Sir Denis Mahon, London (8)

Mauritshuis, Koninklijk Kabinet van Schilderijen, The Hague (12)

The Metropolitan Museum of Art, New York (41)

Musée du Louvre, Département des Arts Graphiques, Paris (24)

Museo del Prado, Madrid (9)

Museum Boymans-van Beuningen, Rotterdam (22)

Museum of Fine Arts, Boston (47)

Private Collections (34, 37, 38, 40)

Rijksmuseum, Amsterdam (11)

Rubenshuis, Antwerp (44)

Skokloster Castle, Sweden (61-70)

Staatliche Museen zu Berlin, Gemäldegalerie (35)

The State Hermitage Museum, St Petersburg (20, 33, 48)

Wallraf-Richartz-Museum, Cologne (on loan from the Federal
Republic of Germany) (7)

# Works in the Exhibition

1
Netherlandish School
*Landscape: A River among Mountains,*
*c.*1525–20
Oil on panel, 50.8 × 68.6 cm
London, National Gallery

2  *Plate 5*
Pieter Bruegel the Elder
*Landscape with River and Mountains,* 1553
Pen and brown ink on paper,
22.8 × 33.8 cm
London, The Trustees of the British
Museum

3  *Plate 7*
Pieter Bruegel the Elder
*The Rabbit Hunters,* 1560
Etching, 21.5 × 29 cm
London, The Trustees of the British
Museum

4  *Plate 8*
Pieter Bruegel the Elder
*Solicitudo Rustica*
Engraving, 32.2 × 42.2 cm
London, The Trustees of the British
Museum

5  *Plate 9*
Pieter Bruegel the Elder
*Pagus Nemorosus*
Engraving, 32.2 × 42.4 cm
London, The Trustees of the British
Museum

6  *Plate 10*
Pieter Bruegel the Elder
*Forest Landscape with Bears*
Pen and ink on paper, 34.4 × 25.7 cm
London, The Trustees of the British
Museum

7  *Plate 24*
*Self Portrait with Friends*
Oil on canvas, 77.5 × 101 cm
On loan from the Federal Republic of
Germany, in the Wallraf-Richartz-
Museum, Cologne

8  *Plate 19*
Paul Bril
*Mythological Landscape with Nymphs and*
*Satyrs,* 1621
Oil on canvas, 70.5 × 93 cm
London, Collection of Sir Denis Mahon

9  *Plate 21*
Paul Bril and Rubens
*Landscape with Psyche,* 1610
Oil on canvas, 93 × 128 cm
Madrid, Museo del Prado

10  *Plate 24*
Hendrick Goudt (after Elsheimer)
*Aurora,* 1613
Engraving, 12.8 × 16.9 cm
London, The Trustees of the British
Museum

11  *Plate 11*
Jan Brueghel the Elder
*Latona and the Lycian Peasants*
Oil on panel, 37 × 56 cm
Amsterdam, Rijksmuseum

12  *Plate 14*
Abraham Govaerts
*Forest Landscape,* 1612
Oil on panel, 62.5 × 101 cm
The Hague, Mauritshuis, Koninklijk
Kabinet van Schilderijen

13  *Plate 13*
Joos de Momper
*Mountainous Landscape with Saint Peter and*
*the Centurion Cornelius*
Oil on panel, 138 × 173 cm
Kedleston Hall, The Scarsdale Collection
(The National Trust)

14
Jan Brueghel the Elder
*Country Scene,* 1600
Oil on copper, 47.6 × 68.2 cm
Lent by Her Majesty The Queen

15  [Illustrated page 10]
*Self Portrait,* 1623
Oil on panel, 84 × 61 cm
Lent by Her Majesty The Queen

16  *Plate 32*
*Pond with Cows and Milkmaids, c.*1614
Oil on panel, 76 × 107 cm
Vaduz Castle, Collections of the Prince of
Liechtenstein
Adler 17

17  *Plate 33*
*Milkmaids with Cattle in a Landscape: 'The*
*Farm at Laeken', c.*1618
Oil on panel, 84.5 × 125.5 cm
Lent by Her Majesty The Queen
Adler 20

18  *Plate 46*
*Peasants with Cattle by a Stream in a Woody*
*Landscape: 'The Watering Place', c.*1620
Oil on oak, 99.4 × 135 cm
London, National Gallery
Adler 25

19  *Plate 48*
*A Shepherd with his Flock in a Woody*
*Landscape, c.*1620
Oil on oak, 64.4 × 94.3 cm
London, National Gallery
Adler 23

20  *Plate 44*
*Landscape with a Cart crossing a Ford: 'La*
*Charrette Embourbée', c.*1620
Oil on canvas (transferred from panel),
86 × 126.5 cm
St Petersburg, The State Hermitage Museum
Adler 19

21  *Plate 69*
*A Wagon fording a Stream,* probably 1625–40
Black chalk and oil on paper stuck on
canvas, 47 × 70.5 cm
London, National Gallery
Adler 57

22 *Plate 70*
*Landscape with a Wagon at Sunset, c.1635*
Oil on panel, 49.5 × 54.7 cm
Rotterdam, Museum Boymans-van
Beuningen
Adler 58

23 *Plate 31*
Lucas van Uden (after Rubens)
*The Escorial, from a Foothill of the*
*Guadarrama Mountains*
Oil on panel, 49 × 73.5 cm
Lent by the Syndics of the Fitzwilliam
Museum, Cambridge

24 *Plate 81*
*Study of a Tree, c.1615*
Pen and wash on paper, 58.2 × 48.9 cm
Paris, Musée du Louvre, Département des
Arts Graphiques
Adler 18a

25 *Plate 83*
*Study of a Fallen Tree, c.1615*
Black chalk with slight touches of water-
colour on paper, 18.4 × 30.9 cm
Lent by the Duke of Devonshire and the
Chatsworth Settlement Trustees
Adler 28a

26 *Plate 84*
*Tree-trunk and Brambles, c.1615*
Red and black chalk, pen and brown ink
and watercolour on paper, 35.2 × 29.8 cm
Lent by the Duke of Devonshire and the
Chatsworth Settlement Trustees
Adler 70

27 *Plate 85*
*Wild Cherry Tree with Brambles and Weeds,*
*c.1615*
Black, red and white chalks and yellow
watercolour on brown paper,
54.5 × 49.5 cm
London, Courtauld Institute Galleries
(Princes Gate Collection)
Adler 71

28 *Plate 86*
*Path through an Orchard, c.1615–18*
Pen over black chalk on paper,
31.3 × 40.3 cm
Lent by the Syndics of the Fitzwilliam
Museum, Cambridge
Adler 72

29 *Plate 87*
*Pollard Willow, c.1618*
Black chalk on paper, 39.2 × 26.4 cm
London, The Trustees of the British
Museum
Adler 73

30 *Plate 88*
*Entrance to a Wood, c.1635–8*
Oiled charcoal with chalks on paper,
38.3 × 49.9 cm
Oxford, The Visitors of the Ashmolean
Museum
Adler 74

31 *Plate 89*
*Landscape with a Wattle Fence, c.1635–8*
Black chalk on paper, 35.3 × 51.4 cm
London, The Trustees of the British
Museum
Adler 75

32 *Plate 90*
*Trees reflected in Water, c.1635–8*
Black, red and white chalk on paper,
27.3 × 45.4 cm
London, The Trustees of the British
Museum
Adler 77

33
Attributed to Rubens, *A Moonlight*
*Landscape*
Oil on paper, 21.5 × 28 cm
St Petersburg, The State Hermitage
Museum
Adler 62

34 *Plate 91*
*Willows, c.1636*
Oil on panel, 18.5 × 33.3 cm
Private Collection
Adler 50

35 *Plate 64*
*Landscape with a Tower, c.1636*
Oil on panel, 24 × 30.8 cm
Staatliche Museen zu Berlin,
Gemäldegalerie
Adler 66

36 *Plate 65*
After Rubens, *Landscape with a Tower,*
*c.1636–40*
Oil on panel, 28 × 37 cm
Oxford, The Visitors of the Ashmolean
Museum
Adler 64

37
Attributed to Rubens
*A Peasant driving a Cart*
Oil on panel, 24.5 × 34.5 cm
Private Collection
Adler 32

38
Attributed to Rubens
*A Countrywoman driving a Cart*
Oil on panel, 23.5 × 34.5 cm
Private Collection
Adler 33

39 *Plate 92*
*Landscape after a Storm, 1630s*
Oil on panel, 49 × 64.6 cm
London, Courtauld Institute Galleries
(Princes Gate Collection)
Adler 45

40
*The Deluge (A Tempest at Night)*
Oil on panel, 39 × 69 cm
Private Collection
Adler 34

41 *Plate 71*
*A Forest at Dawn with a Deer Hunt, c.1635*
Oil on panel, 61.6 × 90.2 cm
Lent by the Metropolitan Museum of Art,
New York, Purchase, The Annenberg
Foundation, Mrs Charles Wrightsman,
Michael David-Weill, The Dillon Fund,
Henry J and Drue Heinz Foundation, Lola
Kramarsky, Annette de la Renta, Mr and
Mrs Arthur Ochs Sulzberger, The Vincent
Astor Foundation, and Peter J Sharp Gifts;
special funds, gifts, and other gifts and
bequests, by exchange, 1990
Adler 49

42 *Plate 60*
*Summer, c.1618*
Oil on canvas, 143 × 223 cm
Lent by Her Majesty The Queen
Adler 22

43 *Plate 72*
*Landscape with Moon and Stars, c.1637–8*
Oil on panel, 64 × 90 cm
London, Courtauld Institute Galleries
(Princes Gate Collection)
Adler 63

44
*Self Portrait wearing a Hat*
Oil on panel, 61.5 × 45 cm
Antwerp, Rubenshuis

45  *Plate 58*
*An Autumn Landscape with a View of Het
Steen in the Early Morning*, probably 1636
Oil on oak, 131.2 × 229.2 cm
London, National Gallery
Adler 53

46  *Plate 62*
*Landscape in Flanders, c.1636*
Oil on panel, 89.8 × 133.8 cm
The Trustees of the Barber Institute of Fine
Arts, The University of Birmingham
Adler 59

47  *Plate 61*
*Landscape with an Avenue of Trees, c.1636*
Oil on paper mounted on panel,
56 × 71.8 cm
Courtesy Museum of Fine Arts, Boston,
Ernest Wadsworth Longfellow Fund
Adler 52

48  *Plate 74*
*Pastoral Landscape with Rainbow, c.1635*
Oil on canvas, transferred from panel,
81 × 129 cm
St Petersburg, The State Hermitage
Museum
Adler 39

49
*Self Portrait in Old Age*, possibly *c.1637*
Black and white chalk on paper, 20 × 16 cm
Lent by Her Majesty The Queen

50  *Plate 80*
*Landscape with Farm Buildings at Sunset,
c.1638*
Oil on panel, 27 × 39 cm
Oxford, The Visitors of the Ashmolean
Museum
Adler 68a

51  *Plate 79*
*Sunset Landscape with a Shepherd and his
Flock, c.1638*
Oil on oak, 49.4 × 83.5 cm
London, National Gallery
Adler 68

52  *Plate 95*
*Portrait of Susanna Lunden ('Le Chapeau de
Paille'), c.1622*
Oil on oak, 79 × 54.6 cm
London, National Gallery

53
Attributed to Anthony van Dyck
*Sunset Landscape with a Shepherd and his
Flock*
Oil on canvas, 107.6 × 158.1 cm
London, Trustees of Dulwich Picture
Gallery

54  *Plate 104*
Jan Wildens
*Landscape with Dancing Shepherds, 1631*
Oil on canvas, 135 × 218 cm
Antwerp, Koninklijk Museum voor
Schone Kunsten

55  *Plate 105*
Lucas van Uden (after Rubens)
*Odysseus and Nausicaa, 1635*
Oil on panel, 52.1 × 74.3 cm
Co. Durham, Barnard Castle, The Bowes
Museum

56  *Plate 106*
Schelte à Bolswert (after Rubens)
*Landscape with a Draw Well, 1638*
Engraving, 28.8 × 42.5 cm
London, The Trustees of the British
Museum

57
Schelte à Bolswert (after Rubens)
*Landscape with a Rider descending to a River*
Engraving, 31.2 × 44.4 cm
London, The Trustees of the British
Museum

58
Schelte à Bolswert (after Rubens)
*Landscape with Cows and Sportsmen*
Engraving, 30.8 × 44.4 cm
London, The Trustees of the British
Museum

59  *Plate 25*
Schelte à Bolswert (after Rubens)
*Landscape with Antique Ruins*
Engraving, 32.9 × 44.1 cm
London, The Trustees of the British
Museum

60  *Plate 107*
Thomas Gainsborough, *The Watering Place,
c.1774–7*
Oil on canvas, 147.3 × 180.3 cm
London, National Gallery

61–70
Group of 17th-century tools: Wooden Set
Square, Tryplane, Smoothing Plane, Axe,
Double-Handed Framed Saw, Hand Saw,
Mallet, Large Flat Chisel, Ruler, Angled
Flat Moulding Plane
Sweden, Skokloster Castle

# Index

# Picture Credits

Full credit lines are given in the captions to
   the illustrations, except as follows:

London, The Royal Collection © 1996
   Her Majesty The Queen: Page 10,
   Plates 33, 60
Antwerp, © Copyright Rubenshuis: Plate
   17
Berlin, Photo: Jörg P. Anders: Plates 43, 73
Boston, Museum of Fine Arts, © 1996. All
   rights reserved: Plate 61
Brussels, Copyright IRPA-KIK: Plates 30,
   37
Brussels, Copyright Musées de la Ville de
   Bruxelles – Maison du Roi: Plate 38
Reproduced by permission of the
   Chatsworth Settlement Trustees: Plates
   83, 84
Florence, Archivi Alinari: Plates 29, 49, 76,
   99
The Hague, Photograph © Mauritshuis:
   Plates 12 (inv. nr. 253), 14 (inv. nr. 45)
London, Copyright © British Museum:
   Plates 5, 7–10, 23, 25, 36, 45, 63, 87, 89,
   90, 106
London, National Trust Photographic
   Library/Robert Thrift: Plate 13
London, Reproduced by permission of the
   Trustees of the Wallace Collection:
   Plate 59
Madrid, Copyright © Museo del Prado. All
   rights reserved: Plates 2, 3, 21, 27, 28,
   94
New York, The Metropolitan Museum of
   Art © 1990. All rights reserved: Plate 71
Paris, Musée du Louvre. Clichés des
   Musées Nationaux. © Photos R.M.N:
   Plates 66, 68, 77, 78, 81